The Philosophy of Theatre, Drama and Acting

The Philosophy of Theatre, Drama and Acting

Edited by Tom Stern

ROWMAN &
LITTLEFIELD
———— INTERNATIONAL
London • New York

Published by Rowman & Littlefield International Ltd
Unit A, Whitacre Mews, 26–34 Stannary Street, London SE11 4AB
www.rowmaninternational.com

Rowman & Littlefield International Ltd. is an affiliate of Rowman & Littlefield

4501 Forbes Boulevard, Suite 200, Lanham, Maryland 20706, USA
With additional offices in Boulder, New York, Toronto (Canada), and Plymouth (UK)
www.rowman.com

Selection and editorial matter © 2017 Tom Stern
Copyright in individual chapters is held by the respective chapter authors.

All rights reserved. No part of this book may be reproduced in any form or by any electronic or mechanical means, including information storage and retrieval systems, without written permission from the publisher, except by a reviewer who may quote passages in a review.

British Library Cataloguing in Publication Data
A catalogue record for this book is available from the British Library

ISBN: HB 978-1-78348-621-2
 PB 978-1-78348-622-9

Library of Congress Cataloging-in-Publication Data Available
ISBN: 978-1-78348-621-2 (cloth : alk. paper)
ISBN: 978-1-78348-622-9 (pbk. alk. paper)
ISBN: 978-1-78348-623-6 (electronic)

∞™ The paper used in this publication meets the minimum requirements of American National Standard for Information Sciences – Permanence of Paper for Printed Library Materials, ANSI/NISO Z39.48–1992.

Printed in the United States of America

Contents

1	Introduction *Tom Stern*	1
PART I: HISTORICAL PERSPECTIVES		**13**
2	'Hegel's "Instinct of Reason" and Shakespeare's *The Merchant of Venice*: What is a relevant *Aufhebung* of nature? of justice?' *Jennifer Ann Bates*	15
3	The theatre of thought: A. W. Schlegel on modern drama and romantic criticism *Kristin Gjesdal*	43
PART II: ACTING		**65**
4	Nietzsche, the mask and the problem of the actor *Tom Stern*	67
5	The image and the act – Sartre on dramatic theatre *Lior Levy*	89
6	Attention to technique in theatre *Paul Woodruff*	109
7	Giving focus *Tzachi Zamir*	123

PART III: THEATRE AS ART — 135

8 'What is the relationship between "observed" and "participatory" performance?' — 137
James R. Hamilton

9 Plays are games, movies are pictures: Ludic vs. pictorial representation — 165
David Z. Saltz

10 Ideals of theatrical art — 183
Paul Thom

Index — 201

About the Editor and Contributors — 209

Chapter 1

Introduction

Tom Stern

This book brings together a number of chapters in an area which is gaining increasing interest, namely the relationship between philosophy, on the one hand, and theatre, drama and acting, on the other. With some important exceptions, including books and papers by the contributors to this volume, philosophical investigations of theatre, drama and acting have been conspicuous in their absence from mainstream discussions of aesthetics and the philosophy of art, at least until the last few years. There seems to be no particularly good reason for this. 'Theatre' and 'drama', for example, are wide-ranging terms which refer to many different practices.[1] But, however one defines them, they are not obscure or unpopular as forms of art. Nor are they evidently without philosophical interest: in the past, they did not fail to draw attention from philosophers, beginning, at least, with Plato and Aristotle and continuing, as some of these chapters indicate, long into the nineteenth and twentieth centuries. Nor, finally, can it be said that theatre and drama are not distinctive as forms of art: it is not as though a philosophical understanding of painting, poetry or film would exhaust what there is to say about theatre, drama or acting. The volume serves to highlight some of the ways in which theatre, drama and acting have provided and continue to provide material for philosophical discussion, as well as the ways in which philosophical discussion can illuminate and complicate our understanding and experience of theatre, drama and acting. The aim is not to provide an introduction or overview, whether historical or conceptual. Such volumes are already available.[2] Nor was it to pretend to comprehensiveness. Instead, what we find, reading through, is a series of interlocking questions and concerns based on the most recent research.

In this introduction, the aim will be to give an overview of the contents of these chapters, followed by a brief summary of the themes which emerge

most prominently from the collection as a whole. The overview follows the section headings of the volume: 'historical perspectives'; 'acting'; 'theatre as art'. These are intended to point the reader in the right direction. However, it will be clear, even from the titles of chapters, that many of them could happily sit beneath two or three of these section headings. The thematic discussion which follows the summaries therefore treats the collection as a whole.

HISTORICAL PERSPECTIVES

Hegel's *Phenomenology of Spirit*, the source for much of Jennifer Ann Bates's chapter, presents its reader with a series of *Aufhebungen*, typically translated 'sublations'. Since, to the average English speaker, 'sublation' means just as little as *Aufhebung*, it is easier to keep the German term, noting that it has three meanings, with Hegel often intending all three at once: lift up, destroy and preserve. To ask what the *Aufhebung* of some concept is is therefore, at its simplest, to ask about its next step – the next step that will in some sense preserve its features, but will also significantly transform it (i.e., to a point where the original version was 'destroyed') to a new and higher ('lifted-up') stage. Bates is using Hegel's *Phenomenology* and Shakespeare's *The Merchant of Venice* to ask about this next step in the case of nature and justice. Readers of Hegel who have been interested in his views of drama have naturally gravitated towards his lectures on aesthetics and on the *Phenomenology*'s account of *Antigone* which is found at the start of the chapter called 'Spirit'. Bates focuses instead on the chapter immediately before the appearance of Antigone – 'Reason' – in which Hegel describes the development of the idea that the world is rational, and therefore that reason can be found in the world. The understanding of this claim develops in various directions, one early phase being the primitive scientific notion that reason can be adequately observed in bumps on the skull (phrenology). What ties these various unsatisfactory strands together and marks them as inadequate, Bates argues, is that they are merely 'instinctive' – that is, they show insufficient self-reflection. Eventually, Hegel's Reason chapter describes a development towards beings who must accept certain features of their world as socially given. This social givenness forms the subject of the next chapter, 'Spirit', beginning with Antigone's commitment to what appears to her to be the everlasting and 'given' laws of the gods. On the analysis developed by Bates, via close readings of Shakespeare's play and Hegel's philosophy, the relevant *Aufhebungen* of nature and justice would have in common a move from unconscious, instinctive coercion to a consciousness of coercion. Bates asks whether we moderns are up to this task.

Where Hegel's *Phenomenology* is one of the most widely read and analysed works in the history of philosophy, August Wilhelm Schlegel's

extensive lectures on dramatic art have received surprisingly little critical attention. Delivered in 1808, the year after the publication of Hegel's *Phenomenology*, they were subsequently collected and published under the title of *Lectures on Dramatic Art and Literature*. By this time Schlegel, one of the key figures in German Romanticism, had already begun translating Shakespeare. His translations would go on to play a central role in the integration of Shakespeare into German culture which, thus helped Shakespeare become a figure of global significance. It is surprising, therefore, that these influential lectures by a leading theorist and translator have not really received critical attention. Kristin Gjesdal's chapter offers a thorough and critical analysis. Schlegel, on her account, gave neither a grand-scale philosophical system nor a series of fragments, but rather a unique combination of general reflection on the artform and sensitive appreciation of the detail of individual works. Schlegel's reflections are further characterized by attention to the role of the critic, who understands the play in relation to theoretical and historical considerations, but who also knows himself or herself to be situated within a particular historical moment. For example, my criticism of Shakespeare cannot ignore Shakespeare's status in my own time, any more than it can ignore historical facts about Shakespeare. In Schlegel's work, we also find an attempt to bind philosophy and drama together: modern drama (as opposed to its ancient relative) invites a kind of philosophical reflection, so that, as Gjesdal puts it, 'modern drama can find itself through philosophy'.

ACTING

My chapter, 'Nietzsche, the mask and the problem of the actor', operates in two different directions. First, it gives an account of Nietzsche's claims about acting. Nietzsche, I suggest, has different models of acting in mind, which can usefully be separated out and described under three headings: 'immersive acting', in which the actor experiences what the character would experience; 'gymnastic acting', in which the actor experiences something very different from what the character feels; 'marionette acting', in which what the actor experiences approaches nothing at all. Second, it uses Nietzsche's claims about acting and theatre to understand his approach to philosophy itself. We begin with an apparent contradiction. Nietzsche liked to describe himself as 'anti-theatrical', and he did indeed put forward various criticisms of theatre and acting. But he is also known as an advocate of using the mask, a theatrical device, in philosophical communication. The chapter therefore tries to explain how Nietzsche can appear to oppose and endorse acting. The answer to this question is that Nietzsche's concerns about acting are quite specific: he worries, I argue, that playing to a crowd has various corrupting features

and masking helps to *prevent* this corruption; hence masking is what prevents the pitfalls associated with acting. But this corruption also threatens the expression of philosophical ideas, which can also be taken to be 'performed' to an audience of a kind. Hence Nietzsche appears to advocate a masked philosophy. While the initial tension between Nietzsche's anti-theatricalism and his mask-advocacy can be resolved, a further tension emerges through the discussion: Nietzsche seems to think that his philosophical task is to describe us as we really are (to use his phrase, to 'translate man back into nature'); but, in order to carry out this task, we have to undermine the very preconditions for its completion. Philosophy therefore looks self-undermining. This, I argue, is the deeper problem in Nietzsche's philosophy that is revealed from an analysis of his account of acting.

Action in general, Lior Levy argues in chapter 5, lies at the heart of Jean-Paul Sartre's philosophy. But our understanding of action in general is illuminated by a better understanding of Sartre's analysis of stage acting. Sartre finds a particular significance in the fact that, in theatre alone, actions are (or at least can be) represented by other actions, not by poetic descriptions or paintings. The artistic medium and the kind of represented object are one and the same: action. Of course, one could paint a representation of a painting or use music to represent other sounds, such as birdsong: in these cases, as in theatrical actions, the way of representing (painting, music) is the same kind of thing as what is represented (another painting, birdsong). But Sartre places action at the heart of human existence, in a way which cannot be said for paintings or music. As Levy puts it, theatrical actions are (for Sartre) intended to enable spectators 'to rediscover their own actions or rediscover themselves as agents'. How so? In theatrical action, properly understood, the actor reveals the 'project' of the character, where this technical term can be provisionally understood as the framework which gives a person's life a meaning, and which is itself a kind of freedom, but which is really completed only with the completion of his or her life. An agent's project therefore cannot be grasped entirely by the agent himself or herself. However, an actor can grasp his or her character's project, because actors have an outsider's perspective on the character they play: the actor playing Antigone really can grasp Antigone's (fictional) project. On Levy's account, the Sartrean theatrical actor conjures the image of the absent character, and this aiming at the ungraspable on the part of the stage actor mirrors our necessary but necessarily incomplete attempts to grasp our own projects. Thus, from the spectator's point of view, an actor is not merely restricted or hemmed in by being told what to say or where to stand: instead, the actor can aid the spectator in understanding his or her own situation, including the freedom which underlies all agency.

The next two chapters mark the shift away from figures in the history of philosophy towards contemporary philosophical analysis. Paul Woodruff's

chapter starts out with an apparently simple feature of the spectator's experience: that when we are being moved by theatrical performances, we typically don't pay all that much attention to the techniques used by actors. Following the definition he defended in his book, Woodruff understands 'theatre' to be a combination of two 'arts': first, performers make some human action worth watching; second, spectators find some human action worth watching. This definition reaches beyond conventional art theatre to include musical performances and sporting events, where the question of technique also arises. The central move, on Woodruff's terms, is the claim that the thing that is made worth watching (typically, the action in the play) cannot be the *means* by which it is made worth watching (i.e., the performers' abilities). One might imagine that paying attention to the impressive technique of an actor would be a reasonable way to appreciate a performance. But Woodruff claims that, at a typical theatrical performance, we have to choose what we find worth watching: often, though not always, we will have to choose between watching for technique and watching for the actions which that technique is employed to depict: for example, between Olivier's skilful acting and Lear's anguish at his betrayal. Which ought we to choose? Woodruff argues that theatre operates best when there is no mismatch between what the performer is trying to make worth watching and what the spectator finds worth watching: going to the theatre to appreciate technique rather than action suggests such a mismatch, because, for example, Olivier is trying to make *Lear* worth watching, not himself. This way of dividing things up will not apply to all forms of theatre, but the thrust of Woodruff's argument is that technique, while it can be, is typically not the proper object of regard for the spectators. This has some interesting consequences. For one thing, the professional critic, if he or she is understood to be the one who must watch for technique, is a 'bad watcher', which is to say that he or she is not fulfilling his or her part of the bargain as a spectator. Another consequence is that theatrical design can be too clever or brilliant, by drawing our attention away from the action. Finally, there is the question of expertise: if concentrating on technique makes you a bad watcher, and if expertise in theatre makes us better able to notice technique, then aren't we better off not being experts? Woodruff suggests that one test for 'greatness in theatre' is that it can make even expert watchers stop paying attention to technique.

Attention, or 'focus', is also the topic of the final chapter in this section. No student of theatre could fail to be familiar with the stereotype of the actor as selfish, self-absorbed or attention-seeking.[3] But this may reflect our tendency to concentrate on the big names or the lead roles. This tendency is not accidental, as Tzachi Zamir points out. 'Giving focus' – the name of Zamir's chapter – is also the name of an actor's technique, typically used to describe those who are not in the lead roles: it is a way of drawing attention

to someone else, of 'lessening one's visibility while heightening another's'. Zamir's chapter offers an analysis of this practice and makes the case for its significance. Giving focus not only sits at odds with our idea of the actor as attention-seeker. It also sits at odds both with the Western ideal of the artist (as creative, assertive and individual) and with the Nietzschean ideal of the self as an artist, who takes this artistic attitude to his or her own life. If acting is an art, and art requires this creative, assertive individuality, then how can we make sense of the actor who 'gives focus' to someone else? Zamir argues that the Nietzschean artistic ideal does not take into account the 'delicate aesthetic work of the performing artist': the ideal is therefore at fault. It would be tempting to suppose, from the way in which the term is typically used, that 'giving focus' is just one more tool in the actor's toolkit, to be used when one plays a minor role and to be put away when one takes the lead. But Zamir's argument is that all actors are always giving focus. Actors are not merely seen, they are seen-as-showing: even the lead actor is 'showing' the central character. Consequently, acting can be understood as a kind of generosity, an other-oriented activity.

THEATRE AS ART

The chapters in the last section of the volume ask about theatre as a form of art. A common feature of all of the chapters thus far is that they are typically thinking in terms of quite conventional, European, mimetic theatre: theatre which involves a literary play text as the source, with performers playing characters described in this text, from which they take their words and at least some of their direction. Even Woodruff, for whom the term 'theatre' is more broadly applied, pays close attention to mimesis. One could hardly fault philosophers like Schlegel or Nietzsche for not writing about forms of art they could never have seen. But a contemporary reader would be entitled to ask about the relationship between traditional European theatre and contemporary theatrical practices. James R. Hamilton's work always finds a central place for non-traditional theatre, and in this chapter his central theme is the relation between 'observed' and 'participatory' theatre. 'Observed' theatre can initially be understood as theatre in which the spectators' role is merely to watch the performance. 'Participatory' theatre performances are those in which the spectators play a more active role of some kind, and this role is an integral part of the performance itself. For this reason, 'spectator' does not seem like quite the right term for those who attend participatory theatre, and terms like 'spect-actor' (Augusto Boal's phrase) and 'spectator-participant' have sometimes been preferred.

Based on these brief distinctions, one might expect the difference between participatory and observed theatre to be fairly self-evident: in the former, spectator-participants are active, whereas in the latter, spectators are passive. But this, Hamilton argues, cannot do: on any reasonable account of 'observing' spectators, they are also active. Another way of drawing the distinction might be to describe participatory theatre as 'interactive'. Here again, Hamilton argues, it would not be right to say that observed theatre is not interactive. A better understanding of the difference would be to present interactivity as a matter of degree, according to which all spectators must be interactive and, to understand a performance at all, must have an appropriate degree of awareness of the amount of interactivity that is demanded by the performance. One consequence which Hamilton draws out from this analysis relates to moral concerns about participatory theatre. These arise for cases in which the spectator-participants do not fully understand what is going on and could perhaps better be described as the victims of a certain kind of trick than as spectator-participants in a theatrical performance. Hamilton deploys the notion of varying degrees of interactivity, as developed in the chapter, to locate the problem in such cases.

David Z. Saltz offers an analysis of the nature of theatre in which key elements are brought out by a contrast with live-action film. Since theatrical performances and live-action films employ 'distinct modes of representation', it is a mistake to view theatre and film as being basically the same kind of thing: 'Film is not merely photographed theatre with close-ups and editing'. Of course, in one sense, the mode of representation is the same: human actors. But the difference lies in what, in each case, a spectator can infer, from the actor and scenery, about the fictional world that is being conjured up. Representation in theatre is 'ludic', a kind of play, whereas representation in film is better understood as pictorial. Saltz claims that film is 'pictorially replete': within the relevant parts of the film (typically what is contained within the picture frame, as opposed to the music or subtitles giving the location of date of the scene), any element present in the film is to be taken as present in the fictional world created by the film. Hence, in one of his examples: a cockroach crawling up the wall behind the actors in a film would have to be taken to be part of the imagined, fictional world of the film (or else it is a mistake, an error in the film); on the other hand, a cockroach crawling up the wall behind the actors in a play could not necessarily be taken as part of the fictional world invoked by the play. The difference is further illustrated by a comparison between watching a play and watching a film of the performance of the play. The latter, for Saltz, however it is edited, becomes a documentary of the play, a film documenting the event that was the play. We might say: a cockroach on the wall in the play might or might not be part of the fictional

world depicted by the play; but when that same cockroach is shown on the wall in the *film* of the play, it is certainly part of the world represented by the film. Saltz is making a claim about the general conventions at work in theatre and film, and the chapter ends with a consideration of exceptions and mixed modes: a play which is pictorially replete; a film which is 'ludic'. Musicals, especially filmed musicals, provide a notable case in which what happens within the picture cannot be taken to be going on in the fictional world created by the film: 'The audience needs to compartmentalize the actors' musical performances and treat that one aspect of the film differently from everything else it sees'.

Finally, Paul Thom's category of 'theatrical idealists' treats those who both reject theatre as it currently is and yet dream of a glorious possible future theatre. There are different ways to be a theatrical idealist. One idealist might envisage a radical reform of theatrical practice. Another might set out rules for the choices that spectators make in theatrical performances, offering an account of which kinds of choices are sound and which are not. Yet another might propose a new way of accounting for the way we grasp performances, indicating which ways of thinking about spectator experience are appropriate and which are misleading. Thom treats cases of each kind. The first is Edward Gordon Craig's Wagner-inspired 'theatre of the future'. Ideally, theatre becomes for Craig a 'pure' art, in which a single mind has complete power over the production of the work, having come to a sufficient understanding of the many techniques employed in theatre, and in which one sense, sight, is clearly taken as central. Craig's ideal relegates actors to a secondary status which, taken to its limit, replaces them altogether. As Thom points out, it remains an open question whether Craig intended this anti-actor stance to be taken seriously as a goal, or whether he thought he was offering a helpful exaggeration. The second and third 'idealists' are contributors to this volume: Paul Woodruff and James R. Hamilton. On Woodruff's account (as briefly outlined earlier), theatre is best understood as the combined arts of making something worth watching and finding something worth watching, the practices which inform our daily lives. On Thom's reading, Woodruff's idealism, despite finding a place for sports and religious ceremonies as kinds of 'theatre', ultimately looks back to classical Greek theatre as its apogee: a social and political environment in which not just art theatre but civic life made central the practice of theatre in Woodruff's broader, ethically infused sense. Hamilton's 'idealism', like Craig's, seeks to give theatre independence from other forms of art (in his case, notably, dramatic literature), via the analysis of spectator experience. (This is the project which Hamilton can be seen to advance in his chapter for this volume.) Basic theatrical experience does not, for Hamilton, make any reference to literary works. On Thom's account, Hamilton must still allow

for a deeper appreciation of theatrical performances – one which may well require an appreciation of works of dramatic literature. Having analysed these three forms of idealism, Thom broadens his approach to consider what makes theatre art, a question which is answered differently by his different idealists, whose different approaches reveal different facets of theatrical art.

THEMES OF THE COLLECTION

The summaries given here are sufficient to indicate a number of interlocking themes which arise in these chapters. To draw some of them out, as I do now, is by no means to deny the variety of subjects and approaches on display in the volume.

A common theme of the chapters devoted to specific figures in the history of philosophy is the conception of philosophy itself as, at least, having something to gain from the consideration of theatre, drama or acting. One could imagine a philosophy of some subject, according to which philosophy was a set of tools wheeled in to help thinkers or practitioners in that area who are in need of clarification, conceptual analysis or rigorous argument. There are times when this is quite a good description of what is going on, and undoubtedly such an approach has its place. But for Hegel, Schlegel, Nietzsche and Sartre, in different ways, this is not really the best description of their approach to theatre, drama and acting as it is set out in these pages. Schlegel takes modern drama to be, itself, a kind of philosophical reflection, one which by its very nature calls for criticism and further analysis, and from which we develop a richer understanding of modernity; this contrasts modern drama with its ancient counterpart, which only called for critical reflection once it had passed its prime. Where Hegel is often and somewhat crudely taken to abandon art in favour of philosophy, Bates argues that his position is one in which drama, as the most comprehensive form of art, is in fact better understood as being needed by philosophy, as much as drama needs philosophy. Nietzsche's deeper concern with the adequate expression of philosophy is, on my account, graspable via an appreciation of what he takes to be problematic about theatrical acting: the pitfalls of being an actor apply also to the philosopher, and this is very much on Nietzsche's mind as he advocates 'masked' philosophy. Finally, following Levy's analysis of Sartre, the spectator at the theatre has the opportunity to learn something of central philosophical significance which could not obviously be learned in any other medium. Of course, in all cases these philosophers approach theatre with their own sets of assumptions and interests – Nietzsche, for example, is highly critical of theatre, as he understands it. But it should at least be clear that, in his case just as much as the others, there is

a willingness to learn from theatre, drama and acting in a way that informs philosophical practice.

Informing practice in a different way – and here, I mean theatrical not philosophical practice – is also a theme which emerges throughout the volume. One could imagine a resistance to the idea that philosophy should always be applied, or that it should be judged as better the more it has some defined result for our everyday lives. Philosophy, one might say, should be allowed to develop of its own accord. The idea that philosophical essays should inform theatrical practice might also be resisted for a further reason: namely, that philosophers are not necessarily going to be very good at knowing, in advance, what sorts of things an artist or theatre practitioner might take from their work. For these reasons, among others, I am reluctant to advertise or spell out a series of practical, take-home messages for theatre practitioners. But a gesture in this direction might not be wholly unwelcome. Sometimes, practical implications are made evident by the author in question. Zamir, in his analysis of 'giving focus', highlights his claim that generosity is a value for the actor: this can remove misconceptions about an actor's goal – misconceptions which might impede the actor from achieving that goal. If an actor who is giving focus sees himself or herself as a kind of mobile scenery, this (for Zamir) mistaken self-conception overlooks the 'aesthetic activity of serving a scene'. Thom's theatrical idealists, despite what the label implies, are all analysed in terms of what they want from theatrical practice, even where Thom does not endorse their claims himself: Thom's Hamilton, for example, seeks to defend avant-garde practices, while Craig wishes to rid theatre of any accidental feature, where that is taken to be something that was not planned by a single mind. Hamilton's own chapter, as we saw, finds a way of mapping out the moral issues which arise in relation to participatory theatre. Saltz does not offer a prescriptive rule about the different goals that theatrical and live-action film artists ought to have in mind, given their different modes of representation, but he does suggest that films that ask spectators to react as a theatre spectator would (i.e., films which use ludic representation) are often unpopular or experienced as awkward. Even the categories of actor set out in my analysis of Nietzsche might be useful in thinking through a performance, even though this was hardly something Nietzsche would have had in mind. Indeed, during the course of writing the chapter, I was invited to use these categories as part of the development of a performance. Finally, Gjesdal and Woodruff can be seen to pose direct questions about the practice of criticism. Schlegel's critic (for Gjesdal) never loses sight of his own contextual location, for otherwise he risks misunderstanding both himself and the work he analyses. Woodruff provocatively challenges the critic to balance an appreciation of

technique with 'good watching', which often seems to run precisely counter to what good criticism demands. The implication, as we have seen, is that the best works of theatrical art are those which manage to evade the critic's eye, by elevating him or her to the status of the 'good watcher' who cannot merely watch for technical skill.

A third theme among these chapters is the question of what the actor is trying to achieve and how the spectator ought to respond. Nietzsche's descriptions of acting remind us of some of the less generous terms that have been sent in the actor's direction: on some of his accounts, though not all, the actor is best understood as a deceiver and, therefore, a spectator who buys into a performance has been misled. To read Woodruff's chapter, one has the sense that thinking too directly about what an actor is attempting to do can get in the way of the effect of the performance. Woodruff does not expect spectators to forget altogether that they are watching a performance, nor does he ask us to be ignorant about the skills required for performance, but he does appear to approve of one's attention being 'stolen away' from questions about an actor's technical practice. In contrast, some kind of attention to the practice of the actor seems to be required, at least at a theoretical level, for the sort of appreciation required in the case of Levy's Sartrean actor and Zamir's focus-giving actor. In both cases, the actor is engaged in a kind of showing, and it is a mistake to lose sight of the relationship between actor and character. Zamir's 'generous' actor must empathize not only with a character, but also, often, with the spectator: the case he studies is one in which a focus-giving actor can be seen to 'perform the audience', in other words to pre-empt or to nudge the spectator into reacting to a scene in a particular way. Zamir may therefore be seen to be drawing our attention *towards* some of the acting techniques which Woodruff thinks should be used to keep our attention away from acting technique. On Levy's reading, the Sartrean actor achieves his or her philosophical impact by evoking a character who is present 'only as image', in other words as a kind of absent ideal. To forget the actor-character distinction, to treat the character as somehow fully present, would be to surrender precisely the unique philosophical dimension that theatre has to offer. One wonders, therefore, whether Sartre's two-level analysis would be compatible with Woodruff's ideal of being 'stolen away' from the technique of acting.

These, then, are some of the themes which emerge from the collection. Needless to say, my hope is that these chapters will form part of a continuing conversation about the philosophy of theatre, drama and acting. My thanks to all of the contributors, and to the publisher, Rowman & Littlefield International, for their efforts in this direction.

NOTES

1 Tom Stern, *Philosophy and Theatre: An Introduction* (London: Routledge, 2013), pp. 10–11.

2 Stern, *Philosophy and Theatre*; Marvin A. Carlson, *Theories of the Theatre: A Historical and Critical Survey, from the Greeks to the Present* (Ithaca: Cornell University Press, 1993).

3 Stern, *Philosophy and Theatre*, pp. 113–124.

Part I

HISTORICAL PERSPECTIVES

Chapter 2

'Hegel's "Instinct of Reason" and Shakespeare's *The Merchant of Venice*: What is a relevant *Aufhebung* of nature? of justice?'

Jennifer Ann Bates

> 'O, these deliberate fools! When they do choose
> They have the wisdom by their wit to lose'[1]
>
> 'Tell me where is fancy bred,
> Or in the heart, or in the head?
> How begot, how nourished? . . .
> It is engendered in the eyes,
> With gazing fed; and fancy dies
> In the cradle where it lies.
> Let us all ring fancy's knell.'[2]

In Shakespeare's *The Merchant of Venice*, the blending of proto-idealist categories like instinctive reason and mercy with natural objects creates an uneasy middle world of clever laws, imaginary justice and seeming comic resolution. In Hegel's philosophy, *die Aufhebung* is a negation and preserving of opposing terms in a third more comprehensive term. It is usually translated as 'sublation' in English and '*relevé*' in French.

Drawing on Shakespeare's play and Hegel (and Haverkamp, Eagleton and Derrida) I answer the question: what would be relevant *Aufhebungen* of nature and of justice?

In Part One, I discuss Hegel's 'Instinct of Reason' in his *Phenomenology of Spirit*. I distinguish this instinctive reasoning's inadequate *phenomenological* empiricism from 'absolute' reason's *speculative* empiricism, and I show why the former needs to be developed into the latter.

Part Two concerns Shylock's bond of a pound of flesh, the caskets and rings, economic and matrimonial engagements, wit, mercy, eyes, blindness, music and other chains of signification in *The Merchant of Venice*.

Part Three draws on Eagleton's Marxist reading of the play (touching briefly on Derrida's reading of it in 'What Is a Relevant Translation?'). I argue that all merely instinctive *Aufhebungen* of nature and of justice share a middle term – unconscious coercions of the bonds of flesh. This is illustrated in the play's symbols of procreation. I briefly discuss how bringing a philosophy text and a dramatic text to bear on each other fulfils Hegel's requirement that *Aufhebungen* involve a medium for thought to think through. The problem is thinking that medium properly.

I argue in conclusion that *relevant* sublations overcome instinctive reason by being conscious of its rational chains – its sexual, cultural and linguistic coercions, its forced assimilations, conversions and translations. Shakespeare's play and Hegel's book teach this. I question how successful we can be.

PART ONE: REASON'S *AUFHEBUNGEN*

Hegel's instinctive reason (phenomenological empiricism in the *Phenomenology of Spirit*: 'The cradle in which this fancy lies')

The *Phenomenology of Spirit* is a phenomenological development of successively more complex *Aufhebungen* by natural consciousness into the social and historically self-conscious spirit of absolute knowing, the standpoint of Hegel's 'speculative science'.

The first chapters of the *Phenomenology of Spirit* follow the development of consciousness into self-consciousness and then reason. The final four chapters of the book – 'Reason', 'Spirit', 'Religion' and 'Absolute Knowing' – each develop forms of reason. The first of these final chapters bears the name of reason. But reason comprehends itself properly only in the last chapter, entitled 'Absolute Knowing'.

Overview of the chapter entitled 'Reason'

The *chapter* entitled 'Reason' stands in the middle of the book. It is higher up the phenomenological ladder than consciousness and self-consciousness, but lower than Spirit, Religion and Absolute Knowing. Thus in this chapter, reason formally reconstitutes our conscious and self-conscious wits (our five senses and our first social triangulations) as rational, but it falls short of a fully reflective comprehension of subject and object. By the end of this chapter, Reason will have learned that natural empiricism is not enough and that theories about the structure of reality have to be developed in and through complexities of kinship and politics. (In Part Three I argue that one way to do this is to bring the texts of philosophy and of drama together.)

At the start of the chapter, reason is *instinctively* certain that it is able to find the truth about things – it has the 'certainty of being all truth'.[3] It starts with a simple empirical attitude. But since reason has not yet recognized its historical and phenomenological constitution, it is actually formal, idealistic. Instinctive reason therefore has strange bedfellows: Cartesian empiricism, and the later Cuvierian empiricism;[4] as well as Kant's fully fledged transcendental idealism, and, even more strangely, Fichte's dialectical, self-as-act interpretation of Kant.

What is common to all these is that they each 'assert essence to be a duality of opposed factors, the *unity of apperception* and equally a *Thing*; whether the thing is called an extraneous impulse, or an empirical or sensuous entity, or the Thing-in-itself, it [the "object"] still remains in principle the same, i.e., extraneous to that unity [of apperception]'.[5] This 'instinct of reason' (*Vernunftsinstinkt*) does not reflect on itself as constituting and constituted by its other. Rather, it 'can attain itself only through the detour of observing things. As an instinct, it is a presentiment of itself but not a self-knowledge'.[6]

In this chapter on Reason, reason develops through three stages. The first, 'Observing Reason,' spirals into a materialism in which reason sees itself as brain fibres and bumps on the skull. Reason then shifts from observation to a second stage, the actualizing of itself through its own activity. This leads it into conflicts any narcissist would encounter – between pleasure and necessity, and its own virtue against the ways of the world. Finally, in the third stage, reason 'takes itself to be real in and for itself'.[7] This leads to a 'spiritual animal kingdom' of competing claims about what the heart of the matter (*die Sache selbst*) is. Reason tries to assert itself as law-giver, actively testing its laws. But it encounters laws which do not appear to have any origin and which are taken to have always been how things are. At this point, we leave the chapter 'Reason' and enter the 'Ethical Substance' of 'Spirit' – the next chapter of the book, and next 'level' of Reason.[8]

Reason has realized that the heart of the matter – the structure of reality – is not merely organic, graspable by natural empiricism: rather, it involves unspoken bonds of kinship and practical powers of state control.[9]

Thus, over the course of the chapter on reason, we slide from a robust natural empiricism, into a materialist pit, only to climb back up through narcissistic failures, into blind acceptance of ethical roles. But an advance has been made (even if more advances are needed): reason as Spirit will go on to learn how ethics and culture are categories of reason and how they shape its observations, its natural, logical and psychological laws. As Spirit, reason will continue to try to find the rational in the real, but from here on it will no longer think that the real is merely a given (albeit rationalizable) 'other' (nor merely a rational act) – it will gradually work out its own social history as part of the essence of the real.

We have seen, then, that the 'instinct of reason' is the impulse of the formally idealist stance; it appears at the very beginning of the chapter on reason, at the start of observing Reason.[10] Instinctive reason is thus the first step on a long path towards speculative reason. It is the conceptual cradle of absolute knowing, the first impulse of rational nesting – an observant, confident, inwardizing, doubling portrayal, of reality.[11]

Instinctive reason's development in detail

Instinctive reason spirals down conceptual levels as it enters ever more deeply into natural objects. At the top, it starts with a general empirical attitude, describing and observing outer nature. Then it develops its observations into inner laws governing inorganic material. Then, realizing that something deeper yet is to be found in organisms, it teases out laws of sensibility, irritability and reproduction. It then digs still deeper to find the basis of the life stream in the genus. It emerges from it all with the conclusion that life is a syllogism in which the living individual is the middle term between the genus and its existential shapes, and that the most general individual is the earth, 'which as the universal negativity preserves the differences as they exist within itself'.[12]

At this point, Hegel remarks that 'organic Nature has no history',[13] whereas consciousness, because it is life that is for-itself and consciousness of itself, does have a history. So instinctive reason turns inward towards the *mind*; it observes itself in order to find the inner of the inner. Thus begins the second part of observing reason ('Observation of self-consciousness . . . Logical and Psychological Laws'[14]). Its trip inward is into the materialist pit mentioned earlier. That is, consistent with consciousness's propensity throughout the *Phenomenology* to reify its object, Observing Reason instinctively focuses itself into objectivity, its object now the corollary of its current self-certainty.[15] It develops the science of phrenology, in which the truth of the psychological laws is observable in the bumps on the skull.

So reason *began* concerned with a difference between outer and inner, *then* looked for the inner of the inner, and *then* turned that inner of the inner into a skull. Reason thus becomes a bone. To echo Shakespeare, 'Fancy dies in the cradle where it lies'.

Let us pause here. Hegel refers to Reason's act in phrenology as a ridiculous bifurcation. Reason has 'directly sundered into itself and its opposite'.[16] It thinks, and yet it thinks itself a thing. It looks, but in a blind, non-productive way. Here is Hegel's witty (albeit unconsciously phallocentric) metaphor for this:

> The *depth* which Spirit brings forth from within – but only as far as its picture-thinking consciousness where it lets it remain – and the *ignorance* of this consciousness about what it really is saying, are the same conjunction of

the high and the low which, in the living being, Nature naïvely expresses when it combines the organ of its highest fulfilment, the organ of generation, with the organ of urination.[17]

More problematic than this phallocentrism, however, is that Hegel compares phrenology to Judaism: phrenology makes reason alienated from itself, just as Judaism generates spiritual self-alienation;[18] the finite (the skull or the chosen people) is separated from the infinite (the act of reason or God), thus making incarnation infinitely remote. Hegel's comparison is all the more objectionable given that he writes that phrenology, 'this final stage of Reason in its observational role[,] is its worst [stage]'.[19]

When Observing Reason looks at its own logical and psychological laws, and then, finds the 'inner of the inner' of those laws to be expressed by the outer bumps on the skull, it has reached the *caput mortum* of observation.

Skulls are always pivotal in Hegel's *Phenomenology of Spirit*.[20] And here, Reason makes an about-turn. It searches for the heart of the matter in its own activity, exhausting itself on the sea of narcissism, and washing ashore on ethical substance. 'The logical priority of "consciousness" as the "own proper shape" of Reason can only be established by the *reduction ad absurdum* of the alternative route through "things"'.[21]

Thus the chapter called 'Reason', especially the section on Observing Reason, has taught us about the rationalizing impulse called 'the instinct of reason'. But even if we appear to have moved on from it as we enter the chapter on Spirit, instinctive reason remains the unconscious cradle of apperception.[22] This latency becomes most destructive politically, in Hegel's later chapters, as the 'Pure insight' of the Enlightenment and the Terror of Absolute Freedom – in which heads role into wicker baskets.

To *properly* move from the phenomenological to the speculative, reason must discover more of its actual structuring. Without that insight into the inner of the inner, reason – the 'organ' which generates chains of signification – remains duplicitous and coercive.

Speculative reason (empiricism in the *Philosophy of Nature*)

Let us move on now to the point of view of completed reason. *Die Aufhebung* (sublation) is a negation of negation which preserves that past in a new form. To look at something properly, one looks not just at the outer and the inner, but at 'the inner of the inner', seeing how the latter unconsciously controlled how we originally set up the outer. The key is to do this speculatively. What does this mean?

In the speculative empiricism of Hegel's *Encyclopedia Philosophy of Nature*, the object is classified within the larger understanding of how the

object has a dialectical history in relation to the classifier.[23] Metaphysics, therefore, is understood to undergo revolutions:

> Every educated consciousness has its metaphysics, an *instinctive* way of thinking, the absolute power within us of which we become master only when we make *it in turn the object of our knowledge*. . . . All revolutions, in the sciences no less than in world history, originate solely from the fact that Spirit, in order to understand and comprehend itself with a view to possessing itself, has changed its categories, *comprehending itself more truly, more deeply, more intimately, and more in unity with itself*.[24]

This 'unity with itself' is, in speculative empiricism, a dialectical relationship between universality and individuality which takes into account its historical revolutions. It realizes itself, therefore, to be equally a dialectic between theory and practice.[25]

We note three things here. First, there is movement. In speculative empiricism '[w]hat is intuited must also be thought, the isolated parts must be brought back by thought to simple universality; this thought unity is the Notion, which contains the specific differences, but as an immanent self-moving unity'.[26] Whether one intuits a flower – or, analogically, a drama or the portrait of Mona Lisa – there is a complex, developing structure to behold. The 'picture' moves.

Second, there is a dialectical interdependence between the terms. 'If genera and forces are the inner side of Nature, the universal, in face of which the outer and individual is only transient, then still a third stage is demanded, namely, the inner side of the inner side, and this . . . would be the unity of the universal and the particular'.[27] One can think, for example, of the genus of life (U), the species (P) and the Individual (S); or Self (U) idea (P) Object (S). Thus if we take today's biology as our example of science, we could say that the species – determined by the sexual reproductive ability of its members – is the way that life has individual existence; or of cognition, we could say that the idea, determined by the production of significance among communicators, is the way that mind has individual existence.[28]

Third: many people think that Hegel asserts that the universal swallows up the individual mind. But this is false: he makes it clear that both sides are each universal and individual and that both sides are negations to the other side. Thus the universal is not passive; it is itself an individual. And conversely, 'the true individuality is at the same time within itself a universality'.[29] Furthermore, universality 'equally finds individuality in them [things] and does not encroach upon their independence, or interfere with their free self-determination'.[30] This is a very important point, one to which I return at the end of my chapter: I argue that we see the interdependence of drama and philosophy when we consider the dramatic individual in terms of the universal and vice versa.

Thus, speculative empiricism – the cognition which comprehends – grasps this syllogistic unity. It thinks by means of all on all three levels (UPS – Universal, Particular and Singular), and it sees its object as doing the same. In this way mind, like an organism, does not urinate picture thoughts on its other; it procreates with it.

In speculative empiricism, the instinct to have a metaphysics has become freedom in context. Without this development, the instinct of reason remains merely observant, and thus unconsciously coercive, the bonds of flesh tied up in its chains of signification.

The question now is, is Hegel's speculative science just another Belmont? To make sense of my question, let us turn to Shakespeare's play.

PART TWO: *THE MERCHANT OF VENICE*

Summary of the play

The merchant Antonio has ships at sea carrying all his wealth. Despite this insecurity, he makes a deal with Shylock, a Jewish moneylender, to secure 3,000 ducats for his friend Bassanio, so that Bassanio can sail to Belmont to win the wealthy lady, Portia. Portia's deceased father had arranged that to win Portia's hand, a suitor must guess which of the three caskets (lead, silver or gold) contains Portia's image. Two suitors make failed attempts, until well-fitted Bassanio arrives and 'reasons' to the right casket. He then learns that Antonio's ships have all wrecked, and that Antonio must answer Shylock's bond.

Shylock had arranged with Antonio that the bond would be either the repayment of the ducats or on forfeit, a pound of flesh cut from near Antonio's heart. In the time it took for Bassanio to sail to Belmont and choose the right casket, Shylock's daughter has run off with one of Bassanio and Antonio's friends (thus, with a Christian); Shylock, having suffered in the past from Antonio's anti-semitism, becomes determined to make Antonio pay the full pound of flesh, rejecting offers of money from other people seeking to cover the debt. Admitting revenge, Shylock's argument in court is based on the letter of the law and the economic and religious sanctity of bonds. He rejects the Christians' pleas that he be merciful, pointing to the Christian hypocrisy of owning slaves.[31]

Unbeknownst to the court, Portia and her attendant Nerissa are disguised as a male lawyer and his attendant, and are present in court. As the lawyer Balthassar, Portia argues that Shylock is justified in taking the flesh; as Shylock goes to cut the flesh she warns him that the letter of Venetian law prohibits the spilling of any blood – he may take only flesh, not a jot of blood. Shylock's penalty for threatening the life of a Venetian is to forfeit half his estate to Antonio, and upon his death, the other half to his

daughter and her new Christian husband, and he must immediately convert to Christianity.

The play ends back in the idyllic Belmont where the various couples are reunited. Portia and Nerissa chastise their new husbands for having rewarded the lawyer Balthasar and his attendant with the rings that they (the ladies) had given their husbands before, in sanctity of marriage, under penalty of forfeiting the marriage should they lose the rings. Portia and Nerissa then release their contrite husbands from guilt, showing them that they (the ladies) have the rings because they were in fact the disguised lawyers in court. All appears to end merrily, but we are haunted by the terrible memory of destitute, forcefully converted, Shylock.

Instinctive reason at play

Inner and outer

From the start of the play, there is a disjunction between inner and outer: the source of Antonio's melancholia is unknown.[32] Later, Antonio says of Shylock's words 'Mark you this, Bassanio? / The devil can cite Scripture for his purpose. / An evil soul producing holy witness / Is like a villain with a smiling cheek, / a goodly apple rotten at the heart. / O, what a goodly outside falsehood hath!'[33] And after the bond is made, Bassanio says 'I like not fair terms and a villain's mind'.[34] This disjunction is played out in terms of blindness.

Blindness

In Act II, there is a telling scene between the servant Lancelot and his blind father. Lancelot pretends to his father to be someone other than Lancelot, saying that the son whom he seeks is now no manservant but rather 'Master Lancelot'. Blindness about the inner and outer, and the fancy to which blindness gives birth, is present through the play.

Shylocks tells his daughter to secure his jewels, adding, 'Fast bind, fast find'.[35] This rhyme – and the fact that it also rhymes with blind – heightens our awareness of Shylock's own blindness that his daughter Rebecca is about to elope with those very jewels in her hand.

By contrast, there is a salutary blindness of love: his daughter elopes dressed as a boy, saying to her lover Lorenzo, 'I am glad 'tis night, you do not look on me, / For I am much ashamed of my exchange; / But love is blind, and lovers cannot see / The pretty follies that themselves commit'.[36]

The caskets

Each of Portia's suitors uses his 'instinct' and 'reason' to 'see' into the caskets, from the outside. The first suitor is the prince of Morocco. Each casket

has an outer riddle. The gold inscription is: 'Who chooseth me shall gain what many men desire'. The silver script reads: 'Who chooseth me shall get as much as he deserves'. The lead: 'Who chooseth me must give and hazard all he hath.'[37] Portia explains that one of the caskets contains her portrait. 'If you choose that, then I am yours withal'.[38]

The Moroccan prince observes the outer. He rejects the lead casket – 'A golden mind stoops not to shows of dross'.[39] Portia's likeness is so valued (and desired by many men) that, for him, only gold is valued highly enough to contain her portrait. 'Never so rich a gem / Was set in worse than gold / They have in England / A coin that bears the figure of an angel / Stamped in gold, but that's insculped upon; / But herein angel in a golden bed / Lies all within. Deliver me the key. / Here do I choose'.[40] He reasons on the assumption that the inner is represented by what he observes on the outside.

Inside the casket he finds a rolled-up scroll stuck in the empty eye-hole of a skull – a blind eye-socket. The scroll scolds anyone who chooses to behold the merely outward: 'All that glisters is not gold; / Often have you heard that told. / Many a man his life hath sold / But my outside to behold. / Gilded tombs do worms infold'.[41]

This suitor embodies the first level of instinctive reasoning: he bases his decision on an observation of the thing's outer material constitution as representative of its inner.

The second suitor observes the inner – the laws not evident from the outside. This suitor rejects the gold casket because the 'many' who desire, do not desire wisely – they are blind: the many are 'the fool multitude, that choose by show, / Not learning more than the fond eye doth teach, / Which pries not to th' interior but, like the martlet, / Builds in the weather on the outward wall, / Even in the force and road of casualty'.[42]

He chooses the silver casket, which has for its outer riddle 'Who chooseth me shall get as much as he deserves'.[43] But inside the casket he finds an image of a fool's head and a document indicating that whoever made this choice is a narcissistic fool kissing his shadow.

And yet the prince is right to complain – for he rightly judged that exteriority alone is not what should be estimated – the interior must be sought; surely this is, as the prince says, what learning is supposed to bring – a deeper knowledge and better character. But he is wrong: more is needed to choose better.

Eyes – the wit to lose or gain wisdom

A good chooser chooses neither on the basis of outer nor on the basis of inner: he observes the inner with the right 'eye'. For without it, one can look and look but *see blindly*.

Before we see how this kind of choosing works, let us first take a small detour.

Salerio depicts what he 'saw' when Antonio took his leave of Bassanio. 'A kinder gentleman treads not the earth. / I saw Bassanio and Antonio part. . . . [Antonio's] eye being big with tears, / Turning his face, he put his hand behind him / And, with affection wondrous sensible, / He wrung Bassanio's hand; and so they parted'. Solanio: [replies] 'I think he only loves the world for him'.[44] What is seen is taken to be what is true: the way Antonio is and what his words mean are transparent to the observers, as well as transparent between Antonio and Bassanio.

By contrast, Shylock must plead to be seen with such eyes, and for his observations to be recognized:

> I am a Jew. Hath not a Jew eyes? Hath not a Jew hands, organs, dimensions, senses, affections, passions; fed with the same food, hurt with the same weapons, subject to the same diseases healed by the same means, warmed and cooled by the same winter and summer as a Christian is? If you prick us do we not bleed? If you tickle us do we not laugh? If you poison us do we not die?[45]

Shylock is no mere callous usurer, nor is his daughter quite so innocent: Shylock mourns when he hears that she sold a ring of his behind his back for a monkey. He says: 'It was my turquoise. I had it of Leah when I was a bachelor. I would not have given it for a wilderness of monkeys'.[46] His eyes see in a loving way – in ways that connect him with the bonds of his flesh and his community, bonds symbolized here by the ring. But others do not see Shylock with those eyes. This eventually leads him to refuse to look with them.

Bassanio's choice of a casket

Portia: 'If you do love me, you will find me out'.[47] Music plays, and the lyrics are telling. They express our entire problematic, namely, that eyes observe and thus give birth to fancy, but their cradle is also the death of fancy.

> Tell me where is fancy [love] bred,
> Or in the heart, or in the head?
> How begot, how nourished? . . .
> It is engendered in the eyes,
> With gazing fed; and fancy dies
> In the cradle where it lies.
> Let us all ring fancy's knell.[48]

I will return to this later.

Bassanio, speaking softly to himself, begins by rejecting choice based on the outer:

> So may the outward shows be least themselves.
> The world is still deceived with ornament.

> In law, what plea so tainted and corrupt
> But, being seasoned with a gracious voice,
> Obscures the show of evil? In religion,
> What damnèd error but some sober brow
> Will bless it and approve it with a text,
> Hiding the grossness with fair ornament?[49]

He rejects the gold. He also rejects the silver, 'thou pale and common drudge / 'Tween man and man'.[50] He chooses to hazard all, picks the lead casket and finds Portia's portrait within.

Bassanio therefore made the same judgement about the falseness of gold's show as did the second suitor. The difference is that rather than take what he thinks he deserves (the silver), he takes what threatens him with the loss of everything. He hazards all for Portia, and gains the princess. The eyes' gaze is on the inner of the inner. But it is not by virtue of the absurd that Bassanio gets the princess; it is, he thinks, by virtue of his love and by God's mercy.[51] Later I will show that, unexamined, this judgement remains tied in chains of signification generated by instinctive reason. But let us return to the scene.

Eyes once again enter discussion when Bassanio lovingly describes the portrait of Portia in the lead casket. The eyes of the portrait appear to him to be moving, so great is the likeness.[52] The reflected-upon picture exceeds mere representation.

And the scroll accompanying the portrait refers to him as 'you that choose not by the view'.[53] That (wrong) view has been blocked by Bassanio's healthy skepticism. His scepticism manifests, for example, when he is unsure of his winnings: he feels himself 'like one . . . That think he hath done well in people's eyes, / Hearing applause and universal shout', but not knowing if it is he who is thus applauded.[54]

Bassanio must ratify his winning with a kiss, a kiss freely chosen and given by Portia to him. And at this point, Portia, like Salario had earlier, takes sight to be transparent, confirming his *inner* eye's view: she replies: 'You see me, Lord Bassanio, where I stand, / Such as I am'.[55]

There is no confusion in Bassanio's eyes. The transparency effects a complete translation in every sense – linguistic and physical. Portia says: 'Myself and what is mine to you and yours / Is now converted'.[56] The same transparency and translation of property occurs later when Portia, identifying Bassanio with his 'bosom lover' Antonio, identifies herself with Antonio and offers to pay Shylock the bond owed by Antonio. Of their similarity she says:

> in companions
> Whose souls do bear an equal yoke of love,
> There must be needs a like proportion
> Of lineaments, of manners, and of spirit,
> Which makes me think that this Antonio,

> Being the bosom lover of my lord,
> Must needs be like my lord. If it be so,
> How little is the cost I have bestowed
> In purchasing the semblance of my soul
> From out this state of hellish cruelty.[57]

There has thus, apparently, been an awaking to the inner of the inner – to love's eyes. These eyes see without error and recast the outer newly as someone now in the seer's possession. The ring which Portia gives to Bassanio symbolizes this unity, and also that the union is a sexual one.

So the three suitors present with three kinds of eyes, three kinds of reasoning, three chains of signification. One chain leads to the skull, the second leads to narcissistic shadows and the third is the chain of life.

Having received the ring, Bassanio replies: 'Madam, you have bereft me of all words. / Only my blood speaks to you in my veins'.[58] We have finally cut to the heart of the matter.

The scene leads us to conclude that love enables genuine sight of what is inner and outer, of the other person, and enables the bonds of flesh their proper expression. The theoretical and practical appear to be united in procreation of meaning and offspring. In Shylock's case – due to anti-semitism and his own miserliness – these are distorted: he is blind to his daughter until it is too late, and after realizing his loss, the bond of flesh is to be measured with a knife. His expression, 'fast bind fast find', is a tight misconception, and the pound of Antonio's flesh, a monstrous literalizing.

Unlike the loving heart of the matter, Shylock's heart is represented as being like stone. Antonio says to the court: 'You may as well forbid the mountain pines / To wag their high tops and to make no noise / When they are fretten with the gusts of heaven, / You may as well do anything most hard / As seek to soften that – than which what's harder? – / His Jewish heart'.[59]

However, there is obviously something incomplete about this 'lover's' picture of things.

The heart of the matter

The Marxist critic Terry Eagleton highlights the bond of flesh:

> Shylock claims Antonio's flesh as his own, which indeed, in a sense which cuts below mere legal right, it is; and the bond looms as large as it does because it becomes symbolic of this more fundamental affinity. To refuse Shylock his bond means denying him his flesh and blood, and so denying *his* flesh and blood, his right to human recognition. The bond, in one sense destructive of human relations, is also, perversely, a sign of them; the whole death-dealing

conflict between the two men is a dark, bitter inversion of the true comradeship Shylock desires, the only form of it now available to him.[60]

According to Eagleton, 'Like jesting, the bonds of human solidarity are beyond all reason. There is no reason of a calculative kind why human beings should respond to each other's needs: it is just part of their "nature", constitutive of their shared physical humanity, that they should do so'.[61]

I agree with Eagleton, with qualifications. I would add that the play's symbolism of a pound of flesh, the caskets and rings are obviously suggestive of organs of reproduction, which generate many kinds of *procreation* (sexual, economic and semantic). Also, on a fundamental level, these bonds of flesh and procreations are not 'beyond all reason' – they are subject to the coercions of instinctual reason.[62] We cannot do without the bonds of flesh or procreation. My question is whether there are ways to sublate coerciveness latent in them.

To start answering this, let me begin with how play *appears* to deal with the heart of the matter.

The final scene in Belmont provides sublations: raw wit – the five senses – is 'seasoned' by context, and context is seasoned by self-conscious wit.[63] The first is accomplished through music and awareness of the environment; the second, through *playful*, linguistic coercions.

Music

> Lorenzo: 'How sweet the moonlight sleeps upon this bank!
> Here will we sit, and let the sounds of music
> Creep in our ears. Soft stillness and the night
> Become the touches of sweet harmony'[64]

He and his new love Rebecca sit down, and Lorenzo waxes eloquent about the music of the spheres:

> Look how the floor of heaven
> Is thick inlaid with patens of bright gold.
> There's not the smallest orb which thou behold'st
> But in his motion like an angel sings,
> Still choiring to the young-eyed cherubins.
> Such harmony is in immortal souls,
> But whilst this muddy vesture of decay
> Doth grossly close it in, we cannot hear it.[65]

Lorenzo calls upon musicians to play 'With sweetest touches pierce your mistress' ear'.[66]

He explains that music brings harmony to humans, animals,[67] vegetation and even lifeless matter ('Orpheus drew [allured] trees, stones and rocks'[68]). Like love, music seasons raw experience: 'Music for the time doth change his nature'.[69] It acts upon our common material existence, thus facilitating community. It is a chain of sound, an engagement, a proliferation. Without music our sensibilities are cut off, and we become abstractly rational. Lorenzo says: 'The man that hath no music in himself, / Nor is not moved with concord of sweet sounds, / Is fit for treasons, stratagems, and spoils. / The motions of his spirit are dull as night, / And his affections dark as Erebus. / Let no such man be trusted'.[70]

Environment

After court, Portia and Nerissa arrive in Belmont, in the dark. They discuss how sight and hearing are affected by their material context: 'That light we see is burning in my hall. /How far that little candle throws his beams – / So shines a good deed in a naughty world'.[71]

They comment on how a candle appears bright until one sees the moon, just as a person might appear noble until one sees the king. Likewise, 'The crow doth sing as sweetly as the lark / When neither is attended, and I think / The nightingale, if she should sing by day / When every goose is cackling, would be thought / No better a musician than the wren'.[72]

They conclude that context matters: 'Nothing is good, I see, without respect [reference to context]'.[73] Context provides chains of signification extending in all directions. Portia muses, 'How many things by season seasoned are / To their right praise and true perfection!'[74]

She had made a similar statement in the court scene: 'And earthly power doth then show likest God's / When mercy seasons justice'.[75] (This last phrase, in particular the word 'seasons', is developed at length by Derrida in his discussion of mercy in the play.[76] I will return to Derrida shortly.)

In this final scene in Belmont, wit is seasoned by context, but context is also seasoned by wit. Lorenzo, driven by Lancelot's witty banter, says of fools generally – 'I do know / Many fools . . . that for a tricksy word / Defy the matter'. The 'heart of the matter' is defied by wit, and, more seriously, by Shylock, throughout the play (I discuss the latter below in more detail).[77] But all the characters are at risk of being 'fools who have the wisdom by their wit to lose'.

Belmont appears to sublate all conflicts.[78] Knowledge of context – of space, time, seasons and differences in nature – 'seasons' raw awareness. The fool's wit then observes that heart of the matter, making it into puns and comedic contradictions. It is no accident that the fool's wit comes to a climax, bantering about laying the table for dinner (a banter full of sexual innuendos). In Belmont, this is what a relevant *Aufhebung* of Nature is.

Belmont even produces, apparently, a relevant sublation of justice, in the dialogue between the lovers, about rings.

The ring that Portia gives to Bassanio is 'a thing stuck on with oaths upon your finger, / And so riveted with faith unto your flesh'.[79] The word 'ring' is the last word of the play, as the lovers Grazano and Nerissa exit to find 'Nerissa's ring'.

In Venice, after the court scene, Bassanio and Grazano had given their rings to the judge and his clerk (disguised Portia and Nerissa). In Belmont, Bassanio pleads with Portia to see that context and to season her instinctive reasoning.

> Sweet Portia,
> If you did know to whom I gave the ring,
> If you did know for whom I gave the ring,
> And would conceive for what I gave the ring,
> And how unwillingly I left the ring
> When naught would be accepted but the ring,
> You would abate the strength of your displeasure[80]

After she chastises him, he pleads:

> Pardon me, good lady,
> For by these blessèd candles of the night,
> Had you been there I think you would have begged
> The ring of me to give the worthy doctor[81]

Portia wittily makes it seem that, because he did not keep his bond, his wits are distorted and his eyes do not see. In the following exchange, he begins, and she interrupts:

> Portia, forgive me this enforcèd wrong,
> And in the hearing of these many friends
> I swear to thee, even by thine own fair eyes,
> Wherein I see myself –
> Portia: 'Mark you but that?
> In both my eyes he doubly sees himself,
> In each eye one. Swear by your double self,
> And there's an oath of credit'[82]

Bassanio cannot season her judgement.

In fact, however, Portia is seasoning his wrong already, with wit, since she knows better than he what the context was and is. Portia and Nerissa play with words and their husband's hearts: 'I had it [the ring] of him [the doctor of law]. Pardon me, Bassanio, / For by this ring, the doctor lay with me'.[83]

The audience sees it all and laughs with Portia. Eventually, all is made clear to the characters and everyone experiences a comedic ending. Apparently, music, mercy and wit have acted like ferromagnetic coercions, reducing original coercions (any crime, any conflicts) to zero.

But there is another kind of sublation at work as well. The disjunction that existed between the characters who were in ignorance, and the audience that could see properly, is salutary: the audience is thereby made aware of an aspect of context important to mercy – namely, that not all characters see all contexts (as Portia/Balthasar says in court, 'in the course of justice none of us / Should see salvation'[84]).

Furthermore, the audience sees that Portia and the others do not see Shylock's context, and that they did not observe the suffering he undergoes at the loss of *his* ring. So the imperfection of wit – that it cannot grasp the entire context – is made explicit for us. Fancy lies in the cradle of instinctive reason. In seeing that this is true of others, we see how it can be true of ourselves. This is comically rendered by Portia in the ring scene.

The tragic undertow is that what Portia is unaware of remains, namely, the suffering which her judgement of Shylock has generated (not to mention the anti-semitic and slave-owning racist environment of Venice). With all this in view, the audience is implicitly asked to look to itself and season its judgement, to adopt the view that it is never omniscient about contexts.

Wit is seasoned by context, context is in turn seasoned by wit (puns/mercy) and all of this too is seasoned by the recognition that we need to make the *whole* context relevant; and we know that last is one which none of us is able to fulfill. This is the tragi-comic ring that binds us. According to *The Merchant of Venice*, and the *Phenomenology of Spirit*, this is the absolute ring, the *Aufhebung* of nature and justice into 'the absolute Notion'. But in asserting this, have we just entered another Belmont?

PART THREE: RELEVANT *AUFHEBUNGEN*: CHAINS OF SIGNIFICATION RING OF DIFFERENCE

Chains of signification

Throughout Hegel's *Phenomenology of Spirit,* what gets sublated never disappears, and so is always potentially a destructive latency: for example, though we are aware of the master-slave dialectic as unjust, it nonetheless remains in our history and must be repressed.

Anselm Haverkamp would, I think, declare a relevant *Aufhebung* impossible. His Nietzsche-influenced view is that the theatre of the *Merchant of Venice* plays out latencies and mis-representations, and these leave nefarious effects in the audience in the afterlife of the play. He is polemically 'honest'

about our inability to be self-conscious of the coercive proliferating of harmful latencies.[85]

It is hard not to agree with Haverkamp, since cases of instinctive reason and its destructive latencies abound even in our authors.[86] If this is indeed the case, then 'let us all ring fancy's knell'.

But there are ways to proceed. One way to disable slavery's return – or anti-semitism's, or sexism's – is to deconstruct its presence. We can do this by asking what a relevant translation of it would be. According to Derrida, *relevé* is a translation of *Aufhebung*. From *relevé*, Derrida gets the word 'relevant' in his title question 'What Is a Relevant Translation?' He concludes that a relevant translation is a kind of Hegelian *Aufhebung*, with the implied difference that, in sending us from signifier to signifier (with his translations), even *Aufhebung* no longer has a stable presence in a single national or linguistic or historical context; similarly, the sublational words in the play, such as 'mercy' and 'seasoning', become deconstructable. This trains us to deconstruct the nefarious concepts as well. In this way, deconstruction is salutary – like wit in the play, it gets both deeper into the heart of the matter and also defies the matter (i.e., recalling Hegel's remark about the organ of reproduction: it takes the piss out of it). It is procreative without being totalizing.

When I think about a relevant *Aufhebung*, rather than a relevant *translation*, I am thinking of Eagleton's bonds of flesh, and Hegel's attempt to get passed instinctive reason's coercions of them. Since *relevé* is a translation of *Aufhebung*, in asking about a relevant *Aufhebung* I am asking about an *aufhebende Aufhebung*, a doubling of reason, a setting of reason onto reason, a fancy that keeps going rather than – or even after – dying in its cradle. I think that one guarantor of this continuance is to be aware of Shylock's ring.

Ring of difference

Shylock's ring (the one Leah gave him) is his 'inner of the inner'. For it, Shylock gives up his economic links: that is, he would not have exchanged his ring for 'a wilderness of monkeys'; and its loss, sublimated, is the bond for a pound of flesh, a bond Shylock refuses to exchange even 'if every ducat in six thousand ducats / Were in six parts, and every part a ducat'.[87]

In severing his economic links to secure his bond – his now-lost-bond – Shylock 'hazards all'. The outcome is the opposite of Bassanio hazarding all: Shylock loses everything – not just his economic links, but also his spiritual bonds, since he must convert from Judaism.

His case shows that one indeed hazards all for the inner of the inner – for if it is lost, one does lose everything; one loses everything because in fact the links are all connected: 'You take my house when you take the prop that doth sustain my house; you take my life when you take the means whereby

I live'.[88] Shylock is no phrenologist. He shows that life exists in contexts – engagements, bonds of money and of flesh, chains of signification. 'Hazarding all' means recognizing that negation is determination, but that even the most radical negation is interdetermining context.

Shylock's demise shows those material and spiritual dialectics to be the heart of the matter. Why does Bassanio get the princess and Shylock loses everything? The lesson here is that if someone is an extreme individual, the responsibility lies not with that individual alone, but equally with the universal. In other words, Shylock's 'extremism' is not subjective radical evil (nor any kind of radical evil). Rather, his person and deeds are inseparable from the 'universal' contexts in which he is operating (as he himself points out in his defence, in court). So the problem lies not with him (alone) but just as much with the Christians, the court and Venetian society of that historical period.[89] Bassanio fares better (unfairly so) because of the failure of their society and justice system to realize their error (i.e., their failure to realize the equal role of universals in defining the individual, and the individual in defining universals – the lesson we learned from Hegel earlier[90]). Despite Bassanio's ability to see the inner of the inner in choosing his casket, in the end his inner eye maintains a merely instinctive certainty because he unconsciously lets it be determined by external rings of power. In this respect, Shylock is a better ethical agent because he at least tries self-consciously to alter the matter at hand.

My point is that the realization of the interdeterminacy of individual and universal might have had (and could have in our day) a salutary effect, one which countered instinctual reason's moralizing finger-pointing at individuals and universals as though they were separate. It takes a mirroring of the mirroring, a doubling of reason against itself, an *Aufhebung* of (merely instinctual) *Aufhebungen*, a persistent effort to 'see' the inner of the inner, to realize this dialectic. Such reflections must be ongoing. They must not settle into a comic *finale* in some ideal Belmont (for that 'inner' sanctuary is really just another abstract outer universal).

We can elaborate and question further by addressing head-on the topic of *The Philosophy of Theatre, Drama and Acting*. In this chapter, our interdetermining contextuality is the relationship between (Hegel's) philosophical text and (Shakespeare's) dramatic texts.

The ring of the globe: Drama and Hegel's absolute spirit (art, religion and philosophy)

The interdetermining singular-particular-universal creates mediums (sublations, *Aufhebungen*) through which consciousness thinks. The fact that

Hegel's 'Absolute Spirit' is made up of art, religion, and philosophy (and is thus not only of philosophy) helps us to see his philosophy as mediated too.

According to Hegel, art is the way we present our world – and thus also our absolutes – to ourselves. In his *Lectures on Aesthetics*, Hegel claims that drama is the highest form in which we convey our absolute spirit to ourselves.[91] Drama is the best artistic medium because it is the most comprehensive production of artistic signification, since it uses painting, sculptured sets, music, live action and real-time speech.[92] Hegel claims throughout the *Aesthetics* that Shakespeare is at the pinnacle of this pinnacle of the arts.[93]

The three forms of Absolute Spirit (art, religion and philosophy) are often taken in Hegel studies to be hierarchized. Indeed, Hegel does assert that philosophy is the highest form of human signification (higher than art and religion) because it grasps the relationship between art and thought in and through thought and language (and does the same with religion) and is therefore not limited by any materiality. However, the interchanging and interdeterminating relationship between singularity, particularity and universality shows us that for Hegel, speculative philosophy needs its other forms of absolute self-representation in art and religion as much as these need speculative philosophy. It does because particular arts and religions are media of self-knowledge. The most comprehensive art form – drama – will yield the most to think about when it comes to human affairs.

An additional argument as to why drama and philosophy need each other can be drawn from *The Phenomenology of Spirit*. In that work, we do not get rid of 'picture-thinking' once we arrive at Absolute Knowing – we merely know that we think through imagination in both senses of thinking-through – that is, thinking by means of imagination, and seeing through it.[94] Thus according to Hegelian phenomenology, too, we ought to bring philosophy and drama together in order to better think through them.

This context of philosophy and drama has ramifications for how we see characters in plays. In my discussion earlier of Hegel's speculative reason, we saw that the genus 'life' realizes itself through particular species and their individuals, and the individuals realize themselves through their species and in the great stream of the genus of life and its multiplicity. By the same logic, Bassanio and Shylock are individuals, and also a particular Christian and Jewish person, respectively, and also Venetian men and also human beings and also living beings; these various levels are interdetermining contexts with causal determinations working up and down the ladder from individual to universal.

But there is a further implication: since for Hegel drama is the highest artistic medium of Absolute Spirit, Bassanio and Shylock are not merely characters in a play. Since Absolute Spirit is speculatively grasped in art, they, like

Hamlet, or Athena for the Greeks, are what really matters to the community interpreting them – they each express our *Sache selbst*, the matter at hand, the real concern.[95] This is especially the case for a community that, like Hegel, thinks drama is most comprehensive and that Shakespeare is among the most accomplished dramatists.

Nonetheless, such 'global' rings of signification, such dramatic mediations of 'Absolute Spirit,' like all mediations (all *Aufhebungen*), need to be persistently reflected upon. They must be if we are to escape enchainment in ideals – those 'Belmonts' to which, as Hegel shows in the *Phenomenology of Spirit*, all consciousnesses are instinctively inclined by their desire to become self-certain. The play is always the thing.[96]

CONCLUSION

Relevant sublations overcome instinctive reason by being conscious of its rational chains – its sexual, cultural and linguistic coercions, its forced assimilations, conversions and translations. Shakespeare's play and Hegel's book teach this. But eyes see limited contexts, and (so) fancy dies in the cradle where it lies. Knowing this, it is our generation's turn to interpret what is in the casket and to wear the ring; to question our Belmonts and ask 'what is a relevant *Aufhebung*?'

NOTES

1. Shakespeare, William, The Comical History of the Merchant of Venice in *The Norton Shakespeare: Based on the Oxford Edition*, edited by Cohen, Howard, Maus. (New York; London: W. W. Norton & Company, 1997) (1081–1224 [henceforth act/scene/line]), 2.9.79–80.

2. 3.2.63–70.

3. Hegel, *Phenomenology of Spirit*, trans. A. V. Miller (Oxford: Oxford University Press, 1977) (henceforth PoS and page number), 139.

4. 'The standpoint of rational classification established here is accepted in Hegel's systematic "real philosophy" at every stage' (Harris, H. S., *Hegel's Ladder*, vols. 1 & 2 (Indianapolis; Cambridge: Hackett Publishing Company, 1997) [volume one is henceforth *Ladder* with page number], 485 and 542).

5. PoS, 145. While these philosophies may seem in line with Hegel's own view that the key is to grasp truth as substance and equally as subject (PoS, 9–10), they are not because they keep the two sides apart, whereas for Hegel, subject and substance are causally interdependent.

6. Hyppolite, Jean, *Genesis and Structure of Hegel's Phenomenology of Spirit* (Evanston: Northwestern University Press, 1974), 235.

7. PoS, 236.

8. PoS, 263. Reason therefore 'will learn that the *thing* is a *Hegelian* concept (not a Galilean or Lockean one). The consciousness we are observing will discover that the *Ding cannot* correspond to Reason because it is essentially and necessarily dead. But we ourselves shall discover what Reason objectively *is*, as a result. We shall achieve the awareness of Reason as the *Sache selbst* [the heart of the matter – JB]. That Concept will then be the contextual frame for our observation of Spirit as it appears in its objective, and finally its absolute shape' (*Ladder,* 478). See my discussion of the *Sache selbst* in 'Absolute Knowing: Consternation and Preservation in Hegel's *Phenomenology of Spirit* and Shakespeare's *Troilus and Cressida*', in *Angelaki*, Special Edition, edited by Russel Ford, vol. 21, no. 3 (Fall 2016).

9. '[A]t the end of reason [observing reason], Reason becomes for us the *Sache selbst* in the objective shape of the "custom of the *Volk*"; and this is what it comes to be 'for itself' at the beginning of the next chapter [on Spirit], after the subjective *Sache selbst* (as the supposed 'Test of Law') has reduced itself to the logical futility of accepting whatever law it *finds*' (*Ladder*, 478).

10. Thus it appears in the first part of the first section, in the Hegelian nesting of reason's concepts: the instinct of reason is the mode of operation in the 'observation of nature' within the broader scope of 'Observing Reason' which is the first section of the Reason chapter in the first of four chapters that are progressively more comprehensive shapes of reason up to Absolute Knowing.

11. Inwardizing is a translation of *die Erinnerung*. By it, Hegel means our internalizing of external objects, a process which makes them 'mine'. It generates the possibility of 'mining' in both senses of possessing and of 'unearthing' from memory, and of the subsequent use of such inwardizations in imagining and reasoning. It is central to Hegelian dialectical thinking. For further discussion see my *Hegel's Theory of Imagination* (Albany: State University of New York Press, 2004) and Phillip Verene's *Hegel's Theory of Recollection: A Study of Images in Hegel's Phenomenology of Spirit* (Albany: State University of New York Press, 1985).

12. PoS, 178.

13. Ibid.

14. PoS, 180.

15. Hegel's *Phenomenology of Spirit* is an education in tempering and complicating self-certainty and the objects about which consciousness is too quick to be certain. Each new immediacy is a form of self-certain objectivity, which is then dialectically complicated into a more comprehensive starting point, a point which is itself a new – albeit a more complex – immediacy about a new immediate 'object', and so it goes until absolute knowing realizes the process. I explain more below but see also my 'Absolute Knowing: Consternation and Preservation in Hegel's *Phenomenology of Spirit*'.

16. PoS, 210.

17. Ibid.

18. PoS, 206.

19. Ibid.

20. Every important transition in the *Phenomenology of Spirit* has a destructive, negative moment, often epitomized by a skull. Each is also a sublational turning

point in this Hegelian tragi-comic book. Consciousness must pass through the deepest layers of presupposing ignorance. Our 'essence' has to comprehend its own social and religious presuppositions before it can be an 'absolute' knowing. Thus in the *Phenomenology of Spirit*, Reason has to pass through its moments as Reason, Spirit, Religion and Absolute Knowing, in each of which it finds a nadir with a skull: in the 'Reason' chapter, it equates itself with the skull of phrenology; in 'Spirit' reason discovers its nadir in the absolute terror of absolute freedom in the French Revolution; in 'Religion' reason bottoms out in the death of Jesus and then the spiritual moment of that death as the death of God; and in 'Absolute Knowing' reason hits the bottom of the 'Calvary of Absolute Spirit' – the tragi-comic realization that reason's absolute essence is inseparable from the content of comprehended history. (This 'bottom' is also the highest insight. In the *Phenomenology*, reason has thus completely bottomed-out.) All of this is why the book is a series of incarnations. It is a *philosophy* of the mythologies of truth's incarnations.

21. *Ladder,* 479. 'It must be established in this way, because the structure of "consciousness" determines that Reason will *naturally* begin by trying to find itself in "things". It is the "science of the experience of consciousness" that is the descent into the depths; and the naïve quest for the rationality of the *world* has its proper place in that descent. It is quite true that the logical science that is found in the depth of consciousness is experienced equally as the rational truth of the knowing self and of the known world' (ibid.).

22. Instinctive reason is an instinct to be self-certain and dogmatic about the world view and the objects which correspond to one's shape of self-certainty. The instinct in general is comparable to Nietzsche's 'will to truth'. (See Nietzsche's *Genealogy of Morals. On the Genealogy of Morals and Ecce Homo*, trans. and ed. Walter Kaufmann [New York: Vintage, 1989], 15–163, especially the third essay.) It is unconscious and latent because it lies behind projects: it resides behind the eye, but also, therefore, informs the object and its objectivity.

23. In phenomenological empiricism, the mind's standpoint is not reflected upon, whereas in speculative empiricism, the standpoint of Absolute Knowing is assumed; the Kantian critical attitude has been accepted, albeit modified into an indetermining dialectic of substance and subject.

24. Hegel, *Hegel's Philosophy of Nature,* trans. A. V. Miller (Oxford: Clarendon Press, 2004) (henceforth PoN with page number), 11, emphasis mine.

25. This, I believe, is the reason performativity is a necessary category in ethical reasoning. For an example of performativity turned back on Hegel's own works, see Judith Butler's *Antigone's Claim: Kinship between Life and Death* (New York: Columbia University Press, 2000).

26. PoN, 12.

27. Ibid.

28. This last example concerns Hegel's *Logic* and its relationship to Hegel's *Realphilosophie* (philosophy of nature and of human sciences [*Geisteswissenschaften*]). His *Realphilosophie* is not simply an implementation of *a priori* logical structures onto matter, so nor is the logic of these entities wholly extractable from them: the rational and the real are interdetermining. This is a vexed topic in Hegel

studies, but my view is that his logic must be read and interpreted in order to have reality. The next paragraph above indicates why. For further argumentation see my 'Hegel and the Concept of Extinction,' in *Philosophy Compass*, Continental Series, edited by Andrew Cutrofello. Editor-in-Chief Elizabeth Barnes, John Wiley & Sons Ltd. (2014): 238–52.

29. Ibid.
30. Ibid.
31. 4.1.89–96.
32. There are other inner/outer statements (e.g., the racist one regarding her Moroccan suitor: 'if he have the condition of a saint and the complexion of a devil, I had rather he should shrive me than wive me' [1.2.109]). For a discussion of racism, see 'Racism and Homophobia in *The Merchant of Venice*', James L. O'Rourke (in *English Literary History,* vol. 70, no. 2 (Summer 2003, 375–397. Johns Hopkins University Press).
33. 1.3.93.
34. 1.3.175.
35. 2.5.53.
36. 2.6.34–37.
37. 2.7.4–9.
38. 2.7.12.
39. 2.7.30.
40. 2.7.54–60.
41. 2.7.65–72.
42. 2.9.25. 'I will not jump with common spirits / And rank me with the barbarous multitudes' (2.9.31).
43. 2.9.35. The prince rants, 'Let none presume / To wear an undeservèd dignity' (ibid., lines 39–40).
44. 2.9.35ff.
45. 3.1.49–55. The unfairness to which Shylock points has only a moment ago been enacted by Salerio. Despairing over his daughter's elopement, Shylock had said, 'I say my daughter is my flesh and my blood' (3.1.32) to which Salerio replied, 'There is more difference between thy flesh and hers than between jet and ivory; more between your bloods than there is between red wine and Rhenish' (3.1.33–35).
46. 3.1.100–102.
47. 3.2.41.
48. 3.2.63–70.
49. 3.2.73–80.

>'So are those crispèd, snaky, golden locks
>Which makes such wanton gambols with the wind
>Upon supposèd fairness, often known
>To be the dowry of a second head,
>The skull that bred them in the sepulchre.
>Thus ornament is but the guilèd shore
>. . . therefore, thou gaudy gold,
>Hard food for Midas, I will none of thee.
>[*To the silver casket*] Nor none of thee, . . .' (3.2.92ff.)

50. 3.2.103–04.'But thou, thou meagre lead,

> Which rather threaten'st than dost promise aught,
> Thy paleness moves me more than eloquence,
> And here choose I. . . . ' (3.2.104ff.)

51. For Kierkegaard's theory of getting the princess 'by virtue of the absurd' see his *Fear and Trembling*, trans. Alastair Hannay (New York: Penguin, 1985).

52. 'Move these yes? / Or whether, riding on the balls of mine, / Seem they in motion?' (3.2.116); and again, speaking of the painter, 'But her eyes – / How could he see to do them? Having made one, / Methinks it should have power to steal both his / And leave itself unfurnished' (3.2.123–126).

53. 3.2.131.
54. 3.2.141ff.
55. 3.2.149–150.
56. 3.2.166–167.
57. 3.4.11–21.
58. 3.2.175–176. This phrase anticipates our discussion below of Terry Eagleton on 'the bonds of flesh' in this play.
59. 4.1.74–79.
60. Eagleton, Terry, *William Shakespeare* (Oxford: Blackwell, 1986) (henceforth Eagleton with page number), 43.
61. Eagleton, 44.
62. Freud interprets of the choice of caskets as being about a choice of woman and as the result of an unconscious compulsion. See Freud's 'The Theme of the Three Caskets' in *Art and Literature*, The Penguin Freud Library, vol. 14, trans. under supervision of James Strachey, edited by Albert Dickson (London: Penguin Books, 1990), 235–247. Unfortunately, I do not have space here to compare Hegel's instinct of reason with Freud's interpretation.
63. To season, '[i]n 16c., also meant "to copulate with"', http: www.etymonline.comindex.php?termseason (Web.): Accessed June 12, 2017.
64. 5.1.53–56.
65. 5.1.57–64.
66. 5.1.66.
67. 'A wild and wanton herd / Or race of youthful and unhandled colts' (5.1.70–71).
68. 5.1.79.
69. 5.1.8.
70. 5.1.82–87.
71. 5.1.88–90.
72. 5.1.101–105.
73. 5.1.98. By 'respect', the editors explain, we are to understand 'reference to context' (ibid.).
74. 5.1.106–107.
75. 4.1.191–192.
76. Jacques Derrida and Lawrence Venuti, 'What Is a "Relevant" Translation?' *Critical Inquiry*, vol. 27, no. 2 (Winter 2001) 174–200. The University of Chicago Press.

77. 3.5.57–60. The character who *self-consciously* has 'the wisdom by his wit to lose' is the fool Lancelot. In response to Lancelot's witty repartees, Lorenzo says, 'How every fool can play upon the word! I think the best grace of wit will shortly turn into silence, and discourse grow commendable in none only but parrots' (3.5.37–39). This foreshadows Shylock's graver utterance that 'there is no power in the tongue of man / To alter me. I stay here on my bond' (4.1.236–37). The fool's ability to splice words in puns in Belmont foreshadows the deadly serious splicing of words in the court scene.

78. In the preceding part of the scene, the characters could not see each other in the dark, whereas when Portia approaches, she is recognized by her voice instantly; she jokes, 'He knows me as the blind man knows the cuckoo – / By the bad voice' (5.1.111–112).

79. 5.1.167–168.
80. 5.1.92–97.
81. 5.1.218–221.
82. 5.1.239–244.
83. 5.1.257–258.
84. 4.1.192.

85. Anselm Haverkamp, 'But Mercy Is Above: Shylock's Pun of a Pound', in *Shakespearean Genealogies of Power* (Oxon: Routledge, 2011), 109–117. The play's message, through the character of Shylock, is of mis-representability, non-fit, a latency that carries over into the 'afterworld' of the audience's reality.

86. We have seen Hegel's error. Shakespeare is either unaware or underplays the fact that Jews lived in ghettos in Venice; Freud represses any engagement with Judaism in his discussion of the play. Even Haverkamp's focus on the 'point' has phallocentric implications he does not discuss.

87. 4.1.84–86.
88. 4.1.370–373.

89. The reverse causality is equally true: 'Everything turns on grasping and expressing the True, not only as *Substance*, but equally as *Subject*' (PoS, para. 17, p. 10). Individuals must hold themselves responsible for the shape of universals, too.

90. See above, pp. 20–21.

91. See Hegel's 'Dramatic Poetry', in *Hegel's Aesthetics: Lectures on Fine Art*, trans. T. M. Knox, Volume II (Oxford: Clarendon Press, 1999), 1158–1237.

92. Religion is also a way in which we represent our absolutes to ourselves. It, like art, has levels of success which Hegel traces (with admittedly Eurocentric bias). The highest form of religion is revealed religion (for Hegel, Protestant Christianity) in which there is a complete incarnation of thought in being, of universal (God) in the individual (Jesus), which is then mediated further through community. Here, as elsewhere in the dialectic of absoluteness, the three positions are interdetermining and interdependent, so that God is nothing other than the community of interpreters. Harris corrects Hegel's Eurocentrism: 'Because *every* religion incorporates all the moments of experience (more or less distinctly articulated, and not "forgotten" or "sublated") it is invidious to reduce any religious consciousness to a uniquely determinate truth-concept. Doing that actually violates the absoluteness of the forgiveness-concept upon which our own procedure of neutral observation rests . . .

the multiplicity of "living" religions provides us with a vivid paradigm of how the experiential science of truth-concepts can actually have practical value' (Harris, *Hegel's Ladder,* vol. 2, 771).

93. That claim was largely what motivated me to write *Hegel and Shakespeare on Moral Imagination*. I cite and discuss his various remarks about Shakespeare extensively in that work.

94. See my *Hegel's Theory of Imagination*.

95. See my discussion of Harris's similar claim about Hamlet in 'Absolute Knowing: Consternation and Preservation'; see too Harris, *Hegel's Ladder*, vol. 2, 125ff.

96. For a great number of possible implications of this Hamlet-inspired concluding sentence, see Andrew Cutrofello's *All for Nothing: Hamlet's Negativity* (Cambridge, Massachusetts; London, England: The MIT Press, 2014).

BIBLIOGRAPHY

Bates, Jennifer Ann. 'Absolute Knowing: Consternation and Preservation in Hegel's *Phenomenology of Spirit* and Shakespeare's *Troilus and Cressida*'. In *Angelaki: Journal of the Theoretical Humanities*. Special Edition, Edited by Russell Ford. Volume 21, no. 3 (Fall 2016): 65–82.

Bates, Jennifer Ann. 'Hegel and the Concept of Extinction'. In *Philosophy Compass*. Continental Series, edited by Andrew Cutrofello. Editor-in-Chief Elizabeth Barnes. John Wiley & Sons Ltd. 9 4(2014): 238–52.

Bates, Jennifer Ann. *Hegel's Theory of Imagination*. Albany: State University of New York Press, 2004.

Butler, Judith. *Antigone's Claim: Kinship between Life and Death*. New York: Columbia University Press, 2000.

Cutrofello, Andrew. *All for Nothing: Hamlet's Negativity*. Cambridge, MA; London, England: The MIT Press, 2014.

Derrida, Jacques and Lawrence Venuti. 'What Is a "Relevant" Translation?' *Critical Inquiry* 27, no. 2 (Winter 2001): 174–200.

Eagleton, Terry. *William Shakespeare*. Oxford: Blackwell, 1986.

Freud, Sigmund. 'The Theme of the Three Caskets'. In *Art and Literature*. The Penguin Freud Library, Volume 14, translated under supervision of James Strachey and edited by Albert Dickson, 235–247. London, Penguin Books, 1990.

Harris, H. S. *Hegel's Ladder*. Volumes 1 & 2. Indianapolis and Cambridge: Hackett Publishing Company, 1997.

Haverkamp, Anselm. 'But Mercy Is Above: Shylock's Pun of a Pound'. In *Shakespearean Genealogies of Power*. Oxon: Routledge, 2011.

Hegel, G. W. F. *Phenomenology of Spirit*. Trans. A. V. Miller. Oxford: Oxford University Press, 1977.

Hegel's Aesthetics: Lectures on Fine Art. Trans. T. M. Knox. Volume II. Oxford: Clarendon Press, 1999.

Hegel's Philosophy of Nature. Trans. A. V. Miller. Oxford: Clarendon Press, 2004.
http: www.etymonline.comindex.php?termseason (Web.): Accessed June 12, 2017.

Hyppolite, Jean. *Genesis and Structure of Hegel's Phenomenology of Spirit*. Evanston: Northwestern University Press, 1974.

Kierkegaard, Sōren. *Fear and Trembling*. Trans. Alastair Hannay. New York: Penguin, 1985.

Nietzsche, Friedrich. *Genealogy of Morals, On the Genealogy of Morals and Ecce Homo*. Trans. and ed. Walter Kaufmann. New York: Vintage, 1989.

O'Rourke, James, L. 'Racism and Homophobia in *The Merchant of Venice*'. *English Literary History* 70, no. 2 (Summer 2003): 375–397.

Shakespeare, William. The Comical History of the Merchant of Venice. In *The Norton Shakespeare: Based on the Oxford Edition,* edited by Howard Maus Cohen, 1081–1224. New York, London: W. W. Norton & Company, 1997.

Verene, Phillip. *Hegel's Theory of Recollection: A Study of Images in Hegel's Phenomenology of Spirit*. Albany: State University of New York Press, 1985.

Chapter 3

The theatre of thought: A. W. Schlegel on modern drama and romantic criticism

Kristin Gjesdal

Among the romantic contributions to philosophy of the arts, August Wilhelm Schlegel's lectures on dramatic poetry are unprecedented in their depth and attention to detail.[1] In these lectures, given in Vienna in the spring of 1808, Schlegel discusses drama as a genre, analyses individual plays and reflects more generally on artistic media, aesthetic experience and the role of art in the modern world. Published a few years later, the lectures were soon translated into a number of languages and read and discussed across Europe.[2] Yet, from within academic philosophy, Schlegel's lectures were met with lukewarm reviews. Perhaps later readers of romantic philosophy approached the lectures with the expectation that they would display the kind of literary virtuosity and stylistic playfulness that distinguishes the works of his brother, Friedrich, and their common friend Georg Friedrich Philipp von Hardenberg (Novalis).[3] Or they may have looked for a transcendentally grounded position, be it a Kantian-Schillerian account of aesthetic subjectivity or a Hegelian system of the arts and their historical development.[4] What they encounter, though, is neither of these, but, instead, a promising alternative to the main positions in idealist aesthetics: Kant's attempt to legitimize the subjective universality of pure aesthetic judgement by reference to a notion of disinterestedness, on the one hand, and Hegel's efforts to justify the scientific status of philosophy of art in a historical-systematical account that presupposes an end to its further developments, on the other. Throughout his lectures on dramatic arts, Schlegel develops a systematically sophisticated and historically responsible attempt at mapping the basic features of ancient and modern drama, and extracts, from his treatment of individual plays, playwrights and periods, a more general theory of this artform and of our relationship to it. From this point of view, Schlegel's attempt to base his discussion of theatre in a survey of individual works is not a weakness – and whoever would think that it is is

likely to have judged his work according to the wrong criteria. In fact, it is precisely Schlegel's willingness to move from individual works to more general reflection (rather than subsuming individual works under universal principles or laws) that makes his Vienna lectures such a valuable contribution to nineteenth-century philosophy of drama in particular, and, more generally, to discussions of methodology in the philosophy of art. It is the strength of Schlegel's lectures, by way of what is sometimes addressed as his bottom-up (rather than top-down) approach, to combine a historical and a systematic approach in aesthetics. Through his discussion of modern (romantic) drama and its relationship to modern (romantic) criticism, Schlegel retains a Kantian interest in the impartiality of the aesthetic judgement, but without, as it were, sacrificing the (Hegelian) reference to art and its historical development. In Schlegel's view, the particular romantic dialogue between dramatic art and criticism allows us to realize the mutual relationship between art and criticism that, in his view, should be at the core of modern aesthetics.

It is my ambition, in this chapter, to return to Schlegel's lectures on dramatic art and show how his discussion of artistic expression and reflection comes to provide an aesthetic methodology that is deserving of renewed attention. In this context, the work of William Shakespeare, whom Schlegel takes to epitomize a proto-romantic spirit, is ascribed a key role, both in his effort to reach a sound understanding of romantic drama and in his effort to develop a philosophically sustainable notion of romantic criticism.

I

Schlegel's lectures on dramatic poetry call for an investigation of the relationship between drama and philosophy. What is drama? How can philosophy help us answer this question? And to what extent can dramatic poetry be said to be philosophical and philosophy be informed by drama? These are some of the challenges that motivate his turn, in the spirit of a broader aesthetic inquiry, to philosophy of theatre.

At the opening of his lectures, Schlegel, in an Aristotelian vein, defines drama as 'the exhibition of an action [Handlung] by dialogue without the aid of a narrative' (LDA 25; W V 24). Action, in turn, is not any one aspect of human life, but qualified as 'the true enjoyment of life, nay, life itself' (LDA 24; W V 22). As I read him, Schlegel's point is not that other artforms do not 'exhibit action', but that action makes up the very core of dramatic art. As such, drama is an intrinsically valuable art form.[5] Theatre, in turn, follows drama as a 'necessary complement', and even when we read a work of dramatic poetry we are, in effect, drawing on the physical, institutional and skill-based aspects of theatre.[6]

As Schlegel argues (and again he follows an Aristotelian line of thought), drama grows out of a natural propensity for imitation (*Mimik*), that is, imitation of an action (LDA 25; W V 24). Yet, as an artform it has a definite historical beginning: it was invented in Athens, and there it was brought to perfection (LDA 27; W V 27). Greek culture, Schlegel elaborates, had what it needed to place its mythological-historical foundations on stage and, in turn, situate theatre at the very heart of communal life. We moderns, by contrast, tend to be more speculative and less expressive (LDA 27 and 356; W V 29 and W VI 431). Can drama, then, be as important for us as it was for the ancient Greeks? Or, somewhat differently, how – in what form and through what kind of experience – can drama matter to us moderns?

Schlegel answers this question with reference to his own culture. Following Lessing and Herder, he argues that the German stage has been held hostage to a backward-looking Francophile taste, which he understands as based on admiration for, and imitation of, the ancients and a willingness to see art in terms of aesthetic norms.[7] A genuinely modern drama, by contrast, would have to grow out of and respond to modern culture. Schlegel speaks of this drama as *romantic* and traces it back to the Spanish Golden Age and Elizabethan Theatre in England. Among the playwrights he covers, Shakespeare stands out – both in terms of the sheer length of his discussion and in terms of the special affinity Schlegel sketches between Shakespeare and romanticism. Hence, in order to fully appreciate Schlegel's philosophy of theatre, we need to ask in what sense Shakespeare's drama is romantic and vice versa, in what sense romanticism is Shakespearean. Schlegel, who had already received praise for his translation of Shakespeare,[8] responds by having us reflect on three central aesthetic categories – central to our thinking about drama – namely, genius, genre and form. Schlegel's analysis of these categories deserves further elaboration and each of these points will be discussed in more detail later.

Shakespearean drama had initially been triggered by a new interest in genius and originality in art.[9] While this was celebrated by some, Shakespeare's critics had blamed his work for being unruly and, relatedly, for its lacking understanding of theatrical conventions.[10] Schlegel attempts to tackle these objections, or, rather, the very premise on which they rest.[11]

As he argues, there is no need to assume an opposition between genius and reason. Shakespeare, he claims, was 'not a blind and wildly luxuriant genius', but displayed a high cultivation of the mental powers (LDA 241; W VI 182). Hence, even though 'the activity of genius [was] natural . . . and, in a certain sense, unconscious', this does not entail that 'the thinking power had not a great share in it' (LDA 241; W VI 183, see also LDA 233; W VI 167). For all his originality, Shakespeare is a reflective poet: 'Shakespeare has reflected, and deeply reflected, on character and passion, on the progress of events and

human destinies, on the human constitution, on all things and relations of the world' (LDA 242; W VI 183). Thus, his genius does not, as his critics had assumed, signify a lack of training, thought or rationality.

The appeal to genius had been a placeholder for a whole array of aesthetic, historical and political concerns: the challenging of the distinction between high and low arts, the rehabilitation of vernacular languages, the attempt to transfer stage craft from its home in the royal courts to the bourgeois institution of the theatre, to mention only a few. The reception of Shakespeare had been part of these larger concerns – and still was in 1808. According to Schlegel, the English dramatists were free of 'the attempts to bring them back to an imitation of the ancients, or even of the French'; they created, he elaborates, 'wholly out of the abundance of their own intrinsic energy, without any foreign influence' (LDA 227; W VI 154).[12]

In its orientation towards German-language drama, there seems to be a nationally oriented ring to Schlegel's discussion (as there would be, later, in Hegel's aesthetics and Nietzsche's philosophy of tragedy). However, in Schlegel's case, it is clear that the influence he fears – the influence to which Shakespeare represents an alternative – is not, per se, foreign, but, rather, a paradigm of passive imitation (both in the sense that the French had imitated Greek and Roman drama and in the sense that the Germans had imitated the French). Were he simply concerned with the *foreignness* of the French (and not with imitation), a turn to English theatre could not do much to improve the predicament of German drama.

Further, Schlegel takes the English stage, serving as a model for German-language drama, to grow out of a particularly cosmopolitan culture: 'The trade and navigation which the English carried on with all the four quarters of the world made them acquainted with the customs and mental productions of other nations; and it would appear that they were then more hospitable (*Gastfreier*) to foreign manners than they are in the present day' (LDA 234; W VI 169, translation modified). Against Hume and Voltaire's worries about Shakespeare's lack of training, Schlegel takes him to be educated in the world (rather than by books) and his work to be driven by a thriving interest in the diversity of cultures (LDA 234; W VI 168).

Shakespeare synthesizes a multitude of perspectives, and does so with care and thoughtfulness: 'In a thousand places, [he] lays great and marked stress on correct and refined tone of society . . . he represents it in all its shades and modifications by rank, age, or sex' (LDA 236; W VI 171). His drama presents a wide range of characters and perspectives, yet his originality does not consist in the representation of these characters per se, but, rather, in the ability to merge them into a synthetic whole (i.e., a play). It is here – and not in the alleged denial of tradition, convention and training – that Shakespeare emerges as a romantic playwright.

Through his reference to Shakespeare, Schlegel thus demonstrates the falsity of the existing oppositions (between creativity and rationality, originality and cultural borrowing) so as to promote a kind of drama that, in turn, is taken as key to its romantic instantiation.

Schlegel also discusses the notion of genre, in particular the idea of set genre definitions as a criterion for dramatic literature (the idea that a work either falls within a given genre, tragedy or comedy, or it is no work of art at all). Again, he proceeds by dismantling the very premise of this kind of thinking. Schlegel's discussion of genre had developed throughout his (aesthetics) lectures in Jena and Berlin. In Jena, he had followed Herder's call for a scientific aesthetics and pointed out that an analysis of genre is key to this undertaking. In the Berlin lectures, he had offered a tripartite division of classical poetic genres – epic, lyrical poetry and drama – indicating a dialectical progress in which drama emerges as a synthesis of epic and lyrical poetry. The Vienna lectures, in turn, focus on drama exclusively and, within this field, distinguish between tragedy and comedy. Schlegel further points out that neither epic nor lyric poetry gives rise to a similar division (LDA 32; W V 38).

According to Schlegel, tragedy grows out of a fundamental insight into the finitude of all things human (LDA 33; W V 40). We are, as it were, shipwrecked at birth (*bei der Geburt schon schiffbrüchig*, LDA 33; W V 41) – and, what is more, throughout our lives we are painfully aware of this predicament. This creates a melancholy disposition, which is given voice in tragedy.[13] Comedy, by contrast, is fuelled by an element of sport and procures a respite from the tragic conditions of human existence (LDA 34; W V 42). It addresses individual life and its 'whole frame of society, the constitution, nature, and the gods' (ibid.).[14] Hence, while it is lighthearted, humorous and offering relief, it is still tied up with a more profound exploration of all things human.[15]

The Greeks, Schlegel argues, cultivated tragedy and comedy in their purest forms. For us moderns, though, dramatic genres can no longer be ascribed with the kind of authority they once had. Indeed, it is the mistake of classicism to take the ancient genres, as they emerge out of a particular historical context, to be universally valid. The Greeks, further, did not base art on formalist genre definitions, nor on ideals derived from a bygone age. In a passage reverberating with Herderian concerns (and anticipating Nietzsche's later approach to tragedy), Schlegel makes it clear that 'the Greeks neither inherited nor borrowed their dramatic art from any other people; it was original and native, and for that very reason it was able to produce a living and powerful effect' (LDA 228; W V 156). This equilibrium could not last; it ended with the period in which the Greeks imitated Greeks (*als Griechen Griechen nachahmten*, LDA 228; W VI 156) – and it is this attitude

that the classicists, in their understanding of genre in terms of static and trans-historical definitions, adopt.

It is a mistake to judge a modern play with reference to ancient genre criteria – be they developed with reference to Greek tragedy or later classicism. That is, if we judge art by way of such a comparison, it will be clear, from the get-go, that even distinguished modern works must be ranked 'far below the ancients' (LDA 228; W 156). A proper theory of dramatic genre needs to acknowledge the fundamental difference between ancient and modern (romantic) culture. Whereas Greek culture had been one and unified – 'much more of a piece', as Schlegel puts it[16] – modern civilization 'is the fruit of the heterogeneous union of the peculiarities of the northern nations and the fragments of antiquity' (LDA 18; W V 10). This new heterogeneity is reflected in Shakespeare's work. Shakespeare's world is no longer unified, and whereas 'ancient art and poetry rigorously separate things which are dissimilar; the romantic delights in indissoluble mixtures; all contrarieties; nature and art, poetry and prose, seriousness and mirth, recollection and anticipation, spirituality and sensuality, terrestrial and celestial, life and death, are by it blended together in the most intimate combination' (LDA 230; W V 161). This, Schlegel points out, is neither tragedy nor comedy, but, rather, romantic drama, or, as he also puts it, *Schauspiel* (LDA 229; W VI 158). Romantic drama is not committed to an absolute distinction between the tragic and the comical, but draws on both.

In this way, Schlegel seeks to get beyond a rigid theory of genre, without thereby giving up genre theory altogether; he does not judge the existing models to be outright wrong, but shows how their applicability is historically and artistically limited and limiting. That is, as he argues, the notion of genre is useful, but only to the extent that it is viewed as part of a larger, cultural context.

Finally, Schlegel turns to the notion of dramatic form. As the audiences approach romantic drama, they need some sense of this being a work of art and therefore something that can be aesthetically experienced, judged and interpreted. Thus, if we let go of a formal aesthetics, we still need an account of artistic cohesiveness or unity. How is romantic drama, in its diversity, held together? How is it given identity as, precisely, a work of art? In line with his response to the concepts of genius and genre, Schlegel introduces a distinction between mechanical and organic unity.

Lately, there has been much interest in the eighteenth-century shift from a mechanistic world view to organicism.[17] Among the representatives of this paradigm are Herder and Goethe, both of whom had been active participants in the Shakespeare debate. Herder's discussion of poetry is ripe with biological metaphors, and he views both the inner unity of a poem and the development of poetic traditions in terms of life and growth.[18] Goethe reasons along

similar lines.[19] Further, Schlegel's brother Friedrich had treated the fragment as an organic unity. Indeed, the Schlegels had initially conceived of romantic philosophy (by which drama, in turn, would be explored) in organic terms. Thus, when Schlegel introduces his distinction between mechanical and organic unity in drama, he assumes that his audience is somewhat familiar with this mode of thinking.

As Schlegel argues, mechanical form works through external force and is imparted to 'any material merely as an accidental addition without reference to its quality' (LDA 229; W V 157). Organic form, by contrast, 'unfolds itself from within, and acquires its determination contemporaneously with the perfect development of the germ [*Keim*]' (LDA 229; W VI 157). It saturates nature from the level of crystallizations to plants and animals and is, as it were, the 'speaking physiognomy of the thing', the way in which its essence is made real and external (ibid.).[20] What is of interest here is how Schlegel connects this notion of form with the activity of criticism. In his view, poetry should not be judged by reference to pre-existing standards. In a language reminiscent of Herder, Schlegel puts it as follows: 'When we give to the new kind of poetry the old [genre] names [*Gattungsnamen*], and judge of them according to the ideas conveyed by these names, the application which we make of the authority of classical antiquity is altogether unjustifiable' (LDA 229; W VI 158). Only when we realize that literature cannot be objectively ranked in terms of periods and aesthetic paradigms can we see that the appreciation of one writer or paradigm (e.g., classicist tragedians) does not imply the depreciation of others (e.g., Shakespearean tragedy). 'May we not', Schlegel asks, 'admit that each is great and admirable in its kind, although the one is, and is meant to be, different from the other?' (LDA 19; W V 12). This, for Schlegel, is the opposite of the 'frigid admiration' and 'dull school exercises' that characterize the timeless normativity that has been ascribed to the classical (LDA 17; W V 8).

The notion of organic form thus serves a number of different purposes: it promotes the idea of an inner, work-specific unity of drama; it draws attention to its historical development; it explains deviation across genres and expressions; *and* it calls for an aesthetic model that can take this into account and move from the level of individual works to more general philosophical conclusions.

While to us the notion of genius might seem somewhat outdated, Schlegel's discussion of historical change, genre and form has retained their relevance, so, for that sake, has his attempt to shake up and renew the conceptual basis for our thinking about drama. He takes modern drama to be intrinsically diverse, argues that we need an (historically) elastic category of genre and advocates a more organic way of thinking about drama. In pursuing such a line of thought, however, Schlegel does not simply wish to revise philosophy

of drama and the concepts by which it is determined. In the spirit of the *Athenaeum*, his goal, rather, is to rethink the relationship between philosophy and drama, as it has historically evolved and will continue to be produced.

II

At the outset of his lectures, Schlegel had addressed the question of aesthetic methodology.[21] While the history of art 'informs us [of] what has been', theory teaches us 'what ought to be accomplished' (LDA 15; W V 4). These two levels of discourse do not typically interact. His lectures, Schlegel makes it clear, seek to overcome this methodological bifurcation; they seek to 'combine the theory of Dramatic Art with its history' and thereby also to clarify its 'principles and its models' (LDA 15; W V 3). It is in this context that Schlegel introduces his notion of romantic criticism – a criticism that seeks to facilitate a work-oriented, bottom-up approach to dramatic literature, a way to move from particular works to more general, philosophical conclusions. It is Schlegel's goal to establish, by way of his theorizing and his critical examples, a practice that 'elucidates the history of the arts, and makes the theory fruitful' (LDA 15; W V 4). In this way, the Vienna lectures transcend Schlegel's earlier work, including his essay on Shakespeare and Goethe, in which he sees criticism, even true criticism (*die ächtere Kritik*), as an activity that does not really affect our relationship to art.[22] In the Vienna lectures, Schlegel offers a new account of criticism, demonstrates his idea of critical practice and seeks, in this way, to pave the ground for a contemporary flourishing of drama.[23] Each of these three points merits further discussion.

At least since Walter Benjamin's path-breaking study of the concept of criticism in the romantic period, romantic criticism is often associated with Fichte and transcendental idealism. Schlegel, we have seen, also draws on Herder, who had positioned himself as a critic of transcendental philosophy, but also as a philosopher of literature – indeed, by René Wellek's standards, the very first philosopher of literature.[24] Making no attempt to hide his sympathy with Hume, the young Herder had seen criticism as related to a willingness to inspect and overcome prejudices and implicit bias. He had observed, for example, that in an everyday mindset it typically applies that 'as soon as I find something true or beautiful … nothing is more natural than the expectation that every human being will have the same feeling, the same opinion, with me'.[25] Consciously or subconsciously, subjective preferences are presented as ahistorical and valid across cultures and subcultural groups. A critical approach, by contrast, will explicate its enabling conditions – though, in this case (unlike that of the transcendental idealists), these conditions are viewed as historically and culturally mediated. In a similar way, Schlegel points out

how '[w]e see numbers of men, and even whole nations, so fettered by the conventions of education and habits of life that, even in the appreciation of the fine arts, they cannot shake them off. Nothing to them appears natural, appropriate, or beautiful, which is alien to their own language, manners, and social relations' (LDA 16; W V 4). Against such attitudes, the true critic aspires to impartiality. As Schlegel puts it, 'No man can be a true critic or connoisseur without universality of mind [*Universalität des Geistes*], without that flexibility which enables him, by renouncing all personal predilections and blind habits, to adapt himself to the peculiarities of other ages and nations – to feel them, as it were, from their proper central point' (LDA 16; W V 5).[26] Yet, as it is facilitated through the encounter with other periods and cultures, impartiality is not abstract or based on formal imperatives, but reached via engagement with particular works. At stake is no longer a kind of judging that reflects a preconceived idea of what art and beauty is and should be, but an open-minded and work-oriented way of proceeding.

The romantic critic does not seek to articulate the universal meaning of the work, but to identify its 'internal excellence [*innere Vortrefflichkeit*]' (LDA 16; W V 5).[27] It is through contemplation of internal excellence that critics arrive at their judgement. In a world where the work can no longer justify itself by reference to a unified life-world context,[28] they ascribe to the work a place within the larger field of literature. Thus, in order for the modern work to have a sphere of reception, adequate critical practices are imperative. Schlegel's romantic critic seeks to forge a non-subsumptive bond between a particular (work) and a universal (cosmopolitan or impartial) perspective; he or she seeks to articulate the values and standards of an individual work, but by catching nuances, drawing distinctions and arriving at clear and illuminating descriptions, the critic also reflects on its place within the literary field. Thus, the critic is able to synthesize a polyphony of dramatic voices and extract from them a point of view that has gained wisdom and generality from this encounter. In a distinctively modern (and reflective) way, the critic thus takes over the kind of impartial gaze that lent authority to the chorus and its judgements in ancient tragedy.[29] At stake is a position that, as it were, combines impartiality with a focus on exposure to, and engagement with, particular points of view – that is, an impartiality that is not posited, but concretely and hermeneutically achieved.

In its call for impartiality, Schlegel's account of criticism leaves us with a dilemma. On the one hand, we have his (Humean-Herderian) acknowledgement of cultural and historical context and bias. On the other, we have a (quasi-idealist) notion of the impartial or even universal critic, who ferrets out the inner excellence of the work. How, then, can these commitments be unified? How can we know that a critic's retrieval of 'inner excellence' is, in truth, impartial (and not simply a reflection of his or her prejudices)?

In a certain way, such knowledge is and remains beyond reach. However, according to Schlegel, epistemic assurance is not really needed in the field of aesthetics (nor, for that matter, is it desirable). As I read Schlegel, his point is methodological: if a critic is to aim for impartiality in judgement (rather than, say, the searching out of concrete instantiations of abstract aesthetic rules or norms), then this will have to be developed in the encounter between critic and work, as they both represent a given historical and cultural nexus. Further, since the critic (or the philosopher) is himself or herself situated in culture, we can assume that aesthetics, as a philosophical subfield, ought to develop its concepts and thoughts on the basis of, or from within, the experience of such hermeneutic encounters.

If, for Schlegel, criticism synthesizes theory and an analysis of the particular work, we might expect that this methodological point finds resonance and application in his lectures. That is, we might expect Schlegel's theoretical position to translate into his own critical practice. Again, his reading of Shakespeare offers a promising locus from within which this point can be discussed.

Having insisted that criticism depends on a will to challenge prejudices and bias, Schlegel reflects on his position as a reader of Shakespeare's work. He worries that we have, at one and the same time, become too familiar and too remote from Shakespeare's drama. In a passage deserving to be quoted in full, he puts it as follows:

> With the poet as with the man, a more than ordinary intimacy prevents us, perhaps, from putting ourselves in the place of those who are first forming an acquaintance with him: we are too familiar with his most striking peculiarities, to be able to pronounce upon the first impression which they are calculated to make on others. On the other hand, we ought to possess, and to have the power of communicating, more correct ideas of his mode of procedure, of his concealed or less obvious views, and of the meaning and import of his labors, than others whose acquaintance with him is more limited. (LDA 232; W VI 164)

That is, the historicity of theatre and dramatic poetry is not simply a matter that concerns our understanding of the work (in its context), but also the reader in his or her relationship to the tradition.[30] Shakespeare's drama, Schlegel points out, is a known entity to us; it is part of our tradition and, as such, of who we are. Yet precisely in being part of our tradition, of the kind of art we know and take for granted, Shakespeare's work is easily misunderstood. Schlegel had already made this point in his essay on Goethe and Shakespeare.[31] Yet, as he now sees it (placing more emphasis on criticism), the goal is to tear open pre-established agreements and traditional concepts and have us recognize that Shakespeare's work may well *feel* familiar, yet true familiarity takes recognition of the uniqueness – the distinctive voices,

characters, forms and temporalities – of this kind of drama. Schlegel's critic seeks to be individualizing and historicizing – both with respect to the text and with respect to his or her own position as a reader. Romantic criticism thus involves a kind of educational process through which readers get better to understand *both* themselves *and* the work with which they engage. How, then, can Shakespeare's work help us think about this aspect of (romantic) criticism?

Shakespeare is, for Schlegel, an observer of men and 'in this his superiority is so great, that he has justly been called the master of the human heart' (LDA 243; W VI 186). Indeed, as Schlegel continues, this mastery of the human heart is rooted in an ability to portray the individual: 'It is [in] the capacity of transporting himself so completely into every situation, even the most unusual, that he is enabled, as plenipotentiary of the whole human race, without particular instruction for each separate case, to act and speak in the name of every individual' (LDA 243; W VI 187). It is his familiarity with all things human – *and* his ability to present existential choices and possibilities concretely on stage – that makes Shakespeare a truly modern dramatist and a profound thinker (*tiefer Denker*, LDA 238; W VI 176). As a modern playwright, Shakespeare's skillset – his particular way of realizing dramatic genius, genre and form – involves an ability to understand, extract and present the essence of individual characters in a way that turns them into exemplars for humanity (LDA 236; W VI 171).

Now, in order to stay true to his ideal of criticism, Schlegel cannot rest satisfied with a general description of Shakespeare's skills as a playwright, but also needs to demonstrate some level of close reading or interpretatory engagement. In this context, Schlegel turns to *Hamlet*. Along with *Romeo and Juliet*, this is a play with which Schlegel has been preoccupied since the 1790s. If Shakespeare is a profound thinker, *Hamlet* is a tragedy of thought (*Gedankentrauerspiel*, LDA 271; W VI 247).[32] It is inspired by deep existential sentiments ('continual and never-satisfied meditation on human destiny and the dark perplexity of the events of this world', LDA 271; W VI 247), and seeks to inspire 'the very same meditation in the minds of the spectators' (ibid.).

Schlegel is not unreservedly enthusiastic about *Hamlet*. He is especially troubled by Hamlet's character. As he puts it (in a somewhat surprising hermeneutic maneuver), Hamlet's 'weakness is too apparent: he does himself only justice when he implies that there is no greater dissimilarity than between himself and Hercules. He is not solely impelled by necessity to artifice and dissimulation, he has a natural inclination for crooked ways; he is a hypocrite towards himself' (LDA 272; W VI 249). Yet, Schlegel lauds the way Shakespeare presents Hamlet's inability to act, his indecisive and enigmatic character and his imperfect disposition. The relationship between

character, action and poetry (language, sound, musicality, etc.) allows the romantic critic to infer from Shakespeare's portrayal of Hamlet a set of more general, philosophical points and insights.

Through their speech and actions, Shakespeare's characters reveal what is lasting in their particular interpretations of the world. In this way, they contribute to a richer understanding of humanity: 'What each man is, that Shakespeare reveals to us most immediately: he demands and obtains our belief, even for what is singular and deviates from the ordinary course of nature. Never perhaps was there so comprehensive a talent for characterization as Shakespeare' (LDA 244; W VI 188). A character that simply presents a universal idea would not work on stage – it would be but a didactic principle, 'merely a personification of a naked general idea', and, as such, could 'neither exhibit any great depth nor any great variety' (LDA 245; W VI 189). At one and the same time, Shakespeare's characters are utterly individualized and 'possess a significance which is not applicable to them alone: they generally supply materials for a profound theory of their most prominent and distinguishing property' (LDA 245; W VI 189). These properties, in turn, emerge against the larger panoply of the play and the individuals that populate it: the characters only find themselves and express themselves, through interaction with others.[33]

Both of the points discussed earlier – that the individual characters reflect the universal and that each individual is developed in interaction with others – inform Schlegel's idea of criticism. That is, in a non-trivial sense, his notion of romantic criticism is reflective of his reading of romantic drama. Schlegel makes this connection explicit in that he describes Shakespeare's work as universal and calls for universality in criticism.[34] Like Shakespeare, the playwright, the romantic critic should treat the work as an individual and, all the same, explicate its universal dimension, its contribution to our understanding of what human life and expression is and can be. Further, the very point of such an exercise is not simply for the critic abstractly or philosophically to grasp the nature of art, but also, in terms of his or her concrete life and practices, through engagement with outlooks that deviate from his or her own, to understand a wide range of human expressions and world views. Thus, there is a strong link between Schlegel's aesthetics and his understanding of human existence. While this link is made explicit in his definition of drama in terms of action, and action, in turn, as the essence of human life, it is spelt out and exemplified in his lectures on Shakespeare as a modern playwright and his understanding of modernity in terms of a diversity of practices and world views. Hence, Shakespearean drama, precisely in its being modern (in its presentation of a diversity of characters, actions, existential possibilities and life forms), extends to critics and audiences, from within a genuinely modern artform, an invitation to develop the kind of impartiality that, in Greek tragedy,

was integrated into this artform itself by way of the chorus. Hence, whereas a Kant, as far as aesthetic judgements go, would see impartiality as related to disinterestedness in the reflection of aesthetic form and a Hegel would see the scientific status of aesthetics as reliant upon the possibility of a closed system (albeit a historically derived one), Schlegel, with reference to drama, takes the relationship between art and philosophy to be historically developed and developing. Hence the purpose of his lecture is not simply to explore the nature of romantic art and criticism, but also, by way of this exercise, to contribute to a better understanding of the art scene of his day.

In his essay on Goethe's *Wilhelm Meister*, Schlegel had argued that Shakespeare's drama is still of relevance, and that a proper understanding of contemporary drama requires a proper understanding of Shakespeare. In his view, though, contemporary drama is not in good shape. This, Schlegel argues, is due to 'a number of unfavorable circumstances', not the least the history of German-speaking theatre (LDA 341; W VI 400). In the thirteenth century, Germany had its own theatrical tradition, related to a culture of festivals and carnivals. With the dawn of the classicist era, this tradition was soon repressed. Schlegel finds this to be an unfortunate development. For although the early beginnings of German theatre were feeble, they were not false, and, as he wistfully continues, 'if only we had continued to proceed in the same path, we should have produced something better and more characteristic than the fruits of the seventeenth century' (LDA 342; W VI 402). In this period, theatre was associated with the learned (*Gelehrten*) and, eventually, French-inspired theatre of Gottsched's kind (LDA 343; W VI 404). Only with Lessing, whom Schlegel treats with tempered enthusiasm, is there again a glimmer of hope.[35] A work such as *Nathan the Wise*, with its 'romantic air [romantischer Anstrich]', displays a free form and a flair that brings it close to Shakespeare (LDA 346; W VI 410).[36] In this way, Shakespeare remains a point of reference for Schlegel. And it is in this broadly construed Shakespearean field that he situates Lessing and Goethe, with whom he admits to being socially close as well as close in spirit. Goethe, in Schlegel's words, gives a 'new poetic animation to his age' (LDA 347; W VI 413). Despite the fact that, like Lessing, Goethe had translated Voltaire into German (which Schlegel takes as evidence of impartial spirit), he is praised for having 'banished [French classicist drama] from German soil' (LDA 348; W VI 415). Hence, in the midst of a rather bleak predicament – a 'poetical as well as moral decline of taste' and a stage repertoire exhibiting 'a motley assemblage of chivalrous pieces, family pictures, and sentimental dramas' (LDA 354–355; W VI 427) – there is hope for the kind of art that was first initiated by Shakespeare, but whose living continuation must seek new and more contemporary forms.

Facing Schlegel's judgement on contemporary drama, we need to ask how a playwright like Goethe can be praised as a Shakespearean without facing

the perils of imitation that Schlegel, from the very opening of the lectures, had sought to combat.[37] This question can be answered only if we take into account Schlegel's particular interpretation of English theatre. As we saw in Section I, Schlegel takes English drama to create without imitation; it allows for borrowing and dramatic training, but cultivates knowledge of tradition without hypostatizing the past as an aesthetic ideal. It issues no manuals for creation. Nor does it look back to an antiquity whose myths and world view are long gone. A drama in the Shakespearean mould grows out of and responds to the culture of modernity; it does not express a unified outlook on the world, but puts into play a display of perspectives. As such, Schlegel's hopes for contemporary theatre do not involve the re-awakening of any particular content, but an ability to present a diversity of viewpoints and, by so doing, create artforms through which modern (romantic) audiences can understand themselves.

The unity (form) of Shakespeare's drama is not immediate, but achieved in the dynamic interaction with the critic: it is not (necessarily) explicitly presented in the play – represented, say, by an impartial chorus (as we find it in ancient Greek tragedy) – but is there for a critic to engage and articulate. Our age, as Schlegel puts it, is no longer poetical, but 'learned and critical' (LDA 240; W VI 180). Critical, however, need not be abstract. And it is precisely the concrete universality put forth in Shakespeare's work, a universality that is not postulated as a principle, but made manifest through characters and actions, that the romantic critic should hold on to. While we moderns have lost the immediate, poetic unity of the ancient Greeks, we can still reach a new, mediated unity – a unity *in* the manifold. Hence, modern drama cannot (and should not) instruct, but, rather, present us with an array of possible ways of being human. These are Schlegel's hopes for a young, yet ailing German-language theatre and an important reason why, in his view, theatre, as an artform, still matters to us – as artists, critics and philosophers.

III

In its covering of both the history of dramatic poetry and its theory (philosophy), Schlegel's treatment of Shakespeare is somewhat idealizing. While he reads Shakespeare as a poet of humanity, there are other aspects of Shakespeare's oeuvre that he does not at all mention: the latent anti-Semitism in *The Merchant of Venice*, the stereotyping of racial features (*Othello*) and other parts of his work that could have challenged, perhaps even undermined, the idea of a particular bond between Elizabethan drama and romantic criticism.

Yet, the value of the lectures does not rest with Schlegel's reading of a particular play or body of works. Rather, the relevance of the lectures rests,

first and foremost, with Schlegel's methodology, his effort to bridge the focus on individual work and the theoretical focus, and his argument that modern theatre, in staging a new variety of characters, voices and lines of actions, invites and requires such a connection to be established. Here Schlegel distinguishes himself from both his predecessors and his philosophical followers. Like Herder and other late Enlightenment and early romantic figures, Schlegel's work transcends the domain of academic philosophy and traverses translation, literary interpretation and the initiation of inter-cultural dialogues. Yet, Schlegel's Vienna lectures, written in the wake of Kant's third Critique, seek systematically to understand the relationship between drama and its philosophy and, with reference to the artform of theatre, theorize the conditions of possibility for aesthetic reflection and judgement. Throughout the lectures, though, Schlegel insists on an art and work-oriented approach. In so doing, he paves the way for the kind of perspective we later find in Hegel's lectures on fine art, although, unlike the latter, Schlegel insists on the continued development, relevance and value of literature and drama. From a point of view like Schlegel's, it would therefore be unacceptable to suggest, as Hegel does, that aesthetics can only begin once great art, as a reflection of the absolute, is over. Schlegel's lectures on drama inhabit a space in between eighteenth-century criticism and an idealist commitment to aesthetic systems. This is not an easy terrain to maneuver. Yet Schlegel offers an example of how it can be done – and the philosophical perils and gains to be reaped from this effort.

In developing his romantic philosophy of drama, in asking what dramatic poetry is and, equally importantly, how philosophers can best answer this question, Schlegel hopes to change the meaning of both drama and philosophy of art. He seeks to move away from a drama whose legitimacy is established through its bonds to an antiquity long gone. However, he also insists that such a task can be taken on only if philosophers of theatre are willing to analyse their methodological preconditions and proceed with a reference to concrete plays, characters and issues. For Schlegel, there is a special connection between modern drama and modern philosophy. As his brother Friedrich had pointed out, ancient drama is only theorized the moment it is over. Complex in its form and constitution, modern drama, by contrast, invites reflection as part of its very existence. It presents different life options, different points of view, different ways of manoeuvring modernity on stage. In approaching modern drama, as it presents us with a variety of life choices and modes of action and self-understanding, the critic, according to Schlegel, should not ask which of these life options are preferable, but should engage the kind of syncretism that emerges in their interaction. The new kind of drama, the drama of the Shakespearean era, thus requires a new kind of audience. In Schlegel's view, it is an open question whether such an audience yet exists. His lectures on dramatic poetry, however, seek to contribute to the cultivation

of an environment in which such a drama can thrive and develop. If the modern artist gives us 'a renovated picture of life; a compendium of whatever is moving and progressive in human existence' (LDA 25; W V 23), then modern criticism, as it has grown out of a speculative mindset, should realize that, qua modern, drama has a reflective dimension, but also that reflection should pay heed to and be expressive of life, as it is articulated and instantiated in and through particular artworks. The point is not that, among the modern arts, only drama inhabits this connection between reflection and life, but that drama, as it centres around action, does so in a particularly interesting manner. In this way, romantic drama can find itself through philosophy, and philosophy, in turn, can find nourishment in critical interaction with dramatic works of art.

NOTES

1. August Wilhelm Schlegel, *Lectures on Dramatic Art and Literature*, trans. John Black, http://www.gutenberg.org/ebooks/7148; *Sämtliche Werke*, ed. Edouard Böcking, 16 vols. (Hildesheim: Olms, 1972), vols. V and VI. Further references will be abbreviated LDA/W, followed by volume and page number.

2. See Christine Roger and Roger Paulin, 'August Wilhelm Schlegel', in ed. Roger Paulin and Adrian Poole,*Great Shakespeareans*, vol. III: *Voltaire, Goethe, Schlegel, Coleridge* (London: Continuum, 2010), 119–120.

3. It is symptomatic that René Wellek states that we 'might be inclined to dismiss August Wilhelm as an unoriginal mind, a kind of middleman and even popularizer of the ideas of his brother. There is some truth in this view, though we would need to stress the enormous historical importance of August Wilhelm's mediating and popularizing role'. René Wellek, *A History of Modern Criticism, 1750–1950*, vol. II, *The Romantic Age* (Cambridge: Cambridge University Press, 1981), 36.

4. Ernst Behler characterizes Friedrich Schlegel's work along these lines and contrasts it with the scholarly temper of his brother. See Ernst Behler, *German Romantic Literary Theory* (Cambridge: Cambridge University Press, 1993), 72–74.

5. This point was anticipated in Schlegel's essay on Goethe and Shakespeare, *Etwas über William Shakespeare bei Gelegenheit Wilhelm Meisters,* W VII 30. Here Schlegel speaks of life as the big secret of nature and the dramatic poet as forming (*bilden*) human beings.

6. Ibid.

7. Schlegel describes the situation as follows: 'Our poets and artists, if they would hope for our approbation, must, like servants, wear the livery of distant centuries and foreign nations' (LDA 241; W VI 182). Within this paradigm, Schlegel polemically continues, 'Art is . . . obliged to beg, as an alms, a poetical costume from the antiquaries' (LDA 241; W VI 182). According to Schlegel, even Lessing, who criticized French drama, 'found in Aristotle a poetical Euclid' (LDA 48; W V 74).

8. For an account of Schlegel's translations (and his collaboration with Tieck, his co-translator), see Kenneth E. Larson, 'The Origins of the "Schlegel-Tieck" Shakespeare in the 1820s', *The German Quarterly*, vol. 60, no. 1 (1987), 19–37.

9. Edward Young had drawn attention to Shakespeare's originality and suggested that this set his work apart from the ancient tragedians: 'The first ancients had no merit in being originals: they could not be imitators. Modern writers have a choice to make, and therefore have a merit in their power'. See Martin William Steinke, *Edward Young's 'Conjectures on Original Composition' in England and Germany* (with the original text) (New York: G. E. Stechert, 1917), 47 and 64–65. Young's *Conjectures* was published in German in 1760. For a discussion of Young's influence in Germany, see John Zammito, *Kant, Herder, and the Birth of Anthropology* (Chicago: University of Chicago Press, 2002), 240–241.

10. From this point of view, it is worth noting that the appreciation of Shakespeare in Germany goes hand in hand with a reassessment of non-canonical literatures. This is particularly evident in Johann Gottfried Herder's early work, both in its early phase and in his later study of Hebrew poetry. For an overview of Herder's importance for Schlegel, see Günther Schmidt, *Herder und August Wilhelm Schlegel* (Berlin: Friedrich-Wilhelms-Universität zu Berlin, 1917 [Dissertation]). Schmidt traces (biographically) Schlegel's friendship and break with Herder and (systematically) Herder's influence on Schlegel's philosophy. See *Herder und August Wilhelm Schlegel*, 39. Their friendship was at its strongest around the time at which Herder wrote his famous Shakespeare essay (in the early 1770s).

11. In his discussion of originality (and, for that matter, other places, too), Schlegel draws on Lessing. Schlegel, though, is less sympathetic towards Lessing than towards Herder and distinguishes himself from his brother who, although positive in his attitude to Herder (who is said to '[join] the most extensive knowledge with the most delicate feeling and the most supple sensitivity'), was an avid reader of Lessing's work. For Friedrich's comments, see *On the Study of Greek Poetry*, trans. Stuart Barnett (Albany, NY: SUNY Press, 2001), 93; *Kritische Friedrich Schlegel-Ausgabe*, ed. Ernst Behler (Paderborn: Verlag Ferdinand Schöningh, 1979), vol. I, 364. For August Wilhelm's discussion of Lessing in the Vienna Lectures, see LDA 344–346; W VI 406–410. For a more general overview of Schlegel's indebtedness to Lessing, see August Volkmer, *A. W. Schlegels Auffassung des Dramas im Vergleich zu der Lessings* (Zabrze: Max Czech, 1906).

12. Yet Schlegel has no problem acknowledging that Shakespeare draws on previous English literature and suggests that 'these labors . . . deserve both our praise and gratitude; and more especially the historical investigations into the sources from which Shakespeare drew the materials of his plays, and also into the previous and contemporary state of the English stage, and other kindred subjects of inquiry' (LDA 233; W 165–166). The crucial distinction here is between an active and a passive use of a tradition.

13. Nevertheless, Schlegel describes ancient Greek culture in a way that would later resound in Nietzsche, as cheerful – indeed, inventing the poetry of joy ('die Poetik der Freude', LDA 20; W V 13). For Nietzsche's emphasis on pleasure and joyous necessity (he, too, uses the terms '*Freude*' and '*freudig*'), see, for example, Friedrich Nietzsche, *The Birth of Tragedy and Other Writings*, ed. Raymond Geuss and Ronald Speirs, trans. Ronald Speirs (Cambridge: Cambridge University Press, 1999), 16; *Sämtliche Werke. Kritische Studienausgabe*, 15 vols., ed. Giorgio Colli and Mazzino Montinari (Berlin: Walter de Gruyter, 1999), vol. I, 27.

14. This is a point Hegel will later take over. For a discussion of Hegel's theory of comedy, see Andrew Huddleston, 'Hegel on Comedy: Theodicy, Social Criticism, and the "Supreme Task" of Art', *British Journal of Aesthetics*, vol. 54, no. 2 (2014), 227–240.

15. See Dorothea Schäfer, 'Die historischen Formtypen des Dramas in den Wiener Vorlesungen A. W. Schlegels', *Zeitschrift für deutsche Philologie*, vol. 75 (1965), 397–414, especially 405–406.

16. However, even though it was formally 'of a piece', Schlegel also recognizes that ancient tragedy is expressive of a culture (mythology) that 'was a web of national and local traditions' (LDA 48; W V 79–80), that is, a culture that, as already Herder had seen, was itself synthetic.

17. See for instance Stephen Gaukroger, *The Collapse of Mechanism and the Rise of Sensibility: Science and the Shaping of Modernity 1680–1760* (Oxford: Clarendon Press, 2010) and Peter Hanns Reill, *Vitalizing Nature in the Enlightenment* (Berkeley: University of California Press, 2005).

18. See Edgar B. Schick, *Metaphorical Organism in Herder's Early Work: A Study of the Relation of Herder's Literary Idiom to His World-View* (The Hague: Mouton, 1971).

19. For a discussion of this dimension of Goethe's work, see Dalia Nassar, 'Romantic Empiricism after the "End of Nature"', in Dalia Nassar (ed.), *The Relevance of Romanticism: Essays on German Romantic Philosophy* (Oxford: Oxford University Press, 2014), 296–315.

20. With reference to the affinities between poetry and natural form, Herder had insisted that we consider, 'as the purpose of Nature', not what 'man is with us, or what, according to the notions of some dreamer, he ought to be; but what he is on the Earth in general, and at the same time in every region in particular'. Johann Gottfried Herder, *Outlines of a Philosophy of the History of Man*, trans. T. Churchill (New York: Bergman Publishers, 1800), 11; *Werke in zehn Bänden*, ed. Martin Bollacher et al. (Frankfurt am Main: Deutscher Klassiker Verlag, 1985–1998), vol. VI, 35.

21. In this way, Schlegel takes up the legacy from Lessing, Winckelmann, Herder and the debate around Laocoön some forty years earlier.

22. *Über William Shakespeare bei Gelegenheit Wilhelm Meisters*, W VII 25.

23. Referencing Adam Müller, Schlegel here speaks of a mediating criticism (*die vermittelnde Kritik*) that not only moves, methodologically, between history and theory, but also across national borders (LDA 229; W VI 159). Roger and Paulin emphasize the contrast between a mere philological criticism and mediating criticism, and trace this back to the distinction between mechanical and organic unity. See their 'August Wilhelm Schlegel'.

24. Wellek, *A History of Modern Criticism*, vol. I, 176. Interestingly, in his study of Schleiermacher and the history of hermeneutics, Wilhelm Dilthey pays attention to the intersection between Herderian and Fichtean impulses in romantic philosophy. I discuss this point in 'Enlightenment, History, and the Anthropological Turn: The Hermeneutical Challenge of Dilthey's Schleiermacher Studies', in Giuseppe D'Anna, Helmut Johach, and Eric S. Nelson (eds.), *Anthropologie und Geschichte. Studien zu Wilhelm Dilthey aus Anlass seines 100. Todestages* (Würzburg: Königshausen & Neumann, 2013), 323–355.

25. Johann Gottfried Herder, *Philosophical Writings*, ed. and trans. Michael N. Forster (Cambridge: Cambridge University Press, 2002), 247; *Werke*, vol. I, 149.

26. The references to feeling and universality of mind are, again, distinctively Herderian. Wellek is not alone in seeing this as an expression of a cosmopolitan mindset (Wellek, *A History of Modern Criticism*, vol. II, 38). Schlegel emphasizes Herder's cosmopolitan lectures in *A. W. Schlegel's Lectures on German Literature from Gottsched to Goether, Taken Down by George Toynbee (1833)* (Oxford: Basil Blackwell, 1944), 35. Here, Herder is praised as 'a critic, and in the best sense of the word' (ibid.). For a study of cosmopolitan attitudes in German romanticism (with special reference to Novalis), see Pauline Kleingeld, 'Romantic Cosmopolitanism: Novalis's 'Christianity or Europe', *Journal of the History of Philosophy*, vol. 46, no. 2 (2008), 269–284.

27. Strengthening his notion of organic form, Schlegel compares this internal excellence with a seed (he uses the Herderian notion of *Keim*). Helmut Rehder explains: 'To begin with, Schlegel says that true critical understanding and judgment are based on three postulates: universality of outlook, freedom from limited or temporal concessions, and intuitive ability of placing oneself within the object of aesthetic experience. These prerequisites not only exclude casual and impressionistic observation; they also reject any kind of normative standards. Instead, they are concerned with the individual work of art itself, its unique character, and the conditions which produce it'. Helmut Rehder, 'Literary Criticism in Germany during the Romantic Period', *Monatshefte*, vol. 38, no. 4 (1946), 237–243, the quote is from page 237.

28. Schlegel here speaks of myth (LDA 50; W V 79). Again we find a similar language in Nietzsche. See, for example, *The Birth of Tragedy*, 108–111; *Kritische Studienausgabe,* vol. I, 145–149.

29. The chorus, Schlegel points out, is an aspect of Greek tragedy that is extremely difficult to grasp for the modern mindset (as Schlegel puts it, their dance had scarcely the name in common with ours, LDA 45–46; W V 67–68). Yet, drawing on his suggestion that Greek culture and mythology does itself grow out of a patchwork of traditions, Schlegel proceeds to judge it a 'republican' aspect of tragedy, an impartial judgement that eventually represents the whole of the human race (*der gesamten Menschheit*, LDA 49 and 50; W I 76 and 77). As such, it is the ideal spectator (ibid.). Nietzsche famously judges this 'a crude, unscientific, but brilliant assertion' (*The Birth of Tragedy*, 37; *Kritische Studienausgabe* I 53), but nonetheless emphasizes the original unity of chorus and audience. Nietzsche, however, misunderstands Schlegel: Schlegel's point is not that the chorus represents an objectivizing audience, but that it represents a non-biased outlook.

30. Herder had developed this point in his Shakespeare studies. See my 'Shakespeare's Hermeneutic Legacy: Herder on Modern Drama and the Challenge of Cultural Prejudice', *Shakespeare Quarterly*, vol. 64, no. 1 (2013), 60–71.

31. Here he refers to *Hamlet* in particular. See *Etwas über William Shakespeare bei Gelegenheit Wilhelm Meisters,* W VII 27–28.

32. The same point is made already in *Etwas über William Shakespeare bei Gelegenheit Wilhelm Meisters,* W VII 31. Schlegel emphasizes how *Hamlet* prioritizes feelings and thoughts over action (*Thaten*). As he summarizes his point: 'Hamlets

Seele ließ, in sein eignes Innre versenken' (ibid. 28). Goethe's *Wilhelm Meister* and Lessing's *Nathan* are also characterized in this way (ibid.).

33. I discuss how this point figures in the earlier *Hamlet* reception in 'Interpreting Hamlet: The Early German Reception', in Tzachi Zamir (ed.), *Shakespeare's Hamlet: Philosophical Perspectives* (Oxford: Oxford University Press, forthcoming).

34. Likewise, in his later Bonn lectures on German Literature, Schlegel criticizes Lessing, Mendelssohn and Nicolai for their lack of universality, which, again, is seen as an essential requisite of true criticism. See *Lectures on German Literature,* 24.

35. Interestingly, Schlegel here views Lessing's work as a mixture of French and English impulses (LDA 345; W VI 408), a description of German culture we also find in Herder and Kant. Schlegel, however, places his hopes for contemporary drama with English and Spanish culture.

36. Although Lessing, in his *Hamburg Dramaturgy*, was positive in his attitude to Shakespeare, he did not quite dare to stage Shakespeare's work in Hamburg. See Simon Williams, *Shakespeare on the German Stage,* vol. I: 1586–1914 (Cambridge: Cambridge University Press, 1990), 10.

37. Schiller is seen as a Shakespeare imitator in plays such as *Die Räuber*, *Cabale und Liebe* and *Fiesco* (LDA 350–51; W VI 419).

BIBLIOGRAPHY

Behler, Ernst. *German Romantic Literary Theory*. Cambridge: Cambridge University Press, 1993.

Gaukroger, Stephen. *The Collapse of Mechanism and the Rise of Sensibility: Science and the Shaping of Modernity 1680–1760*. Oxford: Clarendon Press, 2010.

Gjesdal, Kristin. 'Interpreting Hamlet: The Early German Reception'. In *Shakespeare's Hamlet: Philosophical Perspectives*, edited by Tzachi Zamir. Oxford: Oxford University Press, Forthcoming.

Gjesdal, Kristin. 'Enlightenment, History, and the Anthropological Turn: The Hermeneutical Challenge of Dilthey's Schleiermacher Studies'. In *Anthropologie und Geschichte. Studien zu Wilhelm Dilthey aus Anlass seines 100. Todestages*, edited by Giuseppe D'Anna, Helmut Johach and Eric S. Nelson, 323–355. Würzburg: Königshausen & Neumann, 2013.

Gjesdal, Kristin. 'Shakespeare's Hermeneutic Legacy: Herder on Modern Drama and the Challenge of Cultural Prejudice'. *Shakespeare Quarterly* 64, no. 1 (2013): 60–71.

Herder, Johann Gottfried. *Philosophical Writings*. Ed. and trans. Michael N. Forster. Cambridge: Cambridge University Press, 2002.

Herder, Johann Gottfried. *Outlines of a Philosophy of the History of Man*. Trans. T. Churchill. New York: Bergman Publishers, 1800.

Herder, Johann Gottfried. *Werke in zehn Bänden*. Ed. Martin Bollacher et al. Frankfurt am Main: Deutscher Klassiker Verlag, 1985–1998.

Huddleston, Andrew. 'Hegel on Comedy: Theodicy, Social Criticism, and the "Supreme Task" of Art'. *British Journal of Aesthetics* 54, no. 2 (2014): 227–240.

Kleingeld, Pauline. 'Romantic Cosmopolitanism: Novalis's "Christianity or Europe"'. *Journal of the History of Philosophy* 46, no. 2 (2008): 269–284.

Larson, Kenneth E. 'The Origins of the "Schlegel-Tieck" Shakespeare in the 1820s'. *The German Quarterly* 60, no. 1 (1987): 19–37.

Nassar, Dalia. 'Romantic Empiricism after the "End of Nature"'. In *The Relevance of Romanticism: Essays on German Romantic Philosophy*, edited by Dalia Nassar, 296–315. Oxford: Oxford University Press, 2014.

Nietzsche, Friedrich. *The Birth of Tragedy and Other Writings*. Ed. Raymond Geuss and Ronald Speirs. Trans. Ronald Speirs. Cambridge: Cambridge University Press 1999.

Nietzsche, Friedrich. *Kritische Studienausgabe*. 15 vols. Ed. Giorgio Colli and Mazzino Montinari. Berlin: Walter de Gruyter, 1999.

Rehder, Helmut. 'Literary Criticism in Germany during the Romantic Period'. *Monatshefte* 38, no. 4 (1946): 237–243.

Reill, Peter Hanns. *Vitalizing Nature in the Enlightenment*. Berkeley: The University of California Press, 2005.

Roger, Christine and Roger Paulin. 'August Wilhelm Schlegel'. In *Great Shakespeareans*. Vol. III: *Voltaire, Goethe, Schlegel, Coleridge*, edited by Roger Paulin and Adrian Poole. London: Continuum, 2010.

Schäfer, Dorothea. 'Die historischen Formtypen des Dramas in den Wiener Vorlesungen A. W. Schlegels'. *Zeitschrift für deutsche Philologie* 75 (1965): 397–414.

Schick, Edgar B. *Metaphorical Organism in Herder's Early Work: A Study of the Relation of Herder's Literary Idiom to His World-View*. The Hague: Mouton, 1971.

Schlegel, August Wilhelm. *A. W. Schlegel's Lectures on German Literature, Taken Down by George Toynbee (1833)*. Oxford: Basil Blackwell, 1944.

Schlegel, August Wilhelm. *Lectures on Dramatic Art and Literature*. Trans. John Black, http://www.gutenberg.org/ebooks/7148. Accessed 1 November 2016.

Schlegel, August Wilhelm. *Sämtliche Werke*. Ed. Edouard Böcking. Hildesheim: Olms, 1972.

Schlegel, Friedrich. *Kritische Friedrich Schlegel-Ausgabe*. Ed. Ernst Behler. Paderborn: Verlag Ferdinand Schöningh, 1979.

Schlegel, Friedrich. *On the Study of Greek Poetry*. Trans. Stuart Barnett. Albany, NY: SUNY Press, 2001.

Schmidt, Günther. *Herder und August Wilhelm Schlegel*. Berlin: Friedrich-Wilhelms-Universität zu Berlin, 1917 (Dissertation).

Steinke, Martin William. *Edward Young's 'Conjectures on Original Composition' in England and Germany* (with the original text). New York: G. E. Stechert, 1917.

Volkmer, August. *A. W. Schlegels Auffassung des Dramas im Vergleich zu der Lessings*. Zabrze: Max Czech, 1906.

Wellek, René. *A History of Modern Criticism, 1750–1950*. Vol. II: *The Romantic Age*. Cambridge: Cambridge University Press, 1981.

Williams, Simon. *Shakespeare on the German Stage*. Vol. I: 1586–1914. Cambridge: Cambridge University Press, 1990.

Zammito, John. *Kant, Herder, and the Birth of Anthropology*. Chicago: The University of Chicago Press, 2002.

Part II

ACTING

Chapter 4

Nietzsche, the mask and the problem of the actor

Tom Stern

Readers of Nietzsche are not unfamiliar with the thought that his philosophical writings contain numerous at least apparent contradictions. We begin with one of them. On the one hand, Nietzsche takes pride of place in the canonical parade of theatre-haters.[1] Indeed, he himself demands inclusion: 'I am essentially anti-theatrical'.[2] This antipathy appears to extend to the actor's 'inner longing for a role and mask'.[3] On the other hand, Nietzsche is known as an *advocate* and admirer of the mask: 'everything profound loves masks' reads one of his best-known lines.[4] Mask-wearing, whatever that turns out to be, is not only a social strategy, but also a philosophical or intellectual one, as we shall see. The mask has a variety of associations, of course, but a salient one, for Nietzsche, was its relation to the actor, beginning with its use in Greek tragedy.[5] Thus we seem to find a Nietzsche who on the one hand opposes the theatre and the actor's role-playing and mask-wearing and, on the other hand, who encourages the mask, which he himself associates with acting and theatre.[6]

Of course, this tension has potential implications for our understanding of Nietzsche's antipathy to theatre. To take one example, he seems to connect theatre with lack of honesty, including to oneself (GS 368). And yet some have taken Nietzsche as 'masking' his own thoughts, as a means to avoid being honest with himself.[7] If Nietzsche can advocate masking, and if masking includes not being honest, even to oneself, then why is he and why ought he to be anti-theatrical? But before diving into the details, it is worth noting why this tension might be of some significance for those interested in Nietzsche's philosophy more broadly, beyond just his analysis of theatre. The reason is that Nietzsche's remarks about the mask have been taken by a wide variety of commentators as a way into reading his philosophical method. Frequently, his mask-advocacy is understood as an indication that

all it is not what it seems, either with respect to particular remarks or with respect to his philosophical enterprise as a whole.[8] Related to this is another oft-repeated claim, namely, that Nietzsche's mode of doing philosophy is intrinsically theatrical or dramatic.[9] Commentators vary greatly, of course, on what they take the exact nature of a masked, theatrical or dramatic philosophy to be. But I am particularly interested in one potential implication of a 'masked' philosophy: namely that, in advocating mask-wearing, Nietzsche implies that his own philosophical claims are, at some general level, not to be taken as sincere – that he is not in fact asserting what he takes himself to believe.[10] I choose this definition of sincerity[11] because it highlights that one can be sincere and also wrong about oneself (if, for example, I tell you I am not resentful, and I believe I am not resentful, but on some level, in fact, I am), just as one can be insincere and yet still, despite one's best efforts, communicate quite accurately (e.g., involuntarily). If this way of understanding his mask-advocacy were correct, it would be as though I were to place a footnote in this chapter which said 'it's a thoroughly good idea to dress up one's real and best ideas in confusing ways': whatever else, you ought probably to think twice about taking everything I said as a sincere report of my own views. There is no reason why a philosopher should not decide to write in such a way, and, if executed thoroughly and brilliantly, that philosopher might end up writing like Nietzsche. On the other hand, it would be worthy of comment, at least, if such a philosopher were also to *attack* acting and mask-wearing itself. The point is not that such an attack on mask-wearing would be illegitimate because of its inconsistency: inconsistency of some kind may well be permissible, even necessary, for the mask-wearing philosopher. Indeed, many have taken Nietzsche's mask-advocacy together with his attack on conventional notions of truth to form these sorts of conclusions. Rather, the point is that the self-declared mask-wearer who attacks mask-wearing – like the actor who attacks acting or the poet who attacks poetry – appears as a moment of irony. And irony, as Nietzsche surely knew, has a habit of drawing attention to itself. We should give this irony the attention it demands.

This is a chapter about these two thoughts in Nietzsche: on the one hand, his advocacy of the mask; on the other, his criticism of the actor. It is, therefore, an exploration of Nietzsche's philosophy of theatre but also of the sense in which his philosophy itself might be claimed as dramatic or theatrical, as it so often has. The former, I argue, gives us the tools we need to understand the latter. We first examine what Nietzsche writes about theatre and acting in their artistic context, and then in their social or everyday contexts; with these contexts in mind, we shall turn to his remarks about philosophy itself and its implications for how to understand him.

MASKS AND SINCERITY

One can easily see why advocating the mask might mean advocating insincerity. But we are not entitled to form a general conclusion about Nietzsche's philosophical writing simply on that basis. Three barriers threaten to undermine such an inference.

First, we would want to be sure that, when Nietzsche advocates mask-wearing, mask-wearing really does imply insincerity. At times, to be sure, it seems that masking is associated by Nietzsche with lying, deception, insincerity or seeming to be the very opposite of what one is.[12] Yet, conceptually and textually, we cannot unthinkingly help ourselves to this connection. Take the masked intruder, for example: he does not wear the mask to make you think he is someone else; he wears it so that you don't know who he is – but it is perfectly obvious *that* he wears it and why. If masking simply means concealment, as with the masked intruder, then, while we can freely acknowledge that no writer reveals all of his or her thoughts, no deception is necessarily involved. Some of Nietzsche's own comments on the mask do not meet this first hurdle. Mistaking someone's 'mask' for their deeper personality, he suggests in one place, means treating how they are in some particular situation (the mask) for something deeper about their general character that we posit as lying behind the mask.[13] BGE 40, in which Nietzsche makes his famous remark that everything profound loves masks, includes as one kind of 'mask' the (probably misleading or inaccurate) conception that everyday people have of the profound spirit: *your* mask, in this case, is *my* confused idea of what you are, regardless of how you intended to come across to me. Or take Nietzsche's remark that 'everyday honesty is a mask without knowing it is a mask'.[14] Here, masking is obviously not a matter of insincerity: whatever he is trying to say about masking, it relates to everyday *honesty*, that is, what happens when people try, in good faith, to be honest with one another. To be sure, he suggests that everyday honesty is non-transparent and perhaps is no guide to how the honest person really is, but presumably the everyday-honest person is reporting what he or she takes himself or herself to believe. As we saw from our chosen definition of sincerity, it is possible to be sincere and also (unwittingly) to mislead others about oneself. If mask-wearing means something like oblique or indirect communication, as BGE 40 in part suggests, then that too would not entail insincerity. In sum, when Nietzsche talks about masking, he sometimes does and sometimes does not imply insincerity.

Second, we would want to be sure that Nietzsche is treating mask-wearing as something that he in particular (or his ideal philosopher) is doing or advocating, as opposed to something that all philosophers, or some other philosophers, are doing for the wrong reasons. That's because the claim that

we should not read Nietzsche at face value is typically a claim that Nietzsche is (for Nietzsche and for us) doing something unusual as a philosopher. If he writes that *all* philosophy is masked in some way,[15] or if he writes that some particular philosophers are masked in very specific ways that do not apply to him, then we cannot draw any inference about his own philosophy. As for the latter, Spinoza's geometrical method is described as a mask he wears to intimidate.[16] Supposing Spinoza to have been aware of his flaws, there would certainly be a deliberately deceptive and perhaps insincere element to his philosophy. But this kind of mask-wearing is clearly not generalizable, since most other philosophers, including Nietzsche, do not write as Spinoza did.

Finally, if we want to draw general conclusions about Nietzsche's philosophical method, we would want some evidence that the masking he advocates applies to all of his work, not just to some specific part of it – say a particularly provocative or dangerous idea. Indeed, Nietzsche does suggest that some of his specific moral views (e.g., his anti-egalitarianism) are too incendiary for his age and that, therefore, he must disguise those views in particular.[17] That in itself is worth noting, of course, but it does not follow that he has a general strategy of insincerity. One could, perhaps, try to demonstrate that *all* his philosophical thinking is connected to these moral ideas and therefore that he had grounds to disguise his ideas in general. But such a strategy would be difficult to carry through in this case, mostly because, whatever misgivings he may have had, Nietzsche is perfectly explicit about his anti-egalitarianism in a number of published works.[18]

As we have seen, 'masking' means a variety of different things to Nietzsche, and consequently a masked philosophy may have various implications: misunderstood by others; an act of concealment, perhaps concealing the author's more controversial ideas; deceptively intimidating in its style; the opposite of what it appears to be. Two conclusions should be drawn at this point. First, we can say something regarding the tension we began with, which compared Nietzsche's mask-advocacy to his attack on the actor: the variety of things Nietzsche seems to have in mind with the mask make this tension less self-evident. For example, everyday honesty is a kind of mask, and presumably acting is nothing like everyday honesty. So we will need to look more closely at the context in which Nietzsche advocates the mask for the philosopher, but we will also need to look more carefully at his conception of acting to see how it compares with his discussion of the mask.

Second, as regards the question of insincerity, surprisingly few of Nietzsche's remarks on the mask meet the three criteria we set out, if they are to have the consequence that we ought to treat his philosophy as insincere. There is, therefore, a risk of loading his positive remarks about the mask with a meaning that he did not intend. Of the various candidates for an aphorism which meets these criteria, the best is BGE 25, which we have not analysed.

In that section his mask-advocacy arguably asserts that masking is a kind of insincerity, that other philosophers have not been masked in this way and that masking is (or ought to be, on the grounds he provides) a feature of his own philosophizing in general. Here too, if we want to understand Nietzsche's broader concern in that section and come to a better understanding of its implications for his philosophy, it is necessary to have more of his specific concerns about theatre and acting in mind. It is to these we now turn, before returning to BGE 25 and some of its related aphorisms.

THREE KINDS OF THEATRICAL ACTING

Nietzsche often implies that the actor acts primarily for the sake of the immediate effect that he brings about, as opposed to having any more substantial commitments or interests. The critique of Wagner-as-actor is, in part, that his music is written for show, with big gestures and individual scenes designed to excite a weary audience.[19] But what does Nietzsche understand acting to be, and how does one achieve such effects? A writer in the nineteenth century had three significant models to turn to in thinking about the nature of acting and, I suggest, Nietzsche implicitly appeals to all three. As we analyse these models, it will help us to have four dimensions or variables in mind in any instance of theatrical acting: the actor's inner experience; his or her outer appearance; his or her object of imitation; the state of the spectator. These are clunky terms for simple things. Suppose you are an actor in a naturalistic theatrical performance, playing the part of Tesman, Ibsen's well-meaning, fearful academic specialist. The imitated object is a real, well-meaning, fearful academic; your outer appearance copies that of the imitated object – a tweed jacket or a nervous twitch. Your inner experience is whatever you, the actor, experience during the course of your performance: you might be nervously scanning the audience or you might be completely engrossed in the part. The state of the spectator is whatever *he* or *she* experiences during the course of the performance: boredom, rapture, illusion, enlightenment, empathetic identification and so on.

On the first model, the 'immersive' actor, the actor's inner experience matches that of the character, the imitated object. The best way to communicate a certain feeling or to convince the audience that you hold a certain belief, so the thought would go, is to feel and to believe these things yourself, or to get as close as you could to doing so. The actor's inner experience matches that of the character; therefore the actor's outer appearance matches that of the would-be character; *consequently* the spectator feels what the actor (and imitated object) feels or, at least, responds to the actor as she would to the imitated object. As Horace put it in his *Ars Poetica*: 'If you wish me to

weep, you must feel sorrow yourself'. For our purposes, a key point here is that, taken to its limit, this actor is not *insincere*: fully immersed, she really feels sorrow herself and the spectator who responds accordingly is not duped.

Some of Nietzsche's remarks on acting appear to take this view. Indeed, *The Birth of Tragedy* and its related preliminary materials locate the origins of acting not at a theatre, with spectators to be moved or deceived, but in states of intoxicated ecstasy in which a reveller simply believes himself or herself to be another.[20] Nietzsche recognizes that full immersion in the part means, in an important sense, not really acting: the Dionysiac revellers who imagine themselves to be satyrs (natural, pre-civilized worshippers of Dionysus) are '*unconscious* actors' because each sees himself or herself and the others as really transformed. There are moments in Nietzsche's later writings in which some version of the 'immersive' analysis is offered. The discussion of acting and self-deception in *Human, All too Human* suggests that deceiving others into thinking that one is something that one is not requires, at a deep level, self-deception, a real belief that one *is* that something else.[21]

The notion of immersion, when applied to the modern stage, was open to criticism. The genuinely angry or grieving actor would lack the technical ability to perform his or her task: remembering lines, knowing where to stand. Hence, the inner experience of the actor *cannot* match that of the imitated person. Moreover, the outer appearance of the imitated person – genuine grief and genuine anger, for example – might be quiet and unimpressive on stage. The combination of these thoughts led to scepticism about whether 'real feeling' was appropriate either as a description of what actors do or as an aspiration. Denis Diderot, who pressed claims of this kind against the immersion model, had a second, different analysis – I'll call it the 'gymnastic' model – which combined two distinct claims. The first was that outer appearance does not match the imitated person: on-stage gestures and behaviours were nothing like their real-life counterparts. At best, on-stage emotion is a kind of caricature or a symbolic language which audience members learn to read. Second, the actor's outer appearance – for example, the emotion he or she imitates – does not correspond to his or her inner experience: there is no shared feeling between actor and character. The actor remains cool, calm and distanced, although, as a physical trial, the routine of acting may be very exhausting (hence the 'gymnastic' label). In sum: neither the actor's inner experience nor the actor's outer appearance corresponds to that of the imitated object.[22]

Both components are present in Nietzsche's work. GS 78 has theatre as the art of putting us on stage in front of ourselves, but specifically in a simplified and transfigured form. In the Greek case, he claims, the theatre presented the flattering but false impression that humans, in the throes of the most desperate passions, still produce beautiful speech, which of course they do not.[23] The suggestion is therefore that acted persons and acted passions are sufficiently

like us to be plausible but nonetheless unlike us in a flattering way. In the modern context, Nietzsche focuses on a description of acting by the great French actor, Talma: the actor describes practising his emotional parts many times and drawing on real-life emotional experience, but never actually feeling anything like them when on stage. Talma recounts a performance in which he is close to being overcome with emotion by the performance of a fellow actor who, on noticing his response, warns him to pull himself together. Nietzsche's lesson, from Talma, is that, in theatre, that which is to seem true, or have the effect of truth, must not, itself, be true: if actors like Talma really feel, the audience will not buy into the performance.[24] In one note, Nietzsche's posits, as a 'first law of all theatre-optics: what should seem true must not be true'.[25] This second kind of acting, as Nietzsche's 'law' suggests, would certainly imply insincerity on the part of the actor, since successfully conveying some supposed inner experience precludes actually having it.

The third model was the ideal of the graceful, non-conscious marionette, spelt out in Kleist's story.[26] The marionette, so the story goes, is the perfect performer, partly because it does not need to take a reflective stance towards its own performance: it has no inner experience at all. In one of Kleist's examples, a youth adopts the pose of a well-known sculpture: he can do so perfectly well as long as he isn't trying to, but the effort of deliberately re-creating it in front of a spectator erodes his imitative abilities and his gracefulness. Kleist's marionette ideal is less an instruction on how to perform and more a lamentation on the fact of human mindedness. There is indeed a hint of this in Nietzsche's early analysis of the death of tragedy at Socrates's hands: it was and ought to be 'natural' and 'instinctive' rather than artificial and over-thought; moreover, we have been living too long under the spell of the Socratic, anti-instinctive attitude.[27] In *Daybreak*, Nietzsche calls the actor an 'ideal ape', who mimics the outer appearance of the imitated object without feeling anything of its inner experience.[28] The 'ideal ape' model combines an ideal of verisimilar external appearance (from the first model) with highly dissimilar inner experience (from the second model). Here, though, the disconnect between the inner and the outer is not a matter of deliberate choice or technique, but rather a matter of insufficient understanding: the actor simply does not realize that there is more to someone than how they appear on the outside. There is something of Kleist's model, then, in the 'ideal ape', and in Nietzsche's subsequent suggestion that the 'great actors' are those who do not believe in essence and interiority *at all* – as though understanding the inner experience associated with some action would undermine the actor's ability to imitate it on stage.

These three models do not exhaust Nietzsche's claims about acting. The main point is that 'acting', in each case, suggests very different and in some cases opposing accounts of what is going on. The first model has a kind of

self-deception or self-transformation at its core. The second requires a clear division, and an awareness of that division, in which inner experience and outer appearance are no longer matched up, and neither is there a match between the actor's appearance and that of the imitated person. Here, if a spectator were to believe that the actor's outer appearance is a genuine expression of her inner experience then she would be deceived. The third, in a sense, seeks self-eradication – or at least the eradication of conscious reasoning. What is more, there is a sense in which the metaphor of the mask fits each of these instances: the first, because although the actor is immersed, actor and character are not ultimately, deeply identical; the second, because the actor is deliberately deceiving the spectator; the third, because the actor, at the limit, *becomes* a mere appearance or a mask. To speak of Nietzsche's philosophy as masked or theatrical is to speak highly ambiguously, as we see when we examine his own claims about acting and masking.

THE SOCIAL ACTOR

Nietzsche's remarks on acting are not, however, restricted to the artistic, theatrical context. He has a great deal to say about social acting, which is to say, everyday non-theatrical contexts in which what we do counts as 'acting' in some sense. While a full survey isn't possible in this context, we can helpfully divide many of his remarks along the immersive, gymnastic and marionette-like lines sketched out in the discussion of theatrical acting.

As for immersion, Nietzsche has social 'actors' as those who can really perform a variety of different tasks. Here, as with its theatrical counterpart, the social actor is not pretending or deceiving, since he or she really is competent.[29] Elsewhere, the actor is associated with having varied kinds of knowledge – again, no deception or insincerity is implied.[30] Of course, being good at many things may include being good at deception and Nietzsche remarks on the figure of Odysseus who is talented both at performing many different tasks and at deception. His point is that the Greeks do not condemn his lying, instead seeing it as part of an admirable set of skills. These are positive connotations to immersive social acting, but there are also more dismissive accounts. In particular, Nietzsche associates it with the risk, at least, of permanently becoming what you intended to be only temporarily (a worry which has been associated with acting at least since Plato).[31] This is a worry about conformism: pretending to be like everyone else solidifies into actually being like everyone else.

As for the gymnastic model, sometimes the social actor's talent is straightforwardly one of dissembling: some people are honest, Nietzsche suggests, simply because they aren't good enough actors to be successful hypocrites.[32]

Nietzsche attributes to the actor 'falseness with a good conscience'[33], that is, a lack of particular concern about whether one is deceiving or not. As we saw with the Odysseus ideal, this need not in itself be a negative feature, but what he terms the 'problem of the actor' occurs just when deception changes from a useful tool to a kind of need in itself: dissembling turns from means to end. This is not the same as the conformism we encountered earlier: the conformist genuinely changes with the prevailing winds, but presumably stays the same when the prevailing winds do not change. Unlike the conformist, the problematic actor would continue to dissemble even if fashions were to hold still, since dissembling is the end goal. Here, then, social acting is clearly associated with seeming to be other than you are. Elsewhere, Nietzsche describes the action of trying to move a crowd of people as one in which one must exaggerate, simplify and coarsen one's emotions, becoming 'an actor playing the role of himself'.[34] The idea of getting a crowd going – something Nietzsche strongly associates with Wagner – is therefore connected with overwrought gestures, and it is partly in the context of Wagner's works that Nietzsche invokes Talma's gymnastic acting (see above).

Finally, we come to the marionette ideal. Nietzsche was certainly concerned with what happens when we start to think of ourselves as observed – as with the youth imitating the pose of the statue in Kleist's story. The consequences are by no means altogether negative. BT's aesthetic justification of our existence has everyday humans as aesthetic objects for a quasi-divine world-artist. This is a justification because it offers a positive purpose for our lives, from a perspective which we can, in some sense, occasionally share. Nietzsche would return to the need of the Greeks for an audience for their actions, in this case the gods, and he would also encourage readers to view their own everyday activities and those of others as a kind of performance at which they are spectators, as a means to cope with highly charged circumstances.[35] Another aphorism has the actor as he who cannot help but imagine the effect of his 'performance' on others. Hence 'even when in the deepest distress' – Nietzsche's example is the death of a child – the actor will 'weep over his own distress . . . as his own audience'.[36] One becomes one's own spectator in order to change one's own inner experience.

MASKED PHILOSOPHY IN THE LIGHT OF NIETZSCHE'S CONCERNS

I indicated, earlier, that even a cursory overview of Nietzsche's remarks about the mask suggests that a 'masked' philosophy might mean many different things. Now, we can see that the same is true with respect to theatrical philosophy, understood as 'acted' philosophy. Immersive philosophical acting

suggests really changing your views over time, rather than maintaining any kind of core value or belief. Hence, the immersive philosopher seems to be what he or she is, but what he or she is changes. Nietzsche sometimes appears to endorse such a mode of philosophizing. In his *Genealogy of Morality,* for example, he specifically advocates completely changing one's mind, at least as a preliminary step.[37] BGE 205 has the real philosopher as one who experiments and is tempted by many different things, though note that this is in contrast to the philosopher as 'actor', which, in this aphorism, means a kind of con-artist. The gymnast model allows for the philosopher to maintain his or her own views all along, but *seems* to have a different view when it suits. The marionette ideal, in as much as it can be applied here, downplays the role of taking any reflective stance towards your own philosophical work – and, indeed, there are moments when Nietzsche opposes self-observation on the part of the philosopher-psychologist.[38] Only in the second case would a theatrical or actor's philosophy suggest a lack of sincerity.

Amid all this variety are there general concerns to be brought out? Our discussion of theatrical and social acting has certainly shown that sincerity as such is not central to Nietzsche's analysis of the actor. Earlier, we set out a first concern about acting: when Nietzsche wants to criticize Wagner as an actor, one aspect of this is playing to a crowd for effect rather than being interested in anything of substance. Two further general problems are, according to Nietzsche, associated with the actor. In both cases, his interest lies not in acting as such but in an individual's communication with an audience and specifically in what happens to the individual who becomes concerned with how the audience will think about him or her.

The second is that convincing communication of inner experience at least *can* require a distortion of some kind. This can be a mismatch between outer appearance and the 'real' version of the imitated object: consider the gymnastic models of theatrical and social acting, for example, when I have to exaggerate my emotional behaviours in order to be convincing. Or it can be a matter of mismatch between inner experience and the imitated object: this is suggested by the gymnast and marionette models – for example, in the idea that the most convincing actor is the one who has no notion of the interiority of the character he or she plays.

The third is that attempted communication alters one's own inner experience: it is difficult to remain constant when one steps out onto the literal or the social stage. We have seen that this is not always negative, as in the almost therapeutic process of becoming your own spectator, with the transformation of inner experience which that induces. But there were more troubling versions of this when the focus is on producing an effect in others: in Nietzsche's worry about conformism, for example, and in his discussion of pathological dissembling, in which the actor-type becomes addicted to seeming to be other

than he is. This was contrasted with dissembling for a particular purpose, as in the Odysseus case – to which Nietzsche offers no objection.

We have reached the point where we can turn to BGE 25, the section in which philosophical masking is advocated and seems to encourage insincerity. When we do so, it will be helpful to keep these three concerns in mind. The communication of philosophical ideas, for Nietzsche, raises the aforementioned problems of what happens to the individual on the stage. This includes the question of how to respond when one's views are challenged or criticized, which is in fact the main focus of the aphorism. But Nietzsche makes two relevant further claims in that aphorism, which lie in the background of his discussion. First, any philosopher must acknowledge that, given how things have turned out for past figures in the history of philosophy, their ideas are probably false or at least misguided ('you know that no philosophy so far has been proved right'). At the very best, one might hope to add one's name to a long list of canonical figures, each of whose philosophies contained its fair share of poor argument, confusion and falsehood, together with a degree of hubris. It is hard to see why this would stop us from trying out an idea, but it might give us pause for thought before defending our own ideas too vigorously, at least if we accept that we are likely to be clouded by our desire to be seen to get things right. Second, Nietzsche suggests that if the goal is to display our honest commitment to the truth, then that would in any case be better displayed by attacking our own positions, not in defending them. The point of this appears to be to pull apart two intentions and to set them in opposition: truth-seeking inquiry on the one hand, and convincing others that we are truthful inquirers on the other. This is another instance, then, of the second concern (discussed earlier) that the act of persuading others to accept something about oneself can require undermining that very quality in oneself: I want to convince you that I am right about something; to do so, you need to think I am an honest truth-seeker; to convince you that I'm an honest truth-seeker, I may need to attack my own views – precisely those views I set out to persuade you were true. Of course, if my self-criticism is successful then my own views will have changed (this is a version of the third concern, discussed earlier).

In BGE 25, I would suggest, the masking Nietzsche advocates relates closely to the three concerns I set out earlier and hence to his general analysis of acting: it is intended to prevent the philosopher from thinking too much about how others think about his philosophy. But it is important to see that masking and acting come apart in this aphorism, for Nietzsche claims that the *unmasked* philosopher who defends his work in public ultimately becomes an 'actor'. The philosopher is unmasked, as I suggested, in that he is unprotected against his own concerns about how others think of him. By becoming an 'actor', Nietzsche seems to mean two things. First, that – consciously

(gymnastically) or unconsciously (immersively) – he acts as though his view is better grounded than it really is. Second, the philosopher-actor begins to play to the crowd, to seek out approval or applause rather than serious philosophical engagement with his ideas. He loses touch with the basis of his ideas. Recall the criticism of the Wagnerian actor as playing to the crowd. Recall, too, the notion of playing the role of oneself: the exaggerating, play-acting and coarsening which is required to move the crowd. While this might in theory be persuasive or successful as a strategy for convincing others, we have seen that Nietzsche holds such pretence and exaggeration to be unstable: we are not good, he thinks, at maintaining the line between what we seem to be and how we are. Finally, Nietzsche suggests that playing to the crowd, engaging in very public defence of this kind, turns one into a clownish figure in the minds of those watching. The original intention had been to seek the truth, defend it, promote it and be better understood. The result in each case is a failure. One has become a mere entertainer.

The mask ideal of BGE 25, then, is meant to oppose this by allowing and encouraging misunderstanding: 'Have your masks and refinement [Feinheit], that you may be mistaken for what you are not'.[39] As regards the three concerns given earlier, the masked philosopher is not trying to communicate successfully or trying to entertain – this avoids the problem associated with Wagner's showiness. As for the second concern, not thinking about how others think of you protects against distortion. By analogy, whereas (on the gymnastic model) the actor who wishes to persuade a crowd that he or she is angry had better not be angry, the person who really is angry, and is not concerned about whether others believe him or her, can do as he or she pleases. It follows – and here is the answer to the third concern, above – that the philosopher who is not concerned with persuading others will not experience a problematic change in inner experience and will be able to maintain a grip on his or her ideas rather than turning into the Wagnerian entertainer of BGE 25 or the pathological dissembler.

My interest in Nietzsche's analysis has been guided, first, by the apparent tension between his attitude to the mask and the actor and, second, by the spectre of insincerity in interpreting his works. The discussion up to this point has moved us towards a better understanding of the first: here in BGE 25, at least, Nietzsche advocates the mask strategy precisely to avoid some of the dangers he associates with the actor. We are left with the question of sincerity. It is clear why BGE 25 permits the philosopher to court misunderstanding and to be taken for what he is not: the concern that others understand and agree with us has (so Nietzsche thinks) the negative consequences he sketches. Masking seems to mean building into one's philosophical activity the awareness that one is unlikely to persuade, an awareness which brings constancy and security in comparison to the disintegration of BGE 25's

actor. The masked philosopher is like a person who, being pursued by a pack of angry dogs, throws some red meat at the dogs and therefore enjoys brief respite while the dogs tear apart the meat: now the dogs are not chewing on *him* or *her*, but on the meat he or she threw at them, and so he or she has time to reflect. Equivalently, it is as though the philosopher were to say to himself or herself: 'Look, I'm *so* unruffled by what others think of me that I'm going to write in such a way that I'm likely to be misunderstood'. (My readers are chewing on the meat from a different animal.) Nietzsche, indeed, is certainly capable of suggesting that he himself tries to be hard to understand.[40] One can see, furthermore, why this way of seeing things might justify concealment, deception and insincerity. But we can also see that going out of our way to deceive, or setting for ourselves the goal of conveying false things about ourselves and our views, is itself difficult to unite with the mask ideal: for masking is meant, in part, to protect *against* thinking too hard about how others think of us – these were precisely problems associated with the actor, as set out earlier. And this brings us to a problem: for how else but by thinking of how others think of me could I form an opinion of what will make my writing hard to understand?

If we are to accept Nietzsche's analysis, we will have to agree that there is a distinction between the masking which protects me and the acting which risks a destabilizing emphasis on how I appear to others. The former amounts to something like *indifference* to the opinion of others, whereas the latter would be committed to successful deception. The effect of this distinction is clear: in one case, my focus is on protecting myself and in the other my focus is on producing an effect on others. But from the point of view of the philosopher who wishes to take his advice, or indeed from the point of view of Nietzsche's reader, knowing where to draw this line in practice is not going to be easy. Nietzsche, as I have interpreted him, has reasons to make his views difficult to understand, but he also has reason not to spend too much of his time planning out the intricacies of exactly how his writings are to be difficult to understand. One might imagine, then, something like an instinctive and not overly considered way of keeping one's distance. I shall return to this thought shortly.

THREE OBJECTIONS TO PHILOSOPHICAL MASKING

The analysis I have given sets out what Nietzsche claims about masking and acting, both in general and specifically as it relates to the question of how we might interpret him. Of course some concerns remain. The first and most obvious objection would be to Nietzsche's conception of philosophy as I have presented it here. It comes naturally, since Plato's dialogues, to view

philosophy as a truth-seeking activity which develops through interpersonal interaction. One ground for this is precisely that others can point to flaws in our arguments – flaws which, for whatever reason, we do not notice ourselves. For the truth-seeker, then, the correction and development of ideas that comes from sharing them with others ought to be welcome progress, not a matter of shame or embarrassment. Yet Nietzsche's mask advocacy, as I have presented it, is predicated on the idea that it is better to be misunderstood, at least probably wrong, and convinced of one's own rightness than to be corrected in public. It appears anti-philosophical in its attitude. It imagines someone philosophizing for show, rather than trying, in good faith, to move towards the light. A second and related objection to this way of going about things looks to the difference between the theatrical actor and the philosopher. In the theatrical actor's case, the central and most plausible example was the communication of an emotion. The communication of philosophical theories and arguments works very differently. When Socrates discusses mathematics with Meno's slave, he is not communicating his own inner experience as such: he is taking the slave through the stages of a mathematical proof. The sorts of concerns sketched earlier ought not to apply.

The way that Nietzsche would respond to these objections is at least revealing for coming to an understanding of how he thinks about philosophy at this stage of his writing. As to the first objection, this is partly a matter of empirical prediction: he just thinks that, in fact, we don't respond to correction by admitting defeat and changing our views. Generally, he supposes that the conscious, rational deliberation of the kind to which the first objection appeals is rare and ineffective. In a sense, this reorientation confronts the second objection, too. An individual's philosophy is not merely, and indeed not mostly, a matter of reason, but a matter of a particular configuration of non-conscious drives or desires. To produce philosophy is to be governed by some particular non-conscious drives and, again, the interpreter of a philosophical text is, as with any act of interpretation, subject to his or her own drives.[41] Nietzsche does not, to my mind, produce a sufficiently robust account of the drives to ground a theory of philosophical interpretation.[42] But it is obvious that, to him, treating philosophy of any kind as cold, scientific investigation and communication is going to lead to deep-seated misunderstanding. If we are in any way trying to be truthful in and about philosophy, we must confront philosophy as something to a great extent non-rational and as something which cannot simply be a matter of the abstract communication of ideas through a shared and neutral process of reasoning. From that point of view, the second objection has less force, at least for Nietzsche.

A third objection, however, proves more pressing, and brings us to a more central concern within Nietzsche's own work. I have spoken, as does Nietzsche, about trying to be truthful or truth-seeking in philosophical work.

It was, recall, the starting point of BGE 25's mask advocacy that one was seeking to be and to appear truthful. The problem was that what we might take to be the best way of doing so – making one's views as clear as possible and defending them in public – turns out to undermine this very project: by the end, one neither appears to be nor is in fact a truth-seeker. But a premise of that discussion was that one's views (like those of most philosophers) are likely to be deeply flawed. In places, in BGE, Nietzsche is even more overtly sceptical about both the *possibility* and the *desirability* of successful truth-seeking. You are somewhere between probably and certainly wrong; and, if by any chance there are truths accessible to you, they are as likely as not to be harmful.[43] It would not be unfair, therefore, to ask what Nietzsche could take to be the purpose of truth-seeking, masked or otherwise. The answer he gives also makes reference to the mask and leads us, I argue, to a final, deeper problem.

THE DEEPER PROBLEM: MASKING AND PHILOSOPHICAL EXPRESSION

A well-known and oft-quoted statement of Nietzsche's philosophical intention occurs at BGE 229–30: to 'translate man back into nature'. This means, in other words, to take the same attitude towards human beings as we do to the rest of nature, to treat ourselves as natural entities. There can be no doubt that this description fits with broad swathes of the later Nietzsche's philosophical project and this particular remark of his has justly been described as 'pivotal for the "naturalistic" reading of Nietzsche' which has recently gained some popularity[44] – though one should note that what Nietzsche himself understands as 'natural' is idiosyncratic and undoubtedly brings its own difficulties.[45]

However, it is rare to see any discussion of the immediate context of Nietzsche's statement of intent. For one thing, he goes on immediately to suggest that he has no idea what the point of carrying out this task could be, other than the mere fact that it is a task. More importantly for our purposes, it comes as Nietzsche re-describes truth-seeking activity as a kind of self-directed cruelty. Humans, Nietzsche claims, are guided by two drives or tendencies which conflict with the truth-seeking endeavour: first, we jump to conclusions (making helpful or useful mistakes in the process) and, second, we avoid harmful truths, are content with certain falsehoods, and generally work to keep ourselves and others in the dark, where remaining in the dark is helpful for us. Truth-seeking is cruel to the truth-seeker in that it attacks both of these natural and self-preserving tendencies. It is, in short, a kind of self-denial. Belonging to the second of these two tendencies which are

opposed by the truth-seeker, Nietzsche claims, is a kind of mask-wearing: 'The spirit enjoys the multiplicity and craftiness of its masks, it also enjoys the feeling of its security behind them: after all it is surely its Protean arts that defend and conceal it best'. In sum, then, truth-seeking activity of the kind that Nietzsche's later project seeks to carry out is self-directed cruelty precisely because it opposes the natural activity of the mind, which uses deception and mask-wearing as one of its tools.

The crucial point for our purposes is that Nietzsche's natural-translation project is anti-mask in just the sense that BGE 25 encourages the mask. Note that the masking he describes, this feeling of being secure behind a mask, echoes BGE 25's understanding of the mask as that which protects us from the effects of thinking about how others think about us. BGE 230 has masking as protection against unwanted truths; BGE 25 also has masking as protection, in part, against unwanted truths (i.e., fair challenges to one's philosophical views with which it will be harmful for you to engage), but more generally it is a protection against forces in ourselves and others which will likely undermine us, once we aim to produce certain effects in others. Truth-seeking, in BGE 230, precisely operates *against* the instinctive masking activity which seems required by BGE 25 for the stable expression of the results of truth-seeking.

Readers of Nietzsche will be familiar with the challenge he poses to the truth-seeker: truth-seeking at all costs is an outgrowth of the ascetic ideal and hence the subject of a sustained critique by Nietzsche, as both Christian and anti-natural.[46] However, I am pointing to a further complication, relating not merely to the task of philosophy as a truth-seeking activity, but to the task of philosophical expression, where the latter interferes with the former. To translate man back into nature is, he says, to attack the masks that we naturally wear, the masks which we hide behind and which afford us protection and security: this is the clear message of BGE 229–30, in which Nietzsche sets out his translation task. Yet without just these tools, the philosopher runs up against the problems of philosophical expression set out in BGE 25 – problems which undermine the search for truth, and hence the translation project itself.

We began with the question of Nietzsche's apparent contradiction: the mask advocacy on the one hand and, on the other, his apparent hostility to the actor and the theatre. Behind his remarks about mask, actor and theatre, there lie many different notions and, in addition to the complaint of Wagnerian showmanship, I drew out two particular concerns which reappear in various forms. These concerns were shown to lie behind a central case of mask advocacy, BGE 25, which in fact casts mask-wearing as a means to *prevent* the philosopher from turning into the actor. But ultimately Nietzsche's grounds for encouraging philosophers to be masked reveal a further, deeper

tension, for he leaves his readers in a difficult position. On the one hand, there is his translation project, reworking our self-conception in the light of (what Nietzsche takes to be) our status as 'natural' beings, together with the implication this has for our values: to translate man back into nature. On the other hand, there is the self-critical project, which takes it as part of the truth-seeking enterprise to rake over our own habits, motivations and needs, including those that relate to the expression and communication of our ideas. The concerns about 'acting' and communication show how the second project relates to the first. Ideally, these two enterprises would complement one another: what we found about ourselves as natural creatures would help us to understand how to go about formulating and communicating our ideas. But what Nietzsche offers is a conflict: the truth-seeker attacks the conditions for the stable expression of the results of truth-seeking (in as much as such a thing might be possible). The important conclusion for the Nietzsche reader, therefore, is not so much a warning not to treat Nietzsche as sincere, but a tension in his own philosophical project which, knowingly or not, he brings to our attention. The pursuit of the naturalist philosophy will naturally undermine the possibility of its successful pursuit.

Many of us will not be tempted to follow all of Nietzsche's steps in the argument I have presented on his behalf. His conception of philosophy is unorthodox, as we have seen, and his cynicism about a philosopher's interactions with others may strike us as overblown – or, at least, as far from universally applicable. Indeed, the mask appears much less in Nietzsche's writings after BGE, so perhaps he himself ceased to worry about how to communicate his translation project. But he was nevertheless right, it seems to me, to draw our attention to the communicative and interactive aspects of philosophical activity and to see that how we do philosophy cannot easily be separated from its content and its effectiveness. To ignore the relation between the two would be to lead an unexamined life.

NOTES

1. Jonas Barish, *The Antitheatrical Prejudice* (Berkeley, CA: University of California Press, 1985).

2. Friedrich Nietzsche, *The Gay Science*, trans. Josef Nauckhoff (Cambridge, UK: Cambridge University Press, 2001) (henceforth 'GS'), Section 368. Unless otherwise stated, references to Nietzsche's works will give the standard aphorism number rather than the page number. For other broadly anti-theatrical passages, see his *The Case of Wagner* (henceforth 'CW'), sections 8–12 and *Sämtliche Werke, Kritische Studienausgabe in 15 Bänden*, edited by Giorgio Colli and Mazzino Montinari (Berlin: De Gruyter, 1999), volume 12, p. 475 and volume 13, pp. 242, 403 (henceforth 'KSA', followed by volume and page number).

3. GS 361.

4. *Beyond Good and Evil*, trans. W. Kaufmann in *Basic Writings of Nietzsche* (New York: The Modern Library, 2000) (henceforth 'BGE'), section 40; for a sample of apparently positive remarks about the mask, see KSA 10: 13; BGE 190, 278; KSA 11: 451. We discuss others in more detail in due course.

5. KSA 1: 533; GS 80.

6. I do not present this tension as my own discovery: Ernst Bertram, *Nietzsche: Versuch einer Mythologie* (Berlin: Georg Bondi, 1920), 157–180, marked it in an early study of Nietzsche, but Bertram's remarks are too scattered to be a major focus here.

7. Harold Alderman, 'Nietzsche's Masks', *International Philosophical Quarterly*, vol. 12, no. 3 (1972), 365–388, 368.

8. See, for example: Karl Jaspers's remark that for Nietzsche 'masks necessarily belong to the truth', where masks are understood, in part, as 'indirect communication' (reprinted in Walter Kaufmann, *Existentialism from Dostoevsky to Sartre* [New York: Meridian, 1954], 165); Walter Kaufmann's footnote to BGE 40 in his *Basic Writings of Nietzsche* (New York: Modern Library, 2000), 241; Raymond Geuss, 'Introduction' to Friedrich Nietzsche, *The Birth of Tragedy* (Cambridge: Cambridge University Press, 1999), viii–ix; Laurence Lampert, 'Nietzsche's Free Spirit Mask: Beyond Good and Evil', *International Studies in Philosophy*, vol. 16, no. 2 (1986), 41–52; Alderman, 'Nietzsche's Masks'; Robert B. Pippin, 'Irony and Affirmation in Nietzsche's Thus Spoke Zarathustra', in Tracey Strong and Michael Gillespie (ed.), *Nietzsche's New Seas* (Chicago: University of Chicago Press, 1988), 66.

9. Alderman, 'Nietzsche's Masks', 386; Peter Sloterdijk, *Thinker on Stage: Nietzsche's Materialism* (Minneapolis: University of Minnesota Press, 1989); Martin Puchner, *The Drama of Ideas: Platonic Provocations in Theater and Philosophy* (Oxford: Oxford University Press, 2010); David Kornhaber, 'The Philosopher, the Playwright, and the Actor: Friedrich Nietzsche and the Modern Drama's Concept of Performance', *Theatre Journal*, vol. 64, no. 1 (2012), 29; Peter Holbrook, 'Nietzsche's Shakespeare', in Jennifer Ann Bates and Richard Wilson (ed.), *Shakespeare and Continental Philosophy* (Edinburgh: Edinburgh University Press, 2014), 76.

10. For an early instance of masking as insincerity, see Ernst Bertram's suggestion that doctrines like the *Übermensch* and the eternal recurrence are 'great pedagogical lies in the mask of "absolute truths"' (*Nietzsche*, 151).

11. From Richard Moran, 'Problems of Sincerity', *Proceedings of the Aristotelian Society*, vol. 105, no. 1 (June 2005), 325–345, 343.

12. KSA 11: 452; BGE 40; BGE 194; BGE 230–231.

13. KSA 11: 248.

14. KSA 10: 13.

15. BGE 289.

16. BGE 5.

17. KSA 11: 559.

18. KSA 6: 136–140.

19. See WC 5, 8, 9, 12.

20. KSA 1: 521; *The Birth of Tragedy,* trans. Ronald Speirs (Cambridge: Cambridge University Press, 1999), Section 8 (henceforth 'BT').

21. *Human, All too Human,* trans. R. Hollingdale (Cambridge: Cambridge University Press, 1996), part I, sections 51–52 (henceforth 'HA').

22. See Diderot, *The Paradox of Acting,* trans. Walter Pollock (London: Chatto and Windus, 1883). For Diderot's claims in more detail, see T. Stern, *Philosophy and Theatre* (London: Routledge, 2013), 115–124.

23. GS 80.

24. See WC 8–9; KSA 13: 30–31, 209, 244.

25. KSA 13: 244.

26. Kleist, H. 'Über das Marionettentheater', in Siegfried Streller (ed.), *Werke und Briefe* (Berlin und Weimar: Aufbau-Verlag, 1978), vol. 3, 473–480.

27. BT 13.

28. Friedrich Nietzsche, *Daybreak*, trans. R. J. Hollingdale (Cambridge: Cambridge University Press, 1997), Section 324 (henceforth: 'D'). Nietzsche, here, is talking primarily about historical figures, so there would have been a real, inner experience.

29. D 306.

30. BGE 28.

31. See, for example, KSA 6: 122–123. On the general worry about the actor becoming the character, see Stern, *Philosophy and Theatre,* 116–117.

32. D 418.

33. GS 361.

34. GS 236.

35. *On the Genealogy of Morality*, trans. Carol Diethe (Cambridge: Cambridge University Press, 1997), second essay, section 7 (henceforth 'GM' followed by essay and section number). See also D 509.

36. HH I 51.

37. GM III 12.

38. KSA 13: 230.

39. BGE as a whole, it is worth saying, is characterized by a particular concern with protection against the impact on oneself of dealing with others. We find elsewhere, for example, a fear of letting others into our reasons and our thoughts and consequently the suggestion that we hide them (BGE 284).

40. BGE 27. The immediate reference, I take it, is to his use of Sanskrit – but it could be applied more broadly.

41. On the relative insignificance of conscious deliberation and rationality in philosophy, see BGE 3, 5.

42. I analyse Nietzsche's use of drives at length in Tom Stern, 'Against Nietzsche's "Theory" of the Drives', *Journal of the American Philosophical Association*, vol. 1, no. 1 (March 2015), 121–140.

43. See BGE 4, 11, 24, 25.

44. Joel Westerdale, *Nietzsche's Aphoristic Challenge* (Berlin: De Gruyter, 2013), 76.

45. See Tom Stern, 'The Problem with Nietzsche's Ethics of Affirmation', in Daniel Came (ed.), *Nietzche on Morality and the Affirmation of Life* (Oxford: Oxford University Press, forthcoming 2017).

46. See GS 344 and GM III.

BIBLIOGRAPHY

Works by Nietzsche

Beyond Good and Evil. Trans. W. Kaufmann in *Basic Writings of Nietzsche*. New York: The Modern Library, 2000 (henceforth 'BGE').
The Birth of Tragedy. Trans. Ronald Speirs. Cambridge: Cambridge University Press, 1999.
Daybreak. Trans. R. J. Hollingdale. Cambridge: Cambridge University Press, 1997.
The Gay Science. Trans. Josef Nauckhoff. Cambridge, UK: Cambridge University Press, 2001 ('GS').
Human, All too Human. Trans. R. J. Hollingdale. Cambridge: Cambridge University Press, 1996.
On the Genealogy of Morality. Trans. Carol Diethe. Cambridge: Cambridge University Press, 1997.
Sämtliche Werke, Kritische Studienausgabe in 15 Bänden. Ed. Giorgio Colli and Mazzino Montinari. Berlin: De Gruyter, 1999 ('KSA').

Works by other authors

Alderman, Harold. 'Nietzsche's Masks'. *International Philosophical Quarterly* 12, no. 3 (1972): 365–388.
Barish, Jonas. *The Antitheatrical Prejudice*. Berkeley, CA: University of California Press, 1985.
Bertram, Ernst. *Nietzsche: Versuch einer Mythologie*. Berlin: Georg Bondi, 1920.
Diderot, Denis. *The Paradox of Acting*. Trans. Walter Pollock. London: Chatto and Windus, 1883.
Geuss, Raymond. 'Introduction' to Friedrich Nietzsche. *The Birth of Tragedy*. Cambridge: Cambridge University Press, 1999.
Holbrook, Peter. 'Nietzsche's Shakespeare'. In *Shakespeare and Continental Philosophy*, edited by Jennifer Ann Bates and Richard Wilson. Edinburgh: Edinburgh University Press, 2014.
Kaufmann, Walter. *Basic Writings of Nietzsche*. New York: Modern library, 2000.
Kaufmann, Walter. *Existentialism from Dostoevsky to Sartre*. New York: Meridian, 1954.
Kleist, Heinrich von. 'Über das Marionettentheater'. In *Werke und Briefe*, edited by Siegfried Streller, vol. 3, 473–480. Berlin und Weimar: Aufbau-Verlag, 1978.
Kornhaber, David. 'The Philosopher, the Playwright, and the Actor: Friedrich Nietzsche and the Modern Drama's Concept of Performance'. *Theatre Journal* 64, no. 1 (2012): 25–40.
Lampert, Laurence. 'Nietzsche's Free Spirit Mask: Beyond Good and Evil'. *International Studies in Philosophy* 16, no. 2 (1986): 41–52.
Moran, Richard. 'Problems of Sincerity'. *Proceedings of the Aristotelian Society* 105, no. 1 (June 2005): 325–345.

Pippin, Robert B. 'Irony and Affirmation in Nietzsche's Thus Spoke Zarathustra'. In *Nietzsche's New Seas*, edited by Tracey Strong and Michael Gillespie, 45–74. Chicago: University of Chicago Press, 1988.

Puchner, Martin. *The Drama of Ideas: Platonic Provocations in Theater and Philosophy*. Oxford: Oxford University Press, 2010.

Sloterdijk, Peter. *Thinker on Stage: Nietzsche's Materialism*. Minneapolis: University of Minnesota Press, 1989.

Stern, Tom. 'Against Nietzsche's "Theory" of the Drives'. *Journal of the American Philosophical Association* 1, no. 01 (March 2015): 121–140.

Stern, Tom. *Philosophy and Theatre*. London: Routledge, 2014.

Stern, Tom. 'The Problem with Nietzsche's Ethics of Affirmation', in Daniel Came (ed.), *Nietzsche on Morality and the Affirmation of Life* (Oxford: Oxford University Press, forthcoming 2017).

Westerdale, Joel. *Nietzsche's Aphoristic Challenge*. Berlin: De Gruyter, 2013.

Chapter 5

The image and the act – Sartre on dramatic theatre

Lior Levy

Jean-Paul Sartre's contribution to theatre was both concrete – he wrote about a dozen plays and was often involved in their production – and theoretical – he used examples from the theatre to illuminate philosophical problems in his philosophical works, among them *Being and Nothingness* (1943) and *The Imaginary* (1940), and wrote and lectured on philosophical issues in theatre throughout his life. Thus, his work provides a unique opportunity for exploring the connections between philosophy and theatre. While numerous studies examine the relationship between his drama and philosophy, asking, for example, in what ways do his plays offer concrete examples of philosophical notions such as *the look* or *bad faith*,[1] few works offer a sustained account of his philosophy of theatre.[2] As a result, the numerous texts, lectures and interviews wherein he discusses theatre remain, for the most part, unexplored. Furthermore, his philosophical studies of imagination, embodiment and action, though naturally lending themselves to analyses of acting and spectatorship, are rarely used for such purposes.

In what follows, I build on these works to develop an account of Sartre's notion of dramatic theatre. His vision of dramatic theatre entails a certain conception of the nature and function of plays, acting and spectatorship. This chapter will focus on acting, through which the notion of action that is crucial to his conception of dramatic theatre will be clarified. However, since actors enact texts before spectators, it is nearly impossible to analyse acting without taking texts, on the one hand, and spectators, on the other hand, into account. For this reason, I will also discuss the ways in which actors and spectators utilize and understand dramatic texts, and will touch upon spectators' experience of the enactment of texts in the theatre.

In a lecture given at the Sorbonne in 1960, Sartre, who was already renowned as both a philosopher and a playwright, presented his conception

of theatre to an audience consisting of members of the Paris Students Drama Association. In the lecture, titled 'Epic Theater and Dramatic Theater', he outlined his conception of dramatic theatre. Theatre and action, he argued, are intimately related; actions both constitute the theatrical event and are reflected in it. By suggesting that theatre must be understood through its relation to action, Sartre echoed Aristotle's claim in the *Poetics* that action is central to drama.[3] Expanding this claim, he maintained, 'If you want to know what theater is, you must ask yourself what an act is, because theater represents the act and can represent nothing but the act . . . what we want to rediscover when we go to the theater is naturally ourselves, not ourselves as we are . . . but ourselves as we act'.[4]

Theatre represents action, not characters or types. Two types of action are implicated in the quote above: first, *ordinary, non-theatrical actions*, which spectators 'rediscover' in the theatre; second, *theatrical actions*, which depict the former, ordinary actions. Within the second type we can distinguish *dramatic actions* – those that characters perform in plays (the theatre that Sartre has in mind involves texts or plays) and *acting* itself – the enactment of the drama by actors. We can discern, therefore, three levels of action in the theatre: ordinary action, which dramatic action represents and actors enact. To give a somewhat crude example, when Estelle seduces Garcin in *No Exit*, the dramatic action is her seduction. This action is carried out or portrayed through the performance of flirtatious acts by the actors. And, finally, according to Sartre these two levels of action reveal something about ordinary seductive acts that human beings undertake in the world, towards others.

Theatre differs from other art forms because in it action is the medium for representing action.[5] Other arts can represent action too: we read of Raskolnikov's murderous act in *Crime and Punishment*, see the athlete throwing a discus in the Greek sculpture of the *Discobolus* or see the Achaeans fighting in the Trojan war in Cy Twombly's *Achaeans in Battle*. However, in the novel, sculpture and painting, language, stone and colour, respectively, represent action. In theatre, on the other hand, action is, or at the very least can be, represented by action, enacted by actors.[6] Of course, dramatic actions can be enacted by actions that do not resemble them. For instance, seduction can be represented by a dance, or an act of hanging certain items on a wall. It can also be represented by other means, by music or lights for example. Sartre's point is, then, the representation of action by action is possible in the theatre, whereas it is not in other arts.[7]

Because of the unity between content and form, Sartre determines that 'there is no image in the theater except the image of the act'.[8] Consequently, we must ask, what kind of image is involved in the theatre and how does it appear? And, moreover, what is the nature of the relationship between

image and act? In what follows, I explain what Sartre means by each of these terms, how he thinks the two come into contact in the theatre, and, finally, show how this shapes his understanding of dramatic theatre. The 'Sartre on images' and 'Image and analogue on in the theatre' sections treat Sartre's theory of the image and theatrical images in particular. The 'Acts' section turns to the work of the actor: it is through the actor that images materialize in the theatre. The figure of the actor, then, allows us to move towards an exploration of the intersection between image and action. The last section of this chapter ('Theatrical acts') focuses on theatrical actions. The account in these two sections aims to show how the creation of images of action, which materialize through the actor's work, enables us to rediscover in the theatre 'ourselves as we act'.

SARTRE ON IMAGES

In *The Imaginary*, where Sartre develops a phenomenology of aesthetic experiences, he distinguishes real, material objects that are given to perception from works of art as 'irreal' objects, which are disclosed or better put, constituted, by imagination: 'The photo, taken in itself, is a thing: I can determine from its color the duration of its exposure, the products used to tone it and fix it, etc.'[9] The photo has perceptible properties – size, weight, colour, shape – of which 'we can take measurements'.[10] But it is also a photograph *of* someone. In Sartre's example the photograph shows his friend Pierre, who is not there. Whereas the photograph is inanimate, flat and glossy, Pierre is a living human being. The properties that the photograph possess do not apply to Pierre, who himself possesses properties that are inapplicable to the photograph. The photograph, or more generally the artwork as a material object, is an 'analogical *representative*'.[11] The analogue represents or depicts something other than itself – Pierre, for example. It represents by virtue of analogy, by virtue of its resemblance to the thing depicted. Yet whereas analogues are present as real, material things, the things they represent are absent. When the artwork as thing is apprehended with the imaginative attitude (or imagining consciousness), we cease paying attention to its material or actual properties (those that can be measured). We then go beyond the object's materiality, its concreteness, to the absent, hence imaginary, object. Properly speaking, a work of art resides beyond what is perceptually given; it is an object of a different order – absent, non-existent or unreal.[12] To have an image means to transcend the actual, material world towards what is principally absent, for example, my friend Pierre, Degas' dancers or the characters in Sartre's plays. When consciousness transcends reality in such a way, and it does so

frequently, effortlessly and spontaneously, it comes into contact with imaginary objects, with the 'image', which Sartre describes as part of 'a perpetual elsewhere, a perpetual absence'.[13]

Imagination discloses consciousness's ability to withdraw from the real or annihilate it. Raskolnikov is not a real human being, whose existence is individualized by actual properties. Yet he is present as such to anyone reading *Crime and Punishment*. Imagination enables humans to come into contact with absence or unreality in an intuitive manner, that is, to stand in the presence of absence.[14] For this reason, imagination is emblematic of consciousness's ability 'to escape from the world by its very nature . . . stand back from the world by its own efforts'.[15] In other words, imagination manifests human freedom most clearly, since its acts of withdrawal or negation demonstrate that consciousness is not bound or determined by the world (and what is perceptually given in it).

Yet, isn't the imagining consciousness determined by the world? Isn't it bound to imagine according to the features of the material object, the analogical representative? After all, I imagine Pierre rather than Marie because the photograph depicts and so resembles the former and not the latter. The material features of the object seem to direct the imagining consciousness and invite it to imagine the absent thing on its own terms. The analogue possesses an efficacy; it 'acts upon us . . . it solicits us'.[16] Certain objects exert force on us and solicit us to apprehend the world according to their features. Moreover, as Sartre admits, cultural sensibilities that are shaped by historical and material conditions also inform our possibilities of imagining. Our imagination is often determined by the social imaginary.[17] In this respect, consciousness does not seem entirely free to imagine.

Sartre, however, does not think of these facts as obstacles to the freedom of imagining consciousness. With regard to the first objection, that resemblance between the analogue and the imagined object determines what we imagine, he argues that resemblance is a feature that consciousness establishes between things, which themselves lack such a relationship. Consciousness determines what counts as resemblance in the first place and therefore the relationship between analogue (the photograph of Pierre) and image (our representation of the absent object) is determined by consciousness rather than determining it. This insight enables him to answer the second challenge as well. Even when culture limits or restricts our ways of imagining, the imaginative person is able to constitute connections (between analogues and imaginary objects) where none are said to exist; he or she is able to see beyond the limits of sense or meaning delineated by his or her culture and tradition. In this respect, in imagining, he or she transforms the world, sees it anew and sees new things through it. The imaginative person is always, in this sense, free.[18]

IMAGE AND ANALOGUE ON IN THE THEATRE

Theatrical images differ from the other images that Sartre studied. The majority of examples in *The Imaginary* are drawn from literature and the visual arts, where the real can easily be demarcated from the irreal, and analogues can be distinguished from imaginary, absent objects: Emma Bovary is qualitatively different from the signs on the page in *Madame Bovary*; Pierre is unlike the flat, black and white photograph. Actors, however, do not differ in the same way from the agents that they play. In the theatrical performances that Sartre refers to, both actors and characters are human beings. It seems as though the words, gestures and feelings of the actor are precisely those of the character and vice versa. The melancholy of Hamlet determines the actor's performance, just as the specific nature of an actor's performance influences the particular Hamlet (irritable, depressive, or torpid, etc.), who is brought to life. In this respect, image and analogue, actor and character seem to converge in the theatre. The character *is*, in a sense, the person that we see before us on stage, and the actor is the character that he or she performs while he or she acts.

This affinity led philosophers to argue that the gap between actor and character is indeed minimal or even non-existent. In Plato's *Ion*, for example, Socrates asks Ion, who performs Homer's poetry: 'Do you get beside yourself? And doesn't your soul . . . believe that it is present at the actions you describe, whether they're in Ithaca or Troy . . . ?' To this Ion replies: 'When *I* tell a sad story, my eyes are full of tears; and when I tell a story that's frightening or awful, my hair stands on end with fear and my heart jumps'.[19] Ion is literally out of his mind and *in* the mind of another – in the character that he plays. Thus, performer or actor experiences a total unity between self and role. The audience too is infected by this identification. Their response reveals that they do not distinguish the performer from the character that he or she plays. This view is not confined to the ancient world. Brecht also described, and consequently rejected, certain forms of acting as 'hypnosis' by which actors 'go into a trance and take the audience with them'.[20] According to his account of this state of hypnosis, actor and spectator alike feel that they are in the presence of the character; the former achieves total unity with the fictional character by acting; the latter is convinced that the actor is indeed the person that he or she plays.[21]

Unlike Plato's view of ancient drama and Brecht's description of acting methods used in bourgeois theatre, Sartre holds that acting never collapses the distinction between actor and character. He applies the analogues-images distinction to the theatre as well and argues that actors and spectators alike maintain this distinction. 'Kean is not Hamlet, and he knows it and knows that we know it', he says.[22] Both actors' and spectators' experiences reveal

that the boundaries between actor and character are not blurred. In fact, the very intelligibility of theatrical events rests on this distinction. The actor's performance as Hamlet is motivated by his awareness of the fact that he *is not* Hamlet. The gestures that he labours to acquire in rehearsals, his use of props and make-up are attempts to become Hamlet, but these attempts make sense only in light of his awareness of not being him. Sartre finds support for this claim not only in the actor's own experience – after all, actors could prepare or practise for going into a trance, during which they do not know how they are – but in the audience's experience of a piece of acting, or, better, in the relationship between actors and spectators. After all, acting is a relational activity, done for and before others. Going to the theatre, we are excited to see, for example, Helen Mirren as Phèdre or Kenneth Branagh as Richard the Third. We are excited and enjoy their acting also because we know that they – the actors – know that they are not the characters. Indeed, our enjoyment of a performance as performance hinges on our awareness of the actors' awareness of the difference between them and the characters. Returning to Sartre's example, if spectators believed Kean was Hamlet, they would not have appreciated him as a fine actor, but would have rather judged him as the actual prince (e.g., as we judge the actions of the current prime minister). And if spectators believed that Kean thinks he is Hamlet, then again they would not have admired his acting, but would have rather pitied him for being insane or delusional. According to Sartre, actors are aware of being grasped as other or different from the characters that they play. Furthermore, they are aware of the fact that the appreciation of their acting hinges on the audience knowing that they (the actors) know, at least on some level, that they are different from the characters.

Plato of course would say that the audience does not enjoy acting itself, but that they are actually transported to the scene that the acting depicts; audience, together with the actor, forget who they are and have the same experience they would have in the presence of an actual Hamlet. Sartre, who is a phenomenologist and wishes to capture the features of theatrical experience itself, in its immediacy, from the first-person perspective, thinks that this line of thinking misses the kind of enjoyment that we experience in the theatre. What we enjoy when we enjoy acting is seeing Helen Mirren *as* Phèdre or seeing Kean *as* Hamlet. When only the former or the latter of the two appears, we may still experience enjoyment, but it won't be enjoyment from acting per se. Though we may experience excitement at the sight of a certain celebrity in the theatre, or, alternatively may forget the world while absorbed in reading Racine's *Phèdre* and enjoy this forgetfulness, these kinds of enjoyments are not akin to the enjoyment *from acting*. This particular kind of enjoyment stems from the appreciation of the actor's ability to solicit or provoke a character from whom he or she differs. And this enjoyment requires that we

remain aware of the existence of these two entities – real actors and imaginary characters – as distinguished, on some level, from one another.

Building on his phenomenological account of the spectators' experience, Sartre maintains that actors are distinguished from characters. Actors, as analogues, are present. Characters remain absent as images. The character does not fully materialize in the actor or coincide with him or her; it is present as absent to the actor and the spectators alike. From the perspective of the actor, acting is the embodied awareness of the otherness of the character and a manifestation of an inability to merge with it. From the perspective of the spectator, theatrical appreciation, most notably the judgement that the actor succeeded or failed in depicting the character, has its roots in the awareness of the distinction between the actor-analogue and character image. In other words, when we say that Kean failed or succeeded in portraying Hamlet, we mean that we were able to see the actor as more than himself or herself, we were in the presence of someone else, someone whom we know is different from the actor; someone who is perhaps utterly fictional. We are not only retroactively aware of the two – actors and characters – as separate from each other. While watching, we are aware of the existence of two separate entities – character and actor (one imaginary, the other real) – and perceive the former through the latter, if the acting is skillful. Neither actors nor spectators enter into trance and forget who and where they are.[23]

Yet, Sartre admits that actors are not ordinary analogical objects and that the relationship between analogues and images in the theatre is complex:

> The actor is not just a lump of inorganic matter which has absorbed human work, but a living and thinking man whose immersion in unreality is an unpredictable blend of rehearsal and invention each night, in which at worst he comes close to being an automaton and at the best transcends the habits he has contracted in 'trying out' an effect.[24]

Actors are not indifferent to characters as blocks of marble or texts are to the imaginary entities that they evoke. Actors labour to evoke particular images. They try out different ways of pronouncing the text, change their postures, train their body and so on. These practices are related to their desire to evoke specific characters and to their awareness of being seen as these characters by other people in the audience (a desire and an awareness that other analogues do not share). Furthermore, actors' performances occur not only *before* but also *for* others. In one sense, this seems to imply, as Brecht suggests, that actors try to persuade the audience that they are the characters, a task that can be achieved only when the actors believe in this fact. More recently, Tzachi Zamir argued along these lines, saying that acting implies 'surrendering to the character'.[25] And even Tony Fisher, who rightly points out that according

to Sartre actors are aware of the theatricality of their actions, maintains that actors believe that they are who they are not (the character).[26] According to Sartre, however, actors cannot surrender to the character or believe that they are identical to them, because the actors are aware that the characters do not exist except as an unrealizable ideal. The character functions as a horizon that frames the actor's actions; it serves as an ideal towards which the actor's actions aim.

Actors are both makers and products, both active creators and the object created. The matter in which they work is themselves: they 'chisel' a certain gait onto their own bodies, manipulate their own voices and reshape their faces, language and gestures. These processes of self-fashioning happen in and over time. Actors are not static analogues like paintings or sculptures. They are dynamic – their actions unfold over time, are articulated and experienced differently at different moments and change from one performance to another. This adds an element of unpredictability to actors' work – each performance is shaped by a variety of factors, such as the feel of one's body, the audience's reaction and interactions with other actors. Actors are not self-identical analogues, but fluid and changing ones. They can try to control part of these changes, for example, by repeating the movements until they become habitual and automatic. This, however, will damage the performance, which may then seem mechanical and overly scripted. An example for this can be easily found in children's theatre, where, because of the specific psychology of its audience, actors must remain extremely aware of spectators' reactions and moods. In children's theatre it is particularly clear when actors simply run through a fixed performance without trying to engage their audience and address or respond to their particular responses. In those cases, the performance itself will suffer by losing the interest of the spectators.

Sartre's comment reminds us that certain aspects of the performances are never under the control of the actor. Pains and aches that the actor happens to experience or coughs and noises that the audience makes are examples of such unpredictable and uncontrollable elements in a performance. And, though he does not discuss this directly, it is clear that the temporality of performances differentiates actors from other analogues in yet another respect: whereas painted, sculptured and written analogues stand, once completed, as objects against their creators, the actor-analogue never exists independently of the process of acting that brings it into being. Once actors stop acting, the analogues no longer exist. Yet the performance is given in its entirety only once the actors ceased acting. In other words, it takes the duration of the entire play for the analogue to be fully constituted and in this sense its appearance is inherently connected to its disappearance.

Finally, the relationship between analogues and images is complicated by the fact that it is duplicated in the theatre. The reader faces an analogue,

a text, through which an image, a fictional world, is evoked. In the theatre, actors use texts or dramatic situations as analogues through which they create an image, that of the character that they will enact. Actors themselves then function as analogues for the spectators' imagination, which will accordingly constitute the image of Hamlet, Antigone or Estragon. One analogue – a play, text or dramatic situation – is given through the mediation of another – the actor. And through the superimposition of both the image is constituted in the theatre.

Since actors are living human beings and not just inert, inorganic 'stuff', they actively participate in the constitution of the image – their actions aim at absent characters that they imagine through the play. At the same time, actors offer their performances to spectators, who imagine an absent character through or beyond the present actors. Sartre referred to the active participation of spectators in the constitution of images while discussing the reception and interpretation of his own plays. 'The theater is so much of a *public interest, the interest of the public,* that a play is out of the author's hands once the public enters the theater'.[27] Extrapolating from this remark on the relationship between playwrights and audiences, we see that actors too do not have complete control over the image that spectators constitute.[28]

The interaction between actors' and spectators' imaginations, their joint participation in the constitution of images, makes theatre an inherently democratic art.[29] It also renders theatrical images inherently unstable: it causes them to differ from one performance to another, remaining unpredictable and surprising. Theatrical images embody the freedom, and thus the unpredictability, of the practices of imagination that create them. Referring to the theatre as a public art form, Sartre calls to mind the participatory nature of theatrical events. He also reminds us that the creation of images in the theatre, through the joint efforts of actors and spectators, puts the imagination to work and manifests it. Actors utilize themselves to call or summon absent characters. For that purpose they challenge their bodies, voices, speech and gestures. Yet actors only offer analogues that evoke characters, and it is through such analogues that spectators must in turn create images. Thus, theatre demands the participation of spectators and refuses to assign them the role of passive consumers.[30]

ACTS

In theatre actions both constitute the image (through the creation of analogues) and are reflected in it (the audience imagines agents, characters as acting). We began characterizing theatrical action in the previous section. This kind of action, we saw, attempts to evoke an imaginary action of a

character, and the agent who performs it is aware of his actions as being different from the actions that its summons or evokes. In this sense, theatrical action involves pretence, though one that does not wish to cover up the distinction between the real and fictional.[31] We will now turn to Sartre's notion of action. By examining the type of behaviours that he thinks truly deserve the name action, we will be in a position to understand how theatrical actions differ from, but also relate to, ordinary actions. These points are crucial, since according to Sartre the aim of theatrical actions is to enable the audience to rediscover their own actions or rediscover themselves as agents.

Genuine action, according to Sartre, is always (1) intentional and (2) free.[32] Only something done with the intention of achieving an end is an action. So unintentional human behaviours are not actions, even if they attain some end. In *Being and Nothingness*, Sartre demarcates actions from unintentional bodily behaviours: 'The careless smoker who has through negligence caused the explosion of a powder magazine has not *acted*'.[33] The smoker did not intend this result, and his or her careless gesture is not properly called an action. On the other hand, were he or she to intend this result, but fail to achieve it, he or she would still be acting. Intention is not tantamount to success in attaining the desired goal. Furthermore, intention does not need to be explicit; an agent need not possess full and explicit knowledge of his or her intentions. At the same time, one does not have an intention without being conscious of it; Sartre stresses that being conscious of X does not always mean knowing X.[34]

Next, because action necessarily implies intention, it is free.[35] This is since action, as a purposive behaviour aimed at a desired end, requires awareness of a present lack or deficiency. A worker who revolts against the working conditions 'must posit an ideal state of affairs as a pure *present* nothingness; on the other hand, he must posit the actual situation as nothingness in relation to this state of affairs' (BN, 562). Revolt, for instance, is an intentional act that aims at the foundation of an egalitarian society. On the one hand, the revolutionary act negates a present state of affairs, thus presupposing that the agent grasps it as inadequate or lacking. On the other hand, the agent perceives the present as lacking precisely with regard to some absent or (currently) non-existent state, which he or she desires. Here as elsewhere in *Being and Nothingness* negation or nihilation is connected with freedom. As we saw in the previous sections, Sartre thinks that human existence is not bound by the real or confined to the present. One way of surpassing reality is by imagining; for example, when in reading we imagine a non-existent world through the signs on the page. Acting is another way of surpassing the given conditions. Action manifests freedom and expresses the irreducibility of human consciousness to being.

'To act', says Sartre, 'is to modify the *shape* of the world'.[36] There is a trivial sense in which this statement is true: action reconfigures the world, by

changing the arrangements of things in it – workers protesting their conditions burn a factory; a surgeon transplants a new heart in her patient. However, action also modifies the world in a non-trivial sense, since in intending the absent and negating the present, it introduces new meaning into the world. For this reason, Sartre does not focus on action as a modification of the contents of the world, but as a modification of its form; it modifies the world in the sense that it introduces a different structure of intelligibility.

Contents belong to what Sartre calls *facticity*. An agent, a human being 'appears in a condition which it has not chosen, as Pierre is a French bourgeois in 1942, as Schmitt *was* a Berlin worker in 1870'.[37] The factical dimensions of existence are those that were given to us: the language, body, time and place in which we find ourselves. Facticity limits our possibilities – I cannot be an abolitionist in the Americas, just as the abolitionist could not have been a senator in the Roman Empire. Because of this, certain actions are unavailable to us. Thus, Sartre says that facticity 'can from the start limit our freedom of action'.[38]

However, Sartre emphasizes that both limits and possibilities appear *as such* in light of human values, plans and intentions, so that there is a sense in which humans determine the conditions, which in turn determine them and their actions. We comprehend a given state of affairs as grounds for action, that is, as a situation demanding a certain response because we grasp it relative to our ends, our desired goals. Hence, 'it is our freedom itself which must first constitute the framework, the technique, and the ends in relation to which they will manifest themselves as limits'.[39] In other words, even brute facts are not pure givens, but rather something that humans interpret and endow with meaning.[40] Hence, humans impose structures of intelligibility on the world, through which things appear as unalterable facts, or, alternately as opportunities for change through action.

Actions, therefore, always manifest freedom. But every concrete action, like helping a stranger or alternatively ignoring a plea for help, expresses deeper commitments to what Sartre calls in *Being and Nothingness* original project or original choice. Originality here neither means that the choice is anterior nor that it is more genuine, or authentic than other false or dishonest projects or choices (e.g., lying to oneself or to others). In fact, the original choice was never really chosen, if by choice we mean picking between two or more possibilities. This choice does not involve deliberation, and it cannot be located at a specific time and place. Sartre says that it is a 'projection of myself . . . toward an original possibility'.[41] Let us look at this notion more closely.

Having a project means acting in a certain way, projecting myself towards a possible way of being, as Sartre says. The term 'acting' is appropriate, since the project meets the dual criteria for action: it is intentional, that is, it aims

towards an end – an original possibility of being a particular self – and it is free – it is not determined by prior beliefs, values and reason, since it is the very framework in which all beliefs, values and reasons acquire meaning and are determined as such. However, whereas ordinary actions have particular state of affairs as their desired ends, the project is not aimed at specific results. Unlike particular actions through which concrete possibilities materialize – for example, concrete acts of protest which constitute an equal society – the project is a way of facing possibility as such. The project is an act directed towards being or existing, which in principle cannot be actualized, or can become actual only when it no longer is. On this point, Sartre quotes Sophocles's *Women of Trachis*: 'One cannot pass judgment on the life of mortals and say if it has been happy or unhappy, until their death'.[42] The original project or choice is the ongoing activity through which one becomes someone; it is an act that takes an entire life to be completed. Because of this, the project as a whole is not something that can be known or grasped as an object. Instead, it must be lived: 'Our further freedom (i.e. the project), inasmuch as it is not our actual possibility but the foundation of possibilities which we are not yet, constitutes as a sort of opacity in full translucency. . . . Hence this necessity *to wait for ourselves*'.[43] We wait for ourselves, since we only become who we *are*, possessing a nature, coinciding with ourselves, once we are *no longer*.

THEATRICAL ACTS

Since in Sartre's conception of theatre scripts are the foundation for the actions of actors, it is unclear that acting can genuinely be considered a type of action. Genuine action must be free; however, actors, it seems, are not free in this sense. Whereas outside the theatre one can choose whether to go into exile, the actor who is acting Oedipus has no such choice. According to Sartre this does not impinge the freedom of the actor. Just as ordinary actions encounter the factical dimensions of existence as limits that they transcend, so theatrical actions use the script as facts that are interpreted and gain meaning through acting. In itself, the script includes universal, linguistic signs; we cannot find in them the particular actions that individual agents perform: 'To be or not to be. Who is asking the question? Anyone, if we are to go by the words alone'.[44] Acting is just an attempt to '*singularize* the soliloquy'.[45]

Theatrical actions are freely chosen and aim at bringing desired ends into fruition. The end, Sartre says in his example, is to singularize the soliloquy. In other words, the actions that an actor performs are intended at the creation of an image, of a particular Hamlet or Antigone, for instance. Acting aims at evoking a particular way of being Hamlet. Obviously, an actor singularizes the soliloquy first and foremost because he or she, a particular human being with

particular voice and intonation, is uttering the text. Indeed, as Tony Fisher argues, actors harness and utilize their own facticity for the presentation of the image.[46] Similarly, Sartre observes in his study of acting that 'when Kean walks the boards at Drury Lane, he gives Hamlet his (i.e., Kean's) gait'.[47] Hamlet, according to him, borrows or is infected by Kean's gait. The actor endows the character with material specificity, particularizing it.

This, however, cannot be the only sense in which acting singularizes a text. Acting involves negotiating and subverting one's own facticity. Recall that according to Sartre if spectators only see individuals qua individuals (and not qua actors) speaking the lines, then the performance is unsuccessful. In such a case, spectators and actors do not manage to transcend the real in favour of the imaginary. Actors are successful in evoking the character, that is, in making it concrete, only if they negate their own particularity, and if they enable spectators to transcend their (the actors') actual presence. The successful actor keeps the audience 'absorbed into the prince of Elsinore's gait as he strolls about soliloquizing'.[48]

Furthermore, we should not take Sartre to mean that the purpose of theatrical action is the representation of any particular action – for example, killing Polonius or instructing the actors. It is true that many particular actions are enacted onstage, but these actions are in turn taken for a specific purpose or aim: conjuring a particular fictional character, or, in Sartre's terms, conjuring an image. Actors act in order to evoke an image of a particular character – a Hamlet or a Medea. Their actions harness the materiality of their bodies, gaits and voices, in order to present themselves as analogues for specific characters. The specificity of the character that we imagine hinges on the acts that the actor performs; the actions of the actor guide our imagination and direct it towards a specific Hamlet: a melancholic, anxious or spoilt Hamlet. Acting aims to create an image of Hamlet; that is to say, it invites spectators to imagine a specific way of being Hamlet.

Being someone, for Sartre, means engaging in a particular project. And so we see that the actions that actors perform are employed for the purpose of revealing a specific project – the fictional project of the character – that renders these concrete actions meaningful. The character's project justifies or grounds the actions that actors make in an attempt to direct our imagination. In singularizing the soliloquy an actor freely chooses a way of attaining a goal. The goal, as we said, is the creation of an image. Yet, the image itself is an image of an act, Sartre says. Returning to Hamlet as an example, we can see now that the actor aims at Hamlet as a way of being, or aims at a way of being Hamlet. What the actor's acts aim at, in other words, is an original choice: a fictional choice of being (Hamlet's or Antigone's for instance). Such a choice involves a projection of oneself towards a particular way of being. Since there are many ways of being Hamlet, we accept different

performances of Hamlet as successful. Different actors can evoke different Hamlets, and because Hamlet himself is not a stable character but a way of being, even the same actor can evoke different Hamlets at different times.

An actor's action, then, is similar to the action that unifies our lives, the project through which we become particular human beings. The original project eludes the agent himself or herself, who, while living, can never understand it in its totality. The project is not available to one's conscious grasp; it cannot be turned into an object of knowledge. In his 1960 lecture on the theatre Sartre expresses this point exactly by saying, 'Men cannot see themselves from outside, and the real reason is that in order really to understand a man as an object, it would be necessary – simultaneously and contradictorily – to understand and not to understand his ends, his purposes'.[49] Put differently, to fully understand a human – grasp him or her as an object – means to lose him or her as a person. Instead of understanding one's being, one's personhood, one must live it.

The theatre is the place where we confront both the impossibility of knowing the project and the necessity of living it, of acting it out. The actor's acts aim towards Hamlet as a way of being. Yet, his action builds on the tension between the real and the imaginary. Instead of concealing or collapsing the two, acting exploits the difference between them. In the theatre, action explicitly aims towards being as an unrealizable ideal. In *Hamlet*, for example, every particular action that the actor performs – for example, raising a dagger, holding a skull – aims to evoke an absent Danish prince. Since the actor's success depends on his or her ability to maintain the tension between the image and the real, his or her actions call to mind the principle impossibility of making being (being someone) completely explicit. In other words, actors both evoke an image – a particular way of being someone – and point to the inability of making this image coincide with the real or collapse into it.

Because the project is inaccessible as an object of knowledge, because we cannot cognize it, we can only confront it existentially, choosing who we are through action. Outside the theatre, this is often a difficult task. Indeed, it is a task that we often prefer to ignore altogether. We often focus on or even obsess over specific actions in an attempt to forget or evade the broader framework, the fundamental project that endows these actions with meaning. Moreover, when we think of our life as a whole, of who we are, we often think of our existence in terms of being. Put differently, we hide the activity through which we become who we are, an activity grounded in freedom, behind a façade of a stable and fixed personhood or self. In *The Transcendence of the Ego* (1937) Sartre addresses this tendency, articulating the mechanisms that govern our habit of speaking of our cowardice, generosity or shyness, for example, as a psychological foundation or fixed character trait that inevitably leads us to perform cowardly, generous or shy acts.

Our cowardly acts congeal into an image of 'the coward', an image with which future action, emotions and thoughts aim to coincide. In the *Transcendence of the Ego* Sartre suggests that we learn to see our behaviour as 'sheer performance', instead of narrowing down our sense of agency by collapsing the difference between the image and our acts, thinking that our acts are determined by a certain psychic structure.[50] His choice of words does not seem accidental. As we saw, everyday actions always aim towards something absent, and our ultimate action, our project, aims towards an imaginary ideal. In acting, we aim towards a certain way of being; we act in order to be someone (generous, jealous, timid). But rather than remaining aware of the distinction between our actions and the character that we aim to create through them – a distinction that actors practise on stage – we collapse this distinction. We tell ourselves that our actions are governed by and grounded in our personality or specific character traits. We forget that our actions are grounded only in freedom. The self – which is really only an ideal, an imaginary construct – puts us under its spell. We treat it as a real entity, think of it as a psychological core that determines and binds our actions.[51]

At this point, it becomes clear that Sartre thinks that theatre plays a special role in our lives. It is not 'merely' a form of entertainment, but neither does its value reside in educating us or cultivating our emotions. Instead, theatre is a means for self-discovery, a place where we can 'rediscover ... ourselves as we act'.[52] Watching actors perform, we witness their actions as the foundation for the creation of an ideal – a character that is present only as an image. Actors aim at offering ways of being other than themselves. Furthermore, they explore ways of being other, for through acting they constitute a particular character (the melancholic or the petulant Hamlet). Acting is a way of evoking characters that are present only as images, that is, as absent ideals with which actors never fully coincide. What we see in the theatre, through the work of the actors, is *action* as grounding *being*, rather than the other way around. In other words, theatre helps us regain an understanding of the freedom that grounds our agency. 'Image' and 'action', the two terms with which Sartre frames his vision for the theatre, highlight its role as an art form that is dedicated to exploring and representing existence as an ongoing activity. It is, in this sense, devoted to the drama of existence.

NOTES

1. C. R. Bukala, 'Sartre's "Kean": The Drama of Consciousness', *Review of Existential Psychology and Psychiatry*, vol. 12, no. 1 (1974), 57–70; B. O'Donohoe, *Sartre's Theatre: Act for Life* (Bern: Peter Lang, 2005); J. Ekberg, 'Representation and Ontological Self-Knowledge in Sartre's Drama', *Sartre Studies International*,

vol. 17, no. 1 (2011), 75–92; M. Puchner, *The Drama of Ideas* (Oxford: Oxford University Press, 2014). Puchner explores some philosophical themes that underlie Sartre's drama, but also finds dramatic scenes in his philosophical works, focusing mainly on examples of bad faith in *Being and Nothingness*.

2. Two notable examples are T. Fisher, 'Bad Faith and the Actor', *Sartre Studies International*, vol. 15, no. 1 (2009), 74–91 and A. Van Den Hoven, 'Sartre's Conception of Theater – Theory and Practice', *Sartre Studies International,* vol. 18, no. 2 (2012), 59–71. Van Den Hoven offers a short analysis of Sartre's conception of theatre before turning to examine the philosophical import of his dramatic works. To the best of my knowledge, Fisher is the first to reconstruct Sartre's theory of acting. He approaches the question of acting through the prism of bad faith. My own interpretation is deeply indebted to Fisher's, though I focus more closely on the structures of theatrical and non-theatrical actions and the relationship between them.

3. Aristotle reminds his readers that the term 'drama' come from the Doric verb *drao*, which means 'to act'. Aristotle, *Poetics* 3, 1448 b1.

4. J. P. Sartre, *Sartre on Theater*, ed. M. Contat and M. Rybalka and trans. F. Jellinek (New York: Pantheon Books, 1976), 91.

5. Sartre distinguishes film from theatre on this ground. See: Sartre, *Sartre on Theater*, 102.

6. Dance seems closest to theatre, for it presents human beings engaging in an activity, that of dancing. However, as Alan Badiou recently noted, in dance the body is presented 'from the interior of its own movement'. A. Badiou, *In Praise of Theater*, trans. A. Bielski (Cambridge: Polity Press, 2015), 48. In other words, the dancing body represents the limits and possibilities of person's body, not his or her agency.

7. I thank Tom Stern for helping me clarify this point.

8. Sartre, *Sartre on Theater*, 91.

9. J. P. Sartre, *The Imaginary*, trans. J. Webber (London and New York: Routledge, 2004), 18.

10. J. P. Sartre, *We Only Have This Life to Live*, ed. R. Aronson and A. Van Den Hoven (New York: New York Review of Books, 2013), 191.

11. Sartre, *The Imaginary*, 20. Original emphasis.

12. 'The work of art is an irreality'. Sartre, *The Imaginary*, 188.

13. Sartre, *The Imaginary*, 193.

14. This point is made to distinguish imagining from thinking. In imagining the object appears as a particular thing, given immediately, all in one stroke. Thought, on the contrary, mediates objects by ideas or concepts; hence, in thinking objects are not immediately present to consciousness. Sartre, *The Imaginary*, 8–11.

15. Sartre, *The Imaginary*, 184.

16. Sartre, *The Imaginary*, 22.

17. Later in his philosophical career Sartre emphasized the historical and material conditions that underlie imagination. In the first volume of *The Family Idiot*, Sartre's philosophical biography of Flaubert, he discusses imagination again and, giving a marble sculpture of Venus as an example, says: 'Here the being is the practico-inert aspect of the imaginary, something impenetrable, semi-enclosed, and universally recognized, a piece of merchandise with a *determined* and fixed outlet in its midst,

a function, value, and demand'. The sculpture is invested with social and cultural meanings, which reify the image that it evokes. Placed in the museum, with an informative plank next to it, the thing to be imagined through the sculpture is 'universally recognized'. In other words, cultural conventions direct our imagination and limit its possibilities. Though he admits that imagination is determined, he remains critical of the processes of reification and commodification that limit and confine it. His position invites us to think of ways of imagining beyond, or not in complicity with social conventions and trends. See: Sartre, *Sartre on Theater*, 167.

18. This feature of imagination is crucial for its consequences outside the domain of aesthetics. The ability to envision the world anew, imagine a different future, hope and act for the attainment of conditions that may seem entirely unattainable is crucial for political action. Revolutions and political acts of all sorts require the ability to move beyond the existing conditions; they require the freedom of imagination. No resemblance holds between the 'analogue' and the imagined thing in this sort of imagining. Crushed by the material circumstances, the people protesting during the Arab Spring were moved to action because they could imagine something that resided beyond their immediate material, social and cultural possibilities.

19. Plato, *Two Comic Dialogues*, trans. P. Woodruff (Indianapolis: Hackett Publishing Company, 1983), 27.

20. Brecht criticized this approach to acting: 'There is, however, a complete fusion of the actor with his role which leads to his making the character seem so natural so impossible to conceive any other way, that the audience has simply to accept it as it stands'. J. Willett (ed.), *Brecht on Theatre* (New York: Hill and Wang, 1964), 235. The reason that the audience cannot conceive the character in any other way is that the latter is fully materialized in the actor. It is no longer perceived as fictional or possible, but as an actual person, identical to the actor.

21. Both Plato and Brecht are critical of what they take as attempts to attain identity between reality and fiction in the theatre. Plato takes the claim that actors identify with characters because they are temporarily mad or divinely inspired as proof that there is no such craft as acting; actors do not *know* what they do. Thus, Socrates tells Ion: 'As I said earlier, that's not a subject you've mastered – speaking well about Homer; it's a divine power that moves you'. Plato, *Two Comic Dialogues*, 25. For Brecht too, the knowledge that actors are not characters is crucial and forms one of the principles of his epic theatre. Brecht thinks that acting methods that attempt to turn the actors into roles that they perform obstruct the audience's understanding of the moral, social or political dimensions of the plot. He contrasts feeling with knowing and accuses actors who use emotions to merge with the character of obstructing the possibility of theatre conveying knowledge '[O]f human relations, of human behavior, of human capacities'. Willett, *Brecht on Theatre*, 26.

22. Sartre, *Sartre on Theater*, 160.

23. Sartre thinks that even in trace-like experience we maintain a level of awareness of reality, though he admits that in some situations we can enchant ourselves and disengage from reality to a certain extent. At the most extreme state of hallucination and psychic pathologies, consciousness 'convinces' itself to forget the world to such a degree that it ceases being conscious altogether. In such cases consciousness

disintegrates and loses its intentional centre, its ability to be conscious of thing, which is its constitutive feature according to Sartre. On this point, see: Sartre, *The Imaginary*, 149–167. I discuss Sartre's views of pathological states in 'Rethinking the Relationship between Memory and Imagination in Sartre's *The Imaginary*', *Journal of the British Society for Phenomenology*, vol. 43, no. 2 (2012), 143–160.

24. Sartre, *Sartre on Theater*, 167.

25. T. Zamir, *Acts* (Ann Arbor, MI: University of Michigan Press, 2014), 15.

26. Fisher, 'Bad Faith and the Actor', 84.

27. Sartre, *Sartre on Theater*, 66. He makes this comment in an interview, taken at the time of the production of his play *The Condemned of Altona*.

28. 'The audience writes the play quite as much as the author does'. Sartre, *Sartre on Theater*, 68.

29. Sartre's examples are generally taken from 'traditional' theatrical performances, where actors are demarcated from spectators. Erika Fischer-Lichte describes such performances as employing 'staging strategies to stir the audience into controlled and guided responses'. E. Fischer-Lichte, *The Transformative Power of Performance*, trans. S. I. Jain (New York: Routledge, 2008), 39. According to Fischer-Lichte, since the performative turn of the 1960s performances are 'generated and determined by a self-referential feedback-loop' (ibid., 38). The loop is generated by spectators' varied responses to performances, responses that in turn shape and influence the performance itself. Sartre's conception of theatre clearly belongs to the second, rather than the first paradigm that Fischer-Lichte describes. Though he thinks of more traditional performances, his account stresses the interdependence and co-influence between actors and spectators, despite the fact that the two remain distinct.

30. Spectatorship is a reoccurring theme in Sartre's philosophy. The example of the jealous lover looking through the keyhole at the 'spectacle . . . presented as "to be seen"' is central to his account of inter-subjective relations in *Being and Nothingness*. J. P. Sartre, *Being and Nothingness*, trans. H. Barnes (New York: Washington Square Press, 1993), 347. His ontology does not treat the gazing subject and its object as independent from one another. He portrays the two as constituting each other dialectically. The scope of this chapter does not permit me to develop an account of Sartrean spectatorship. I develop an account of the Sartrean trope of the gaze as a meta-theatrical devise in L. Levy, 'Little Eyolf – A Sartrean Reading', *Ibsen Studies*, vol. 15, no. 2 (2016), 113–141.

31. Such form of pretence can also be found in children's games. When a child pretends to spill imaginary tea out of an imaginary cup, he or she understands that such a situation does not hold. For a comprehensive psychological account of children's understanding of pretense, see: P. L. Harris, R. D. Kavanaugh, H. M. Wellman and A. K. Hicking, 'Young Children's Understanding of Pretense', *Monographs of the Society for Research in Child Development*, vol. 58, no. 1 (1993).

32. This outline of Sartre's theory of action is meant to shed light on his theory of acting (theatrical action). For a thorough analysis of his conception of action in *Being and Nothingness* see: J. E. Atwell, 'Sartre and Action Theory', in H. J. Silverman and F. Elliston (eds.), *Jean-Paul Sartre – Contemporary Approaches to His Philosophy* (Pittsburg, PA: Duquesne University Press, 1980), 63–104.

33. Sartre, *Being and Nothingness*, 559.

34. On the latter point see Sartre's discussion of bad faith, where actions are taken intentionally, yet without the agents *knowing* the ends that guide their behaviours (see, for instance, the examples of the homosexual and his friend, the champion of sincerity in Sartre, *Being and Nothingness*, 107–109).

35. 'We must recognize that the indispensable and fundamental condition of all action is the freedom of the acting being'. Sartre, *Being and Nothingness*, 563.

36. Sartre, *Being and Nothingness*, 559.

37. Sartre, *Being and Nothingness*, 127.

38. Sartre, *Being and Nothingness*, 620.

39. Sartre, *Being and Nothingness*, 620.

40. 'Even if the crag is revealed as "too difficult to climb", and if we must give up the ascent, let us note that the crag is revealed as such only because it was originally grasped as "climbable"; it is therefore our freedom which constitutes the limits which it will subsequently encounter'. Sartre, *Being and Nothingness*, 620.

41. Sartre, *Being and Nothingness*, 77.

42. Sartre, *Being and Nothingness*, 169.

43. Sartre, *Being and Nothingness*, 688.

44. Sartre, *Sartre on Acting*, 160.

45. Sartre, *Sartre on Acting*, 161.

46. Fisher, 'Bad Faith and the Actor', 79.

47. Sartre, *Sartre on Theater*, 163.

48. Sartre, *Sartre on Acting*, 163.

49. Sartre, *Sartre on Acting*, 88.

50. J. P. Sartre, *The Transcendence of the Ego*, trans. F. Williams and R. Kirkpatrick (New York: Hill and Wang), 1960, 94. In French, Sartre speaks of '*simple représentations*' *La transcendance de l'ego* (Paris: Librairie Philosophique Vrin, 1966), 75.

51. Sartre refers to the ego as a 'magical object' (ibid., 81). Like a magic trick, the ego is different than it seems. Moreover, similarly to the magic trick, the ego masks its illusionary core. Just as we cannot detect any secret compartment in a sleight of hand magic trick, so we cannot 'see' the ideality of our ego.

52. Sartre, *Sartre on Acting*, 91.

BIBLIOGRAPHY

Aristotle. *Poetics* Trans. A. Kenny. Oxford University Press, 2013.

Atwell, J. E. 'Sartre and Action Theory'. In *Jean-Paul Sartre – Contemporary Approaches to His Philosophy,* edited by H. J. Silverman and F. Elliston, 63–104. Pittsburg, PA: Duquesne University Press, 1980.

Badiou, A. *In Praise of Theater*. Trans. A. Bielski. Cambridge: Polity Press, 2015.

Bukala, C. R. 'Sartre's "Kean": The Drama of Consciousness'. *Review of Existential Psychology and Psychiatry* 12, no. 1 (1974): 57–70.

Ekberg, J. 'Representation and Ontological Self-Knowledge in Sartre's Drama'. *Sartre Studies International* 17, no. 1 (2011): 75–92.

Fischer-Lichte, E. *The Transformative Power of Performance*. Trans. S. I. Jain. New York: Routledge, 2008.

Fisher, T. 'Bad Faith and the Actor'. *Sartre Studies International* 15, no. 1 (2009): 74–91.

Harris, P. L., R. D. Kavanaugh, H. M. Wellman and A. K. Hicking. 'Young Children's Understanding of Pretense'. *Monographs of the Society for Research in Child Development* 58, no. 1 (1993): 1–107.

Levy, L. 'Little Eyolf – A Sartrean Reading'. *Ibsen Studies* 15, no. 2 (2016): 113–141.

Levy, L. 'Rethinking the Relationship between Memory and Imagination in Sartre's *The Imaginary*'. *Journal of the British Society for Phenomenology* 43, no. 2 (2012): 143–160.

O'Donohoe, B. *Sartre's Theatre: Act for Life*. Bern: Peter Lang, 2005.

Plato. *Two Comic Dialogues*. Trans. P. Woodruff. Indianapolis: Hackett Publishing Company, 1983.

Puchner, M. *The Drama of Ideas*. Oxford: Oxford University Press, 2014.

Sartre, J. P. *Being and Nothingness*. Trans. H. Barnes. New York: Washington Square Press, 1993.

Sartre, J. P. *The Imaginary*. Trans. J. Webber. London and New York: Routledge, 2004.

Sartre, J. P. *La transcendance de l'ego*. Paris: Librairie Philosophique Vrin, 1966.

Sartre, J. P. *Sartre on Theater*. Ed. M. Contat and M. Rybalka and trans. F. Jellinek. New York: Pantheon Books, 1976.

Sartre, J. P. *The Transcendence of the Ego*. Trans. F. Williams and R. Kirkpatrick. New York: Hill and Wang, 1960.

Sartre, J. P. *We Only Have This Life to Live*. Ed. R. Aronson and A. Van Den Hoven. New York: New York Review of Books, 2013.

Van Den Hoven, A. 'Sartre's Conception of Theater – Theory and Practice'. *Sartre Studies International* 18, no. 2 (2012): 59–71.

Willett, J. (ed.). *Brecht on Theatre*. New York: Hill and Wang, 1964.

Zamir, T. *Acts*. Ann Arbor, MI: University of Michigan Press, 2014.

Chapter 6

Attention to technique in theatre

Paul Woodruff

THE PROBLEM

Yo-Yo Ma is drawing us towards the end of the Saint-Saëns concerto. He begins a crescendo on a single note so quietly that we in the audience all hold our breath as if we were one awestruck creature. There is no counting in this music now. The note seems to grow from perfect silence for time without end – long enough, to be technical, that he must change the direction of the bow at least once, though we cannot hear the change. The note grows smoothly, on and on. I turn to look at my cello teacher, who is sitting beside me, and see that she is in tears. I am close to that myself at the sublime beauty of this single note. Only later do I wonder, 'How did he do that? What extraordinary technique! How could I or anyone learn to do that?' Anyone could appreciate the beauty, but I do not expect that anyone who had not played a stringed instrument could appreciate the technique. But those of us who were cellists were not attending to the technique at the moment that it brought us to the edge of tears.

A reverse case: I am teaching a class in philosophy of art. We have read Tolstoy's blistering attack on Beethoven's Opus 101, number 28 in A major, and I am presenting the piece to the class as played by a brilliant pianist, available on YouTube, Emil Gilels.[1] Afterwards, I ask for their reactions. Most of them have rarely listened to classical music. They don't much like the sonata (as Tolstoy predicted[2]), but they are impressed by the technique. In fact, they think Gilels is showing off what he can do, perhaps as, in the music they like, a guitarist might show off his or her chops with a riff. For my part, I was carried away by the beauty of the music, dimly aware that the player had a matchless technique, but not interested in that at all. The music was all to me, the composer's finest piano sonata in the judgement of many.

109

But to my class, the performance was not music but technique showing itself off. Had Gilels known of this, the pianist would have been disappointed: his performance failed for my students, since his aim was not to impress with technique but to be a vehicle to the audience for Beethoven's magnificent sonata. But not too disappointed: he must have learned by now that even the best performance will fail for an audience not prepared to receive it.

Technique in music and dance is more obvious than it is in acting. Acting studios teach young actors not to call attention to the fact that they are acting; they are told that what is called indicating is a cardinal sin. Generally, in conventional theatre, the performance is geared to draw the audience's attention towards the action being represented, and not to the technique of the actors. If the audience says, 'Wow, what super acting,' or 'Yuck, what a miserable performance!' then they are not attending to the action represented, but have pulled at least part way back.

In 1967, I was fortunate to have a ticket to see Laurence Olivier's acclaimed performance as Edgar in August Strindberg's *The Dance of Death*. But unlucky too: the master actor was ill on the night I attended, and his role was taken by an understudy who (I felt at the time) did a splendid job imitating Olivier's technique.[3] That was informative, but I did not think it a successful performance. Yes, I had been drawn to the event by Olivier's reputation as a technical actor, but what I thought I saw was not what I came to see. When actors strut their technique on stage, their acting cadenzas interrupt the flow of the play. If you play the part of Hamlet, it is Hamlet you are trying to present to the audience, not yourself. This evening I did not see Edgar at all but the understudy, and through him, the famous actor.

In music, by contrast, we are often most impressed by the technique of a performer, especially in the bravura pieces used as cadenzas or encores. And yet when Yo-Yo Ma draws out a long graceful crescendo we hold our breaths, not because we are impressed with Ma or his technique, but because his sound is so ravishing.

When and to what extent does the art of theatre properly draw attention, or pay attention, to technique? That is the question of this chapter.

THE ART OF THEATRE[4]

The art of theatre, as I understand it, is the dual arts of making human action worth watching (for performers) and finding human action worth watching (for audiences). The art succeeds at events in which the dual arts match and are both practised well. The art fails when performers fail to draw attention in the right way, or when watchers fail to attend in the right way. This chapter, then, is about the right ways of practicing the dual arts with respect to technique.

The art of theatre draws attention to many different kinds of human action – live performances of music, dance, improvisation and scripted plays, but also rituals such as religious ceremonies and games for spectators. Among the games we should consider are not only great sports such as football and baseball, but also household games such as charades. Often neglected in discussions of pedagogy is the value of the art of theatre in teaching. Not all teaching is performance, but some of it is, and when teaching is performance, both teachers and students must practise the art. Although closely related, the arts of filmic and digital representation are not arts of theatre, as I have argued elsewhere.[5]

Mimesis is common in human action; in theatre, both performers and watchers may engage in mimesis – or not. The art of theatre is neutral with respect to mimesis. It is also neutral with respect to fiction, which is not the same as mimesis. We have mimetic representations of actual history (which is not fiction), as well as representations of fiction without mimesis. Nevertheless, mimesis is important to the question of this chapter: the *Dance of Death* failed because the actor was aiming at mimesis of another actor, who had been aiming at mimesis of the action of a character in the play. Mimesis can be especially vulnerable to exposures of technique.

Whether it is right to call attention to technique, or pay attention to it, depends in part on the sort of performance in question, and especially on the sort of action which is supposed to be the object of attention during the event. A human action (I take it) is an event that proceeds from choice on the part of a human agent.

OBJECTS OF ATTENTION

Olivier, playing Lear, walks on stage and takes his seat on a highly decorated chair. He is practising the art of theatre, making his action worth watching. But what is the action he is making worth watching in this short scene? These take place simultaneously:

1. Olivier walks across and takes his seat on a chair.
2. King Lear enters and takes his seat on the throne of England.
3. Olivier acts the part of King Lear entering and taking his seat on the throne of England.

Olivier's partner may have come to watch the first – her partner move about the stage. A visiting class of young actors from Julliard may have come to watch the third. Had I been there, I would have come to watch the second. Olivier (I take it) has chosen to do the third by means of the first, while

diverting attention from both of these to the second. The watchers he hopes for will focus on the second.

The art of theatre flourishes when the watchers and the watched are in agreement about what is to be watched. I will say that an action is the proper object of attention when both sides agree: when the majority of watchers are trying to *take* the same action as worth watching that the people who are watched are trying to *make* worth watching. Just about any action, including a display of technique, can be a proper object of attention in a theatrical event. In some cases, a compound of actions may be proper in my sense. I may be able to divide my attention between Olivier's acting and Lear's actions, and he may be aiming for that division, if he is performing for an acting class. But most of us, I think, have to choose.

Mimesis is an issue here: attending to technique can undermine mimetic effects. So theatrical art forms that rely less on mimesis (e.g., music performance) are more open to divided attention. I can listen to the Miro quartet playing Opus 132 and attend both to their technique and to Beethoven's magnificent composition at the same time, for a few minutes, before I relapse into attending only to the music – or, if I am a student, to the technique.

Technique is rarely the single proper object of attention, but it can be. The most obvious cases are from demonstrations in pedagogy. The violin teacher shows her students a certain technique for fast passages, which requires the bow to bounce on the strings. As she demonstrates it, she tries to draw attention to certain details of the technique, and her students try to see and hear what she is doing. But if they attend only to the technique, they will lose track of the reason for it – the beauty that such a technique can produce. So they need to hear the music well if they are to want to reproduce the technique. And if they don't hear the music well, they will not know what they are trying to reproduce. So music is an object of attention in this case, but so is technique. Neither is the single proper object. She plays so that we will ask: 'What exactly is she doing to produce that gorgeous sound?'

Contrast this with a concert performance I attend with the sole purpose of studying the bowing of the cellist on the stage. There is nothing improper in my doing this; by making his technique the object of my attention I set myself up for learning important lessons. But there is a mismatch between his art and mine in this case: he is trying to make Bach's fourth suite worth listening to, and I am trying to improve my bowing by observing his. We are both succeeding in what we set out to do through our arts of theatre, but the two arts do not match. That is an unstable situation; probably before the final movement his art will have overpowered mine. The music of Bach will carry me away, and I will lose track of his bowing and hear the wonders of Bach's music. Then the arts are in alignment.

Imagine an analogous event in the art theatre. I have come to see how a certain actor pulls off Hamlet's soliloquies. If the actor is good enough, he or she may succeed in distracting me from his or her technique, and then I will be hearing Shakespeare's gorgeous poetry – or even better, then I will be hearing the turbulent music in Hamlet's confused soul. What should be the object of my attention here? That depends. A performance of poetry should make poetry the object, but a performance of *Hamlet* takes the action of that play as its object – and that includes the wild to and fro of ideas in Hamlet's soul.

In the theatre of sports, we need to distinguish games from contests. A contest may be all about technique; in that case watchers are encouraged by the announcers to pay attention to technique, although they may be ill-equipped to do so. Watching a figure skater jump and spin in a contest, I have no idea how she pulls this off. I know that if she tumbles, she has failed. And I can judge whether or not she looks graceful as she lands. But I do not know enough to judge her technique in a contest. The judges who do know about technique are, for me, part of the show. The trained figure skater beside me may whisper in my ear comments that help me notice technical achievement, but I can appreciate the beauty of the movements on my own, and that is why I came to watch.

A game is another matter. A hockey team aims to score goals, not win on technical points. I can enjoy the drama of the game without knowing much about technique. I will probably enjoy it more, however, if I understand how the passing game works in hockey. The teams sweep up and down the ice so rapidly that if I did not know what to look for, I would miss fine points in the game.

I will pay most attention to technique, in game, contest, concert or drama, if I am a student of the art in question. As a student, I come to learn, and I may come again and again to watch for fine points I may have missed. Modern technology has enabled us to watch exactly the same event repeatedly. I have seen a weightlifter watch the same video of the same lift twenty times, looking for fine points. Live theatre (the subject of this chapter) never repeats exactly. Still, teachers and students may be willing to watch many iterations of a scene, while the rest of us would be content with a single viewing. Pedagogy stretches theatre towards technique.

Pedagogy represents one extreme of a continuum, the extreme at which technique may be the primary proper object of the art of theatre. Religious ceremony represents the other extreme. Before our eyes, bread and wine are transformed into the flesh and blood of the living God; if I focus on the way the priest pronounces his Latin, I am absenting my mind from the ritual (though the sacrament will not be impaired and may have the same efficacy on me).

Much of theatre seems to fall between these extremes, but on balance, I propose that outside of pedagogical contexts technique should at most be a secondary object. Performers who draw attention to their technique risk making their actions less worth watching because technique in itself is boring to most watchers.

Emotional connections are sure-fire ways of making human action most worth watching (though these may not be available through pure music or non-narrative dance). That is why good teachers make emotional connections with their students even when their objects are unexciting technical points. The art of theatre depends on caring – caring about people, about events, about beauty or whatever. For you to care about a person or an outcome is to hinge your emotions on that. In watching a play, you will be happy if the hero you love comes off well, fearful if he comes into danger, grief-stricken if he dies. In watching a sports event, you will be happy if your team wins, sad if it loses, thrilled by a beautiful pass, horrified by an ugly one. That's why fans will stay to the end of the game, if they do stay. But absent these connections, no display of technique alone will keep most fans in the stadium till the last.

Professional watchers, however, usually stay to the end no matter what; their job is to watch. Critics are the best-known example of professional watchers. The critics' job is not only to watch, but also to observe technique, even at the cost of losing some joy in the experience.

MIMESIS[6]

Mimesis occurs whenever one thing has an effect that properly belongs to another. The hunter makes a sound like that of a female moose in heat, and a male comes to investigate. This is all real: the hunter did make the sound and the male did arrive on the scene. But the sound properly belongs to the female moose, and the hunter cannot produce all of the satisfactory effects of female on male. The male will be disappointed. Or a child sees picture of a lion; this is an example from Aristotle. The picture has part of the effect of the lion: it shows the child what a lion looks like. But it will not do everything a lion does. It will not eat the child. Put the lion safely in a zoo, and the picture still will not do what the lion does. It will not show the child how a lion moves or sounds. If you really want to learn about lions, you must be in their presence. Learning about lions is properly an effect of lions, not pictures, but pictures can do part of the work. That is lucky for the child.

Mimesis is especially valuable when its object is dangerous. Consider war. Only veterans can know all of what it feels like to be in combat, but the cost of the learning is high, and the trauma that attends it may hopelessly blur the

mind of the veteran. Terror and rage are great distorters of memory. Mimesis of war is certainly safer, and in some respects it can be more accurate, than direct experience of war.

Medicine (the ancient Greeks thought) is mimetic of nature. Nature heals us naturally. Medicine, following the example of nature and using some of its devices, has an effect similar to that of nature, but not identical. It may be quicker or more certain, but yet remain incomplete, and is often more dangerous than natural healing. Healing properly belongs to nature.

Music (they also thought) can be mimetic of character: martial music can make you feel as you would if you were actually brave. It has part of the effect of genuine bravery, but only part. When the music stops, and you can no longer even play it in your mind, the effect stops too. You will no longer feel brave. But you would if you were brave. Enough exposure to martial music may give you the habit of feeling brave, so you are no longer dependent on the music; if so, music can mould character. And bad music could corrupt character. That is why Plato wanted to control music.

Realistic theatre aims to have part of the effect of real life on an audience, especially through emotions.[7] The death of a character gives an audience part of the blow they would receive from a real death. But only part. Real grief is painful, but we enjoy the experience of theatre, in the long run, though it may require some painful moments. Like the picture of the lion, theatre is mimetic in having a selective effect – it deals us only the safer cards when real life would mix them with dangerous ones.

Most performers of mimesis wish to mask their technique, rather than to call attention to it. An interesting case is that of the polished orators who present themselves as plainspoken. Their oratorical technique is most effective when it is best hidden through mimesis. In theatre, mimesis is usually masked. But not always: Brecht designed the alienation effects of his theatre to show his audience that mimesis is going on, with the intention of blocking the kind of emotional responses they normally have from mimesis. He was not entirely successful. No matter how he adjusted the play, his *Mother Courage* still drew on the heartstrings of its audiences. A theatre audience will climb over many an obstacle in order to indulge in emotions provoked by mimesis.

At the other extreme from Brecht is the theatre that aims for illusions as captivating as those we see on film, such as the musical version of the *Lion King,* or *Spiderman.* When watching a movie, we don't wonder how the special effects were made, but in the live theatre, we do wonder about these. Brilliant design in live theatre calls attention to itself and so may block the mimetic effect at which it aims. 'How did they do that?' we may wonder, as an actor appears to die a bloody death realistically on the stage. Instead of shuddering inside, we are mentally applauding the maker of the effect. We

are more likely to be more indulgent as an audience to productions that are not so polished.

Mimesis in theatre often demands complicity from the audience. Complicity occurs when those who are affected by mimesis help it along through an effort of imagination, through make-believe. Imagine children running from their beloved teacher when he or she is wearing vampire teeth. They run away and squeal only because they have consented to a game of make-believe. The children know perfectly well who the teacher is, and they are delighted by the game.

We come to the theatre knowing that we will see actors performing; we may even know who they are behind the make-up and costumes. We contrive to forget that we know the truth, however, if we wish to have the full experience of mimesis. The same children who ran from the vampire teacher may themselves put on a play. Perhaps it is a single scene, the witch's brew scene from *Macbeth*. Now roles are reversed, and it is the teacher who must be complicit. Complicity here calls for a substantial effort on the watcher's part, as the children do not know how to act like witches. Mimesis need not be convincing; it can give pleasure all around if both sides are willing to play the same game.

What I am calling complicity is sharing in a game of make-believe.[8] Make-believe calls us to use imagination, whether we are watching or performing. If you pay too much attention to technique, you may hobble the horses of your imagination.

TECHNIQUE AND IMAGINATION

Your violin teacher has reason to draw your attention to good technique. Bad technique has a way of calling attention to itself. It is almost always bad technique that calls attention to itself, diverting the audience from attending to the music, dance or drama that is being performed. In a similar way, a well-made photograph usually calls us to look at an image or the subject of the image, while a badly made one makes us think of the quality of the artist or equipment. The rule is not strict: an artist may wish to call attention to the technology of photography as such, and Brecht called attention to stage technology in order to forestall mimetic rousing of emotion. But this is rare in theatre.

No matter how poorly made an image is, however, I can ignore issues of technique if I wish. You show me a blurry picture of my grandchild? I do not see the blur; I see the much-loved child through the blur. And when the same child sings a song for us before dinner, it is the song I hear, and the child singing it, not the childish technique. You are no relation of the child? Then I forgive you for noticing only how much he or she has still to learn about

music. You and I care about different things. But it would be kind of you to care about the child and his or her song.

In the opening scene of the last act of Shakespeare's *A Midsummer Night's Dream,* Theseus, Hippolyta and the other newlyweds are offered a choice of entertainment, including a play by the rude mechanicals. Hippolyta demurs, but Theseus reassures her with a play on the word 'kind':

Philostrate

>No, my noble lord;
>It is not for you: I have heard it over,
>And it is nothing, nothing in the world;
>Unless you can find sport in their intents,
>Extremely stretch'd and conn'd with cruel pain,
>To do you service.

Theseus

>I will hear that play;
>For never anything can be amiss,
>When simpleness and duty tender it.
>Go, bring them in: and take your places, ladies.

Exit PHILOSTRATE

Hippolyta

>I love not to see wretchedness o'er charged
>And duty in his service perishing.

Theseus

>Why, gentle sweet, you shall see no such thing.

Hippolyta

>He says they can do nothing in this kind.

Theseus

>The kinder we, to give them thanks for nothing.
>Our sport shall be to take what they mistake:
>And what poor duty cannot do, noble respect
>Takes it in might, not merit.

As expected, the performance goes badly, and audience members are mocking the players to their faces. The player who represented the Wall has just made his exit when Hippolyta comments:

Hippolyta

>This is the silliest stuff that ever I heard.

Shakespeare is making fun of theatre here, showing performance art at its silliest. The scene has been a delicious romp and will grow further into hilarity. The sad tale of Pyramus and Thisbe will bring a tear to the eye of every member of the audience – but it will be a tear of laughter. The whole scene is cleverly written to focus our watching on bad technique, and that is designed to undermine the mimetic effect of a death on stage. Of course, that design will succeed only if the performers of the rude mechanicals are highly proficient in technique: they are performing a mimesis of bad acting. We in the audience must forget that the actors we are watching are very good actors indeed. We do so happily, for the pleasure of laughing at their (apparently) bad acting.

If the scene is well acted, then, no one will cry for Pyramus – as many would were the man really to die in front of us by his own hand after losing his beloved. We will cry for Juliet, who will die in this way when she believes her lover is dead. In her play, mimesis will succeed unless her acting is so bad that we focus on technique. To feel the full mimetic effect of dramatic performance, we have to close our eyes to technique.

Shakespeare is well aware of this. From making a mockery of bad performance, he suddenly turns his spotlight onto bad watching – which is unkind watching. The newlyweds have not been kind watchers of the rude mechanicals. Theseus offers a corrective:

Theseus

>The best in this kind are but shadows; and the worst
>are no worse, if imagination amend them.

Hippolyta

>It must be your imagination then, and not theirs.

Theseus

>If we imagine no worse of them than they of
>themselves, they may pass for excellent men.

'The best in this kind are shadows': Even the best play acting calls for the audience to be complicit in the mimesis. Complicity requires an effort that is rarely consistent with attending to technique. The children running from the teacher, when he or she pretends to be a wolf, are not examining the wolf technique. Imagine that one child stops, turns and says to the teacher: 'You're not doing it right. The other teacher howls better'. To do that, the child has stepped out of the game and is no longer complicit. He has, at least for him, put an end to the mimetic effect of the game: no running or squealing for him. But even the best wolf-teacher requires complicity.

And so do the worst: 'The worst are no worse, if imagination amend them'. Can we watch with imagination and still attend to technique? As Hippolyta suggests, it should not be all up to us. Actors, designers, directors and writers need to exercise their imaginations in order to give ours a chance. I cannot leave this subject without quoting Theseus's speech about imagination, delivered earlier in the same scene. The poet shares with the madman and the lover a capacity for imagination that can give to fiction the power of what is real:

> And as imagination bodies forth
> The forms of things unknown, the poet's pen
> Turns them into shapes, and gives to airy nothing
> A local habitation and a name.
> Such tricks hath strong imagination
> That, if it would but apprehend some joy,
> It comprehends some bringer of that joy;
> Or in the night, imagining some fear,
> How easy is a bush supposed a bear?[9]

And when, on a dark night's camping, you imagine a bush to be a bear, then your heart quickens, adrenaline pumps and you freeze or run or call for help. On such a dark night, no complicity is required. The fear is simple, real, electrifying. The effect of mimesis is strong in you – so long as you do not think about how the effect is produced. But if you stop to think how a bush can look to you like a bear, then you are blocking or curtailing the mimetic effect. Change the story slightly: suppose you playfully imagine the bush to be a bear. No adrenaline this time, just a slight, pleasant *frisson* from a game of mimesis.

In theatre the fear may also be electrifying, but only with the complicity of the audience – who are willing (as part of the price of admission) to let their imaginations override their interest in how such effects may be contrived.[10] With the help of a good audience's imagination, the art of theatre apes the real-life mimesis of the bush on the dark night.

EDUCATED WATCHING

Remember the students who listened to Gilels play Opus 101 and were aware only of technique on display? Why were *they* struck by his technique, while I was oblivious to it? Or consider my listening experience with Yo-Yo Ma. Why were my cello teacher and I not attending to his technique when he brought tears to our eyes?

Here is a speculative answer: the more you know technique the less you have to be aware of it as you watch a performance. Musical techniques are familiar to me from long habituation to listening and playing. A great cello technique is no surprise to me, as it would be to my uneducated students.

At the same time, because I am an educated listener, I am prepared to appreciate fine points of technique that would pass by my students unnoticed. The more different performances I have seen of the Bach Suites, the better I am prepared to notice fine points – differences in bowing and phrasing and dynamics.

So education is a two-edged sword. It prepares me both to hear the sublimity of the music and to attend to fine points of technique (though probably not at the same time). Perhaps I could have too much education. Suppose I have seen so many productions of *Hamlet* that I am bored by the play. Now only technical features of a production catch my interest. Luckily, that has not happened to me with any of Shakespeare's plays or with the Bach Suites or with any other great work of art for theatre. Perhaps that is the best test for greatness in theatre: can a performance steal the attention of educated watchers from technique?

NOTES

1. 'Emil Gilels – Beethoven - Piano Sonata No 28 in A major, Op 101', YouTube, accessed June 11, 2017, https://www.youtube.com/watch?v=ZsItzA34B1I.

2. Tolstoy, Leo, *What Is Art,* Trans. Aylmer Maude Indianapolis, IN: Hackett Publishing Company, Inc., 1996, 146–148.

3. I find now from the Internet that the understudy was probably Anthony Hopkins, though I did not note the name at the time. The very fact that he was an understudy made me watch him for his technique, and that spoiled the evening for me. In fact, he might well have given a fine performance for which I was a bad watcher.

4. Here I draw on the theory developed in my *Necessity of Theater* (Oxford: Oxford University Press, 2008).

5. For film see *Necessity of Theater*, 43–44, and, for digital representation, which is more complicated, see my 'Lighting Up the Lizard Brain: The New Necessity of Theater', *Topoi*, vol. 30, no. 2 (2011), 151–155.

6. Here I am using ideas and examples from *Necessity of Theater,* chapter 7. See also my essays on mimesis: 'Aristotle on Mimesis', in A. Rorty (ed.), *Essays on Aristotle's Poetics* (Princeton: Princeton University Press, 1992), pp. 73–95 and 'Mimesis', in Pierre Destrée and Penelope Murray (eds.), *The Blackwell Companion to Ancient Aesthetics* (Oxford. Wiley-Blackwell, 2015), 329–340.

7. Keep in mind that even the most mimetic theatre depends on non-mimetic behaviour. The actor playing Laertes is really slashing with his sword, and it may really be a dangerous weapon. The actor playing Claudius does take his seat to watch Hamlet's play. No mimesis there. He is really sitting. Mimesis has its place in theatre through the selective effects that theatre can borrow from real life.

8. On this see Kendall Walton, *Mimesis as Make-Believe: On the Foundation of the Representational Arts* (Cambridge, MA: Harvard University Press, 1990).

9. Theseus earlier in the same scene speaks of the lovers' stories, which he finds 'more strange than true' and attributes to the power of imagination.

10. Technique can call attention to itself by being too good, in theatre as in rhetoric. Public speakers who are too polished lose our trust. 'What polish! Where did the speaker learn to do that?' we say to ourselves, losing track of the message. Similarly, a stage production may make us wonder how an effect was produced, and so make our attention wander from the action represented. For an example, see Tom Stern (2014), 66.

BIBLIOGRAPHY

Stern, Tom. *Philosophy and Theatre: An Introduction*. London: Routledge, 2014.

Tolstoy, Leo. *What Is Art?* Trans. Aylmer Maude. Indianapolis: Hackett Publishing Company, Inc., 1996.

Walton, Kendall. *Mimesis as Make-Believe: On the Foundation of the Representational Arts*. Cambridge: Harvard University Press, 1990.

Woodruff, Paul. 'Lighting Up the Lizard Brain: The New Necessity of Theater'. *Topoi* 30, no. 2 (2011): 151–155. http://www.springerlink.com/openurl.asp?genre =article&id=doi:10.1007/s11245-011-9101-z.

Woodruff, Paul. *The Necessity of Theater: The Art of Watching and Being Watched*. New York: Oxford University Press, 2008.

Chapter 7

Giving focus

Tzachi Zamir

Mack Swain. That's the name of the actor. He appears in one of the most celebrated scenes in cinema, one which is often commended for exemplifying magical acting. Despite the fact that there are only two actors in that scene, and while you have probably watched it more than once, it is unlikely that you have heard Swain's name.

Swain is the actor looking at Chaplin's tramp eating a shoe in *The Gold Rush*. While Swain is also himself morbidly chewing footwear, his own comic acting is mostly responsive: he gruffly refuses to play along with the tramp's attempts to lighten the atmosphere, he gazes in disbelief as Chaplin sucks on the metal nails as if they were meaty bones, he angrily ignores Chaplin's pseudo-mirthful invitation to break an L-shaped sole-nail as if it were a wish-bone. It is Chaplin who gets the attention and laughs. His actions aim to transform the wretched reality of the scene into a fancy dinner as he lavishes a spoonful of boiling water on the shoe as if he were treating it to rich gravy. Swain's character is, by contrast, confined to nauseating reality. He insists on remaining gloomy, munching in disgust on what remains barely edible leather.

Actors call what Swain is doing 'giving focus'. It demands intuiting what the audience currently attends, and actively contributing to what they experience without drawing attention to oneself. To give focus calls for lessening one's visibility while heightening another's. All actors are required to give focus. Even lead roles in which the character seems to never leave the centre of attention call for episodes in which someone else is momentarily foregrounded. Many, perhaps most actors, will never actually be focalized throughout their career, and will always be pushing attention away from themselves.

All this can sound touching, particularly so when what comes to mind are the ego-related aspects of the lives of those who play second fiddle (jealousy, frustration, etc.). I propose, though, to ignore these more familiar aspects, and take a closer look at the *art* of giving focus. True, fame-as-artist tends to be correlated with drawing attention, which is why it is the Chaplins and Oliviers who come to mind when contemplating acting, not unsung heroes like Mack Swain. But if a crucial part of the art of acting involves the spotlighting of someone else, allowing the lead roles to monopolize the philosophy of acting risks attaining an incomplete understanding of the actor's art. Concerning this last word, 'art', I will assume that acting is an art. I will not repeat the arguments why this is so, or the arguments aiming to counter the old bias for which actors and performers are merely vehicles enabling the real art, the work, to be experienced.[1] Instead, I will concentrate on the manner whereby the part of acting that is devoted to giving focus is itself a dimension of the actor's art, rather than a necessity occasionally needed.

This chapter delineates three areas in which the self-deemphasizing of actors shapes a philosophy of acting. The first concerns how giving focus questions a familiar narrative that weds artistic work onto conceptions of the self. The second is how giving focus reveals a broader gesture of showing that acting involves, thereby influencing how we ought to understand watching actors and being watched as an actor; the actor, I will argue, is not just seen, but is seen as someone who is showing. The third is how giving focus overturns a conventional understanding of empathy in the theatre, in particular, its direction. In all three, I will suggest why abstract considerations, intrinsically important as they are, also carry practical implications for actors. While a philosophy of a practice need not modify what practitioners do, when it does possess such pragmatic implication it acquires additional interest.

The centrality of giving focus in acting questions an implicit manner in which acting as art is related to subjectivity. The art-subjectivity connection is nowhere clearer than in Nietzsche, who yoked together Romanticism's reverence for art with success in living one's life without being reduced to a replica: 'Artists alone', Nietzsche wrote, 'reveal everyone's secret bad conscience, the law that every man is a unique miracle; they dare to show us man as he is, uniquely himself to every last movement of his muscles, more, that in being thus strictly consistent in uniqueness, he is beautiful, and worth regarding, and in no way tedious'.[2] He crafted a vision of self-authorship modelled upon this idea. Assertive, active and judicious, the life-forming choices of the authentic self would ideally resemble the aesthetic selections of original authors or painters at work.

Nietzsche's examples were poets or composers, artists for whom this analogy is apt. In such arts, what makes creative decisions worthwhile and

what makes living a life worthwhile appear to be overlapping merits. By modelling one's life upon the activity of authors or painters, one becomes a subject rather than an object. Instead of mindlessly living a pre-designated role, instead of actualizing the life scripts lived by others, one is authentically becoming.

Basing life on art can be rewarding in many kinds of ways. Instead of the ultimately facile understanding of authenticity as unfalsified correspondence with an inner self, a 'me' awaiting realization, what is encouraged is a creative process. One is relieved of the burden of a hidden subject. Instead, one's self-authorship becomes guided by aesthetic considerations. Does choosing a course of action establish a more interesting, worthwhile, richer 'me'? The factual constraints of a life cannot become excuses for conformity, because even the most severe contexts typically allow for numerous ways of responding to them, weaving a life story around them in various ways. To subject one's life to aesthetic criteria is, then, not merely an empowering route for self-realization, but also reshapes the meaning of liberty and responsibility. Such an understanding of authenticity is also informative when assessing inauthentic lives. The problem with these is unrelated to truth, to realizing a false life story that has gravitated away from the genuine underlying self. The problem is, rather, aesthetic: one lives an unimaginative life, a superficial one, a predictable pattern that has been followed through many times before, or one that is unique in structure, but poor in its parts. These are all aesthetic criteria, imported from the world of assessing art to assessing lives.

At the same time, the centrality of giving focus in acting means that when the art one has in mind is a performing art like acting, the locomotive drawing the art-life analogy is derailed. To claim that when Mack Swain gives focus, he thinks primarily of original, carefully selected creative choices on his part is not impossible; it is just not fully convincing. A less forced description of Swain's creative undertaking is that what is upmost in his mind is *serving* the scene, becoming an unnoted support enabling the overall effect of the episode. If this is true, it would be theoretically misleading and practically counterproductive for him to think solely or even primarily in terms of a creative agent. His task is different. His art is different. A Mack Swain cannot think like a Wagner or a Goethe, Nietzsche's favourite examples.

The point that emerges concerns not subjectivity in general. What surfaces, rather, is an explanation of a tension built into the experience of acting. The tension is particular to Western acting, embedded as it is in a specific Romantically inspired aesthetic configuration, one which has devised a unique mode of braiding together liberal subjectivity and art. On the one hand, as artists, actors are meant to exemplify the activity that turns interchangeable people into authentic subjects; they are expected to creatively breathe life into words,

to avoid recycling previous enactments by others, to encounter anew their dialogue with the imagined space throughout consecutive performances. On the other hand, their art invites them to seek out self-marginalization, the very state that, for the same paradigm of subjectivity, counts as defeat. Actors may thus look with envy on poets or choreographers. For the latter, the analogy between liberal selfhood and the creative labour of the artist fits as smoothly as Cinderella's slipper. Such artists can, indeed, take pride in how their efforts demonstrate to others that they can become who they are. But when actors draw inspiration from the same analogy or resort to the same vocabulary, they are more akin to Cinderella's wicked sisters, forcing their feet where they do not belong. An ill-suited aesthetic vocabulary is being imposed on an art form by its own practitioners.

Acting books tend to psychologize this process. They say that more than the mere give-and-take of collaboration, acting calls for Dionysian de-individuation, for a letting go, for a dissipation in the Freudian Oceanic.[3] The needed clarification here is, however, philosophical, not psychological, which is why the actor's unselfing deserves more than a learned nod in the direction of Freud or Bersani. To be satisfied with a psychologizing of this process means overlooking an explanation that appeals to the explicitly endorsed values that ought to govern artistic effort, values that need to be adopted and cultivated as part of an actor's training.

Regardless of its psychological attractions, unselfing is an aspect of a distinct kind of creative labour calling for a distinct set of aesthetic action-guiding values. What this means in practice for the actress is that her art requires the consistent performance of ego-suppressing acts. These are governed by considerations relating to the optimizing of projected overall effect of scenes on the audience. Faced with deciding between a unique, striking acting choice and one that better serves the scene's impact, she will choose the latter. Moreover, while this last point can apply to collaborative aesthetic creation in general, in which good creators prioritize overall success rather than personal distinction, the unselfing of actors extends much further. Actors are, for example, repeatedly advised to learn how to 'give in'. Actors give in to the role – hoping for it to take over at some point.[4] They give in to another's text, to another's directing and to the creative input of their partner actors, allowing these to shape their responses rather than being confined to pre-decided gestures.[5] This give and take exposes the difference between the teamwork of actors and other kinds of collaborative art. Yes, the work of more autonomous artists – authors, sculptures, composers and the like – also typically relies upon the efforts of others. But dependency differs from collaborative creation. The latter encompasses dependency – a film actor's work may be ruined by a careless editor – but, in addition, calls for something other: an ongoing artistic dialogue with the actions of others.

Again, the processes being singled out are irreducible to psychological descriptions of the actor's mind. The explanation which actors will find most useful is philosophical. It is an explanation that exposes the values that should orient an actor's development as artist, values via which the degree of an actor's aesthetic failure or achievement can also be gauged. Swain's success is rooted in how none of his gestures stands out. He is humourless, angry, possessive. Yet all of these amount to underemphasized acting, the kind of acting that allows Chaplin's choices to spark. To be the background that provides the minimal shades necessary for bringing out Chaplin, to work so as to be seen through and immediately forgotten – that's Swain's achievement as artist. The values guiding Swain are not the ones typically associated with artistic achievement, but ones connected to an optimal support of the scene's impact.

Note, though, how the misfit between this unique creative work and authenticity modelled upon the creative (non-performing) author carries intriguing implications for authenticity as such. Without abandoning the manner whereby aesthetic creation provides an illuminating paradigm for authentic selfhood, broadening the range of inspiring lives that exemplify authenticity to include the performing artists who mobilize the aesthetics of giving focus, enables discerning seams of authentic agency within other-emphasizing acts. This conforms with intuitions regarding how thoughtful acts of self-underpresencing can amount not necessarily to avoiding choice, but to unique ways of being. Self-authorship of one's life, when this encompasses not only one's own life plan but also networks linking us to others – for example, nurturing children, caring for friends, enabling oneself to be helped – has little use for models such as the life stories of Wagner and Goethe. Instead, the idea of subordinating personal creative choices to overall effect can function as a rewarding, action-guiding analogy for self-other relations. I can choose to be a minor character in another's life story, for example, and this decision can become a treasured part of what makes some aspects of my own life story meaningful and unique to me.

Another fruitful implication of including the aesthetics of giving focus when thinking of self-authorship concerns the experience of being scripted. It seems simple to hold that lives which conform to a pre-given script are, by virtue of that fact alone, bereft of authenticity. There are alternative ways of allowing oneself to be scripted, some incompatible with authenticity, others not. Ceding control and allowing an unchosen process to lead and reveal can open new ways of being and experiencing. In an inquisitive dialogue with an existential option, the ability to de-solidify can become a virtue. Good artists are sometimes good because they are able to loosen the hold of rigid schemes, plans and agendas; instead of deciding and executing, they are discovering and responding, remaking themselves and their art. The idea that 'giving in'

or allowing oneself to be led can themselves be constituents of an aesthetics, not simply modes of self-nullification, enriches the manner whereby lived authenticity is illuminated by art.

In short, Nietzsche was right to aestheticize authenticity. He was also right to consider great authors and composers as inspiring paradigms demonstrating how a life story can be originally authored. His point would have been more complete, however, had he included the delicate aesthetic work of the performing artist. He would have then been thinking not exclusively about solo creators but about ensembles. To admit this may have tempered the shrill egoism sometimes associated with his work. The point, though, is less related to Nietzsche, and more to how the actor's selflessness can enrich the aesthetics of self-creation, not simply be at odds with the dominant manner in which it has been formulated.

In order to explicate further this unique kind of creative labour, it is necessary to understand the precise nature of being seen as an actor. We know that watching actors is a complex phenomenon. Unlike, say, watching a person jogging, when an actor jogs in character, one is looking both at the character and at the actor. The audience will typically collapse the two levels into one, merely responding to the fictional character. Nevertheless, the jogging is done by two entities, one fictional, the other real, and the watching of it subliminally reacts to the two levels. Sometimes, a third level enters the picture. This occurs when what the actor performs in character involves moral or legal accountability that transcends the performance. I have elsewhere argued that this third level is always implicated in values whose applicability is not fully determined by the performer. If, for example, an actress urinates on someone's holy text in performance, she cannot hide behind this as being merely acting in character.[6] An actor, then, is seen as a character, as a performer and, sometimes, as a person.

Turn, now, from the act of looking at actors, when such beholding is done by others, to the experience of being seen as an actor. The two perspectives can but need not merge. While an actor's experience of being watched includes the three levels that are operative in spectators, there exists at least one additional (fourth) dimension that Mack Swain's focalizing of Chaplin brings out. The dimension relates to *showing*. Actors are not merely seen. They show. This applies to much of what they do: actors show a mindscape, they show an unfolding story, they show characters, they show words written by another. The numerous ways in which actors serve scenes – playing dead, handing out drinks, cheering a spotlighted occurrence, being lookers on – are also, too, showing something else: for Chaplin, it is 'the tramp'. Actors are thus not just seen, because to be seen is something that on its own can be attributable to an unthinking object. Actors are, rather, seen as actively showing something.

True, in other arts the artist can also become at once visible and showing something else: a Rembrandt self-portrait or an autobiographical novel can draw us into thinking or looking at their creators, who are not merely documenting themselves, but are pushing our attention elsewhere. The difference between such showing and what acting demands is both quantitative and qualitative. The quantitative difference is that whereas the opportunity for the artist to become visible is available and is occasionally pursued in other arts, for actors the complex looking I am describing is a structural given of their art: actors are *always* being looked at while being looked through, and this looking through is achieved by their own creative labour. The qualitative difference is that a Rembrandt self-portrait lacks the actor's selflessness: unlike a Mack Swain who gets us to look at Chaplin, with Rembrandt it is Rembrandt that we are thinking of all the time.

The unexpected value that surfaces from these reflections is generosity. The surprise is rooted in the stigma according to which actors are attention-craving narcissists. Like a leaking barrel that can never be filled, an actor's hunger for the limelight cannot be satiated – such is the stereotype. However, when showing becomes an organizing concept enabling framing an actor's work, the value that actually emerges as underpinning it is generosity. To show (not to show off, to show) is an other-oriented act, selfless in implying the centrality of a thing shown. You show another's text, you show a character embodied by you but created by another, you show a character embodied by another actor by having the character embodied by you direct attention to the other. To accept this can modify actor training and the kinds of aesthetic qualities actors will aim to refine in themselves and in others. A good actor must be generous, and be able to flexibly mobilize the three-part interaction among the shower, the shown and the beholder. The values that drive painters or authors, values that draw our attention to what *they* are doing, may thus become interferences for the actor. Generosity means attending to what another is meant to experience, and finding ways of enhancing it. The foregrounding of one's own agency is itself relevant only to the extent that it is subordinated to a broader gesture of establishing the audience's experience. Inferior acting often fails precisely by not exhibiting the necessary generosity: the actor insists on drawing attention away from where it is meant to be directed, forcing an audience to note displayed acting skills rather than to experience the work.

The emergence of a value such as generosity from this analysis demonstrates why a philosophical conceptual analysis does not amount to mere hair-splitting. If the distinction between being seen and being seen as showing is a correct one to draw, this would be one of the areas in which the arid analysis of the philosopher carries practical implications for the performer – again, in the sense of removing misconceptions regarding one's art

and directing one to the virtues that need to be refined. Sainte-Albine, for example, has distinguished actors from painters by announcing that the latter represent scenes, whereas actors reproduce them. James Boswell claimed that poets represent something to our imagination, whereas the player *is* what we behold.[7] In one sense, Sainte-Albine and Boswell are in the right: Shakespeare is not seen in his Rosalind or in his Othello while an Adrian Lester performing them is. But the formulations are misleading. They turn actors into scenery. Sainte-Albine and Boswell push actors too far in the direction of objects. They are, accordingly, overlooking the aesthetic activity of serving a scene, of successfully becoming background for something else. They miss the activity that throbs beneath some parts of the façade they are watching – the activity that sets apart actors from props: the activity of showing.

It could now be argued that the self-effacing involved in this kind of activity is, indeed, necessary for successful theatre, but that such work is not art. Actors need to sometimes objectify themselves, becoming scenery, and this may involve a degree of generosity. Yet the status of such work is not thereby elevated into an artistic achievement. The obvious response to this objection is that it begs the question of the meaning of art. The objection implies a willingness to acknowledge only spotlighted work as an aesthetic achievement, which amounts to excluding the possibility we are considering: that a kind of labour involving directing attention elsewhere can count as an aesthetic achievement. An intriguing implication of recognizing this error is that it suggests the need for reconceptualizing some of the more recent attempts to bestow artistic status on performance. Richard Wollheim has influentially claimed that the 'kind of regard' occasioned by an aesthetic work is one in which the vehicle becomes the target of ever-increasing attention. One looks at a line of poetry or a sequence of dance moves, and instead of satisfying oneself with grasping the meaning being conveyed, one attends to the medium: the selection of metaphors, the sequence of movements, the non-semantic features that turn the medium into more than a vehicle.[8] We can now see that this is valuable but incomplete. Not all aesthetic activity invites its addressee to attend it. If Swain draws increasing attention to his work, he fails as an artist. So while it is true that when art is regarded as such, this involves attention to the vehicle; what is true of the whole is not necessarily true of the parts. Some aesthetic achievements are undermined when they call for attention.

A less obvious response to the 'but is it art?' objection brings out the discrepancy between aesthetic values that govern focalized artistic work and the ones that orient self-effacing, scene-serving labour. The difference relates to the existence of a threshold in the latter but not the former. The work of focalizing something else ends when it achieves its goal. There are no endless depths that can be pursued once the goal of directing attention elsewhere has been realized. The case is different for focalized acting, which can often invite limitless exploration. This distinction holds for functional kinds of

giving focus. However, for reasons presented in the next section, it falsifies the kind of work performed by Swain, which, while goal-oriented, is not merely over and done with when pointing attention elsewhere.

Standard assumptions concerning the directionality of theatrical empathy will be modified if the preceding analysis is accepted. We tend to impose upon theatrical fictions a literary paradigm, according to which empathy (or identification) is what an audience experiences. Like readers who empathize with literature's fictional characters, the audience in the theatre identifies with the fictional characters embodied by actors.[9] But the generosity of showing indicates the opposite direction in the case of theatre. In an important way, actors who give focus are identifying *with the audience*, and their acting is guided by such identification.

I hope to clarify my intent by returning to Swain's acting. Swain is not merely looking at the tramp and getting us to do the same. Swain's entire persona broadcasts a voice humming in the minds of his projected audience. It is the voice of the unamused self, the no-nonsense realist, for whom life is nothing but a grim power play. His ability to breathe life into a mind governed by such outlook is responsible for the scene's success. The charm of the tramp is how he tries to package bleak near-starvation into imaginary luxury. In philosophical terms, Swain and Chaplin are thus embodying a clash of versions regarding reality: the world seen as it is when one insists on its morbid wretchedness versus the world as it can appear when infused with imaginary life. Swain and the tramp both perceive the same inputs – they just interpret them differently. The tramp twirls the shoelace around his fork as if it were spaghetti. Swain, in turn, angrily ignores Chaplin's pseudo-mirthful invitation to break in two one of the nails. A nail is a nail – not a wishing-bone.

The triumph of the imagination over the prosaic is the wellspring of the scene's humour. For the audience to laugh, they must recede from Swain's outlook, an outlook that is not in itself misguided but one that, while grim, actually serves an important function. The audience recedes from a perspective in which life's wretchedness is permitted to remain unadorned, by momentarily sympathizing with an imaginative recreation of hopeless reality, in which one is not really starving but is experiencing gourmet cuisine. By enacting a hyperbolic version of a mind locked into absorbing reality at its most hopeless unvarnished form, Swain enables the audience to temporarily neutralize the voice insisting on looking at what is there before one's nose. In short, Swain is *performing the audience*.

Giving focus often works in this way. Actors externalize not only the voices that potentially hamper an audience's experience, but those capturing what the audience is hoping to experience. To perform the audience or to identify with it does not accordingly mean meshing wholly with the projected audience, but selecting voices that play a part in the audience's

experience and dramatizing these. The acting thus becomes part of the work's rhetoric, a device serving its hoped-for effect. Consider, for instance, how cinema often inserts snippets of characters who cheer or cry along in sad climactic scenes. What the crying onlooker or the cheering supporter typically performs is not 'the audience' as such, but the precise moment of overcoming the resistance to externalize one's feelings. Such acting thereby mirrors to the audience not what they do now, but what they desire to do, a desire instilled by the film. The acting is modelled after what the audience is conceived as wishing to do.

Such forms of giving focus are not merely an attempt to direct a beam to some other occurrence. They require careful, balanced selections that support the scene by echoing something which, when encouraged or discouraged, is responsible for the scene's success. They are also not merely instrumental, goal-oriented acting. An easy example is the expression of dismay in comic sequences – the outraged-prude–type acting – when the topic is predicted to be potentially distasteful to some. Shock and disgust are imported from what a viewer may experience into the dramatized space. When skilfully done, this induces a withdrawal from experiencing such responses in the audience (we apparently tend to respond by gravitating towards unoccupied gaps, often skipping responses that are already dramatized within the work). The morally dubious potential of this mechanism – encouraging responses that are ostensibly condemned by giving feeble voice to the condemnation – is well known (e.g., media coverage expressing outrage at a sexual offence but careful to simultaneously vividly recap each detail of the offence thereby crossing the line between reportage, condemnation and titillation). Giving focus in acting can entail precisely this well-moderated embodiment of a predicted response.

I have been suggesting some ways whereby giving focus may shape in unpredictable ways our understanding of performance, as well as definitions regarding aesthetic achievement. I claimed that actors should avoid modelling their creativity solely on the kind of qualities which turn people into authentic, original, rich-to-behold subjects. An influential ideology of art pushes them into this distortion. They should, however, either resist it or reconceptualize what aestheticized self-authorship ought to mean. Acting includes a selfless component, an unselfing that actors ought to embrace. Such selflessness, I claimed, is not passive but is best captured by the idea of generously showing: the actor is someone who is seen as showing something. I further suggested that such showing often involves the actor performing subliminal forces in an audience, forces that block a fuller realization of the audience's experience. By performing their audience, empathy in performance loses the single-track directionality that tends to be associated with it, and becomes a to-and-fro movement.

NOTES

1. All of Thom's *For an Audience* is an extended argument for the artistic autonomy of performance; Paul Thom, *For an Audience: A Philosophy of the Performing Arts* (Philadelphia: Temple University Press, 1993). See, in particular, pp. 159–162 in which Thom lists aesthetic qualities of performance that are irreducible to the qualities of the source (if there is one). For a variation on this argument, see also David Osipovich, 'What Is a Theatrical Performance?', *Journal of Aesthetics and Art Criticism,* vol. 64, no. 4 (2006). For David Davies, the status of 'art', 'art work' or a performance of an art work, crucially depends on the intention to generate a particular 'kind of regard': 'For something to be an artistic *performance*, the actions of the agent must be guided – either immediately or through the instruction of the choreographer or director – by the expectation that they will be the object of this distinctive kind of regard on the part of an intended audience'. Whether or not a distinct way of regarding works of art exists is, needless to say, a contested matter. Yet much of what acting involves is – like the creation of non-performed art – designed to invoke a kind of regard, see David Davies, *Philosophy of the Performing Arts* (Chichester: Wiley-Blackwell, 2011), 16. For James Hamilton, a cardinal dimension of viewing something – an object, a performance – aesthetically is to appreciate it as an achievement. His book provides great detail on the kind of factors that enable evaluating performances as distinct aesthetic achievements. See James R. Hamilton, *The Art of Theater* (Malden MA: Blackwell Publishing, 2007), in particular, chapters 9 and 10.

2. Friedrich Nietzsche, *Untimely Meditations*, trans. R. J. Hollingdale (New York: Cambridge University Press, 1983), 127. For some of his additional formulations for the life-as-art ideal, see fragments 299, 301, 335 in *The Gay Science*. For an extensive analysis, see Alexander Nehamas, *Nietzsche, Life as Literature* (Cambridge, MA: Harvard University Press, 1985).

3. Richard Hornby, *The End of Acting: A Radical View* (New York: Applause Theatre Books, 1992), chapter 2.

4. Simon Callow, *Being an Actor* (Londong: Vintage, 2004), 31.

5. Declan Donnellan, *The Actor and the Target* (London: Nick Hern, 2002), chapter 2.

6. Tzachi Zamir, *Acts: Theater, Philosophy, and the Performing Self* (Michigan, Ann Arbor: University of Michigan Press, 2014), Part III.

7. Cited in Jean Benedetti, *The Art of the Actor: The Essential History of Acting, from Classical Times to the Present Day* (London: Methuen, 2005), 60, 64.

8. For a discussion of Wollheim's view and an attempt to import it into the context of performance, see Davies, *Philosophy of the Performing Arts*, 14–17.

9. For the complex relationship between literature and theatre, see Hamilton, *The Art of Theater*, 23–34; Osipovich, 'What Is a Theatrical Performance?'; David Z. Saltz, 'What Theatrical Performance Is (Not): The Interpretation Fallacy', ibid. 59, no. 3 (2001). For my own view, see Zamir, *Acts*, 69–86. Brecht's attempt to politicize acting via disrupting such identification is likewise built on the assumption that such empathy is the by-default experience of the audience.

BIBLIOGRAPHY

Benedetti, Jean. *The Art of the Actor: The Essential History of Acting, from Classical Times to the Present Day*. London: Methuen, 2005.

Callow, Simon. *Being an Actor*. London: Vintage, 2004.

Davies, David. *Philosophy of the Performing Arts*. Chichester: Wiley-Blackwell, 2011.

Donnellan, Declan. *The Actor and the Target*. London: Nick Hern, 2002.

Hamilton, James R. *The Art of Theater*. Malden MA: Blackwell Publishing, 2007.

Hornby, Richard. *The End of Acting: A Radical View*. New York: Applause Theatre Books, 1992.

Nehamas, Alexander. *Nietzsche, Life as Literature*. Cambridge, MA: Harvard University Press, 1985.

Nietzsche, Friedrich. *Untimely Meditations*. Trans. R. J. Hollingdale. New York: Cambridge University Press, 1983.

Osipovich, David. 'What Is a Theatrical Performance?'. *Journal of Aesthetics and Art Criticism* 64, no. 4 (2006): 461–470.

Saltz, David Z. 'What Theatrical Performance Is (Not): The Interpretation Fallacy'. *Journal of Aesthetics and Art Criticism* 59, no. 3 (2001): 299–306.

Thom, Paul. *For an Audience: A Philosophy of the Performing Arts*. Philadelphia: Temple University Press, 1993.

Zamir, Tzachi. *Acts: Theater, Philosophy, and the Performing Self*. Ann Arbor: University of Michigan Press, 2014.

Part III
THEATRE AS ART

Chapter 8

'What is the relationship between "observed" and "participatory" performance?'

James R. Hamilton

In this chapter, I present brief accounts of spectating and of performing. But much of the chapter is devoted to answering this question: 'What is the relationship between "observed" and "participatory" performance?' One can easily cite instances: plays by Ibsen, for example, are usually produced for audiences to observe and respond to; participatory performances are those created on the spot, so to speak, by using the quite varied techniques of what Matthew Reason calls 'active theatre', those in which

> audiences [are] engaged in some kind of participatory relationship with theatre performance. Whether that is walking through a museum as the performance unfolds around them; physically navigating non-linear immersive worlds; being rudely provoked or playfully encouraged to interact with the performers; or taking part in private one-to-one exchanges with the artist . . . [and] it is worth stressing that there is no one singular form of audience participation here . . . audience participation is an integral aesthetic and structural feature of the performances, often motivated by the artists' and companies' desire to reformulate the performer-spectator relationship and to invite a different, explicitly more active, kind of audience engagement.[1]

Two things are noteworthy about this: one is that citing examples requires that we already use the terms we want explained, and the other is that citing examples does not give us any analysis of those terms. I hope to redress these drawbacks in this chapter.

I will first discuss the nature of spectating at its most basic level. Audiences for any kind of performance are initially concerned to understand what is going on in the events they see and hear presented to them.[2] I analyse these phenomena using material from cognitive science, formal epistemology and decision theory. I call what spectators see and hear 'the data-stream' and

hold that, to understand a performance, they must both discern what is in the data-stream and draw inferences about what is causing that data-stream.

Next I propose a view of performing derived from the ethnological observations that briefly influenced performance theory in the 1970s. The rough ideas are that performers send signals to guide spectators in discerning the data-stream and that those same signals are shaped to guide spectators in grasping what is causing the data-stream. I analyse these phenomena using material from ethnography, signalling theory and demonstrative theories of quotation. I hold that performers, similarly to other animals but for other purposes and in other circumstances, display features, mostly of themselves, that in this case function to guide spectators towards hypotheses that yield understanding of what the performers are presenting to them. On that basis, I also present an account of the relation between performing and acting.

I then address the main question of this chapter: 'What is the relationship between "observed" and "participatory" performance?' My approach is to ask first what the relation is between spectators and 'spect-actors'.[3] This is because those who observe theatrical performances are usually referred to as spectators, and those who engage with participatory performances have often been referred to as spect-actors.

As a number of theatre theorists have argued, following Jacques Ranciere, the difference between spectators and spectator-participants cannot rest on some sort of alignment between spectators *versus* spect-actors and 'passivity' *versus* 'activity', respectively. For both spectating and spect-acting are 'active'. Furthermore, however, I demonstrate that both spectating and spect-acting can be modelled as *inter-active*. That is, both can be taken to refer to individuals whose active relation to a performance is 'interactive', as that notion is discussed in narratology and the philosophical literature on the aesthetics of video games. I argue that the alleged distinction is not a distinction at all but, instead, refers to variable points on a scale, and that the relevant scale is determined by the degree of *interactivity* involved.

This approach allows for a better way to determine the relation between observed and participatory theatre. It too is a matter of degree of invited interactivity: where, in order to understand the performance at all, spectators must at some point assess the level of interactivity it calls for. If spectators get that wrong, they simply cannot understand the performance. To think of the audience/performance relationship as scalar also provides a better way to specify *the moral status* of people who function as 'participants' in so-called participatory performances and fruitfully discuss the moral dimension of their situations. Finally, thinking of the differences this way provides a better way to explain why instances of interactive theatrical performances are likely to generate *transferable* changes in the attention-capacities of those who interact

with them, and make those people more proficient at attending and more attentive to a larger range of lived experience.

WHAT DO SPECTATORS THINK ABOUT IT, AND HOW DO THEY THINK ABOUT IT?

For reasons that come out later, I initially make no distinction between spectators and spect-actors, using the term 'spectators' indifferently to refer to each. What follows is a description of the apparatus and mechanisms of understanding that are employed in the theatre as well as in the everyday grasp of events.

Spectators attempt to figure out both what they are presented with and what causes that performed data-stream.[4] The data-stream consists of the features presented to spectators sequentially in a performance. At a basic level, spectators respond to the data-stream they are presented by trying to understand it, to describe it and to minimally explain it. Explanations track events and their causes, as Alison Gopnik has argued.[5] So a large part of what spectators are doing consists of trying to determine the sequences of features they have seen and heard and the causal structures of those sequences and features. As we will see, from an example described later which involves a performance using the script of Caryl Churchill's *Love and Information*, the emphasis here should be on the word 'trying', for not everyone does figure this out.

Perceiving, describing, interpreting, evaluating a performance

Descriptions of the data-stream that is commonly perceived by spectators usually present objective reports of fact, regardless of what situation, attitudes or beliefs individual spectators bring to the theatre. Arguably, when spectators turn to *interpreting* or *evaluating* a performance, they are doing something different and different standards apply; moreover their situations, attitudes or beliefs may have significant effects on interpretive reactions. Why?

An interpretation of what was seen and heard often involves stating what the spectator thinks was significant about the performance, or what it means, or even what it is about. And when a statement of significance, meaning or aboutness is bruited, it seems always possible to ask, 'significant *to whom*?' or 'meaning that *to whom*?' or 'about that *for whom*?' As a result, determining whether an interpretation is plausible can depend, in no small part, on relativizing the answer by specifying who it is to whom the performance had that significance, meaning or aboutness. Since these relativized answers generally make reference to subjective reactions, interpretations often have

a subjective component. And this entails that *mutatis mutandis,* evaluations based on interpretations, are often subjective as well.

But why should we think what is in the description of a data-stream report's objective facts? Aren't even our base-level reactions to the features presented in a performance subjective, influenced by who we are and what we are concerned about at any given moment? Surely that is possible. But I think we have grounds on which to reject that view with respect to the data-streams encountered by and given base-level descriptions and explanations by spectators.

Figuring out the cause of a performance involves making inferences at the time the data-stream changes in some important respect. It is a commonplace to observe that theatrical performances take time to perform. As is well known, it follows that what spectators understand of a performance is also developed over time, often the very same time as the performance. In this regard theatrical performances are like musical and dance performances. And in this same regard they are unlike paintings and sculptures, which may of course take time to make but are typically not observed during the time of their making but only when completed.

What is less often noticed about the time it takes for a performance is that, even if a spectator is not be able to describe exactly what is going on some particular moment, he or she changes his or her thinking about what has happened and what to expect, given that he or she is often able to reliably guess what is going to happen next.[6] In narrative theatre and narrative movies (especially of the Hollywood variety), changes in 'situational dimensions' (such as 'spatial location, time, the characters present, and the interactions between characters, causes, and goals') cause observers to mark changes among boundaries of the represented events.[7] That is, event segmentation theory has demonstrated that people perceive event boundaries in the representation of events at the places where situation changes occur. Moreover, as it happens, we do this in pretty much the same ways, under pretty much the same circumstances.[8] And so, for performances, event segmentation is crucial to accurate perception of the data-stream. This is an important reason for thinking descriptions of a data-stream are objective, even if the interpretations and evaluations plausibly drawn about the contents of that data-stream are not.

Attending to performers

The data-stream is perceived by attending to performers or other animated objects presented in a theatrical performance.[9] That is, spectators discern the data-stream by attending to performers, what performers do, what features they allow us to see and where they intend us to focus. The perception of the data-streams in theatrical performances is dependent on the

'salience' of certain features, as that term is understood in cognitive science and game-theoretical analyses of rational choice in coordination problems. Coordination problems require individuals within group contexts to attempt to coordinate their activities in conditions under which each is uncertain or simply does not know what the others in the group will do. In these analyses, a feature is said to *stand out* from others when there is a trigger that is not specific to the feature or the problem themselves that makes the feature stand out. Instead, the trigger is determined by contextual elements.[10]

One clear example of this involves a situation in which I have called you on a cell phone and, in the middle of our discussion, the phone service 'drops' the call. Who calls back? There is nothing in the nature of the situation itself that requires either of us to reinitiate the call. But suppose you and I both know that we are each avid chess players and that, moreover, you favour playing white and I favour playing black. Well, of course that is not germane to the situation we are in; but it might well be the contextual fact that prompts you to call me rather than the other way round.[11] White goes first.

Features of a performer are salient to a spectator for a fact or set of facts just when the learner-spectator, under a suitable common knowledge requirement, (a) can notice those features as regularities in the behaviour of the performer, (b) when the spectator concludes both that some pattern and some set of causal facts obtains and that whenever those features appear in the same context then the same set of causal facts obtains *and* (c) that most other spectators will conclude both the first two of these things as well.[12] The first two of these conditions, as in standard coordination problems, specify that a feature is salient if it is thought to guide future responses, if it is seen as *projectable*. And, as in standard coordination problems, the third condition specifies that a feature is salient if it stands out as projectable *for a population*, in this case a population of spectators.

To reiterate: the data-stream is perceived *by attending to performers* or other animated objects presented in a theatrical performance. There is nothing esoteric about *attending to* someone or something. We all do it. Think of the kinds of things going on when you attend to your sick friend, when you attend to your lover, when you attend to your nemesis at cards or when you attend to someone on the street whom you have never seen before but whose behaviour suddenly strikes you as odd, interesting or entertaining in some unusual way. There are three elements in these phenomena: attending to someone involves listening and watching for particular events and features, where the range of things listened and watched for is defined by the kind of situation in which the listening and watching take place; attending to someone requires being prepared to respond to that for which one has been watching and listening, where that preparedness and the responses themselves usually take some sort of physical form;[13] and those people who

are attended to also react physically and sometimes emotionally. This last fact is important for applying this analysis to spectating because, as anyone who has ever worked in a theatre knows, performers are keenly aware of the reactions of those spectating them. If the response is not what was intended, performers may change the performance to make it more likely to get the responses they intended.

None of this is controversial. But its importance has been underemphasized in the literature on spectatorship. For what it reveals is that it is not stories, or any other *representations*, but *features of what is presented* that are salient to a spectator. These are usually features of performers, but of course, we should also include features of the *mise en scene* as well. For they too are likely to be salient in this way, as would be expected were we to employ a standard notion of 'salience'.[14] The crucial point is that it is the features presented, out of which representations are constructed, that constitute the data-stream that any spectator sees, hears and feels.

The comparative objectivity of any description of a data-stream is not guaranteed, of course. But to the extent it does occur in a population, the explanation for its objectivity is provided both by the feature-salience story about convergence to at least roughly the same features and by the fact that event segmentation appears to be universal. We should recognize that it is highly unlikely that *all* spectators will always find salient *all* and exactly the same features. But this is not the disastrous conclusion it appears to be. For one thing, the absence of some convergence does not entail there is no convergence. And the following three considerations may lead us to accept the rough objectivity of most descriptions of the data-stream.

First, each spectator also knows that whatever he or she says when discussing a performance with others will not be counted as demonstrating understanding if it does not agree in the main with the characteristics others are discussing. So there will be conservative social pressure both to look for and respond to the same features that others are likely to find salient and to track precisely those in developing the description of the content of the performance.[15]

Second, spectators' physical reactions are 'catching'. Anne Ubersfeld makes this and related observations the basis of a detailed analysis of spectator pleasures.[16] And, of course, there are many involuntary or nearly involuntary responses that are contagious.[17]

And third, spectators go to theatrical performances expecting performers to present them with an ordered sequence of materials to grasp, *and* they are rarely disappointed in that particular regard. This common practice allows spectators to assume they *are likely to* grasp that which is presented; so there is less built-in risk of finding the 'wrong' features salient. They are usually and accurately confident that they will find salient the same features that

others are fixing upon. Often, the relation between performers and spectators that is central to these art forms nearly guarantees that will be the case.

Updating

Inferences made in time involve updating. A successful theory of theatrical understanding will involve figuring out how to model the updating of spectators' expectations regarding what is to come, what has happened and the kind of events that are transpiring. While that may be obvious, I do not think the implications of this fact have been obvious to many theorists of theatre. Semiological analyses, for example, seem right to me insofar as they construe performances as intentional arrangements of *signals*.[18] They go wrong, in part, by giving a thoroughly semantic interpretation of the notion of 'signal' and – even though the temporality of theatre is acknowledged – in part by treating performances as sets of synchronic, momentarily stable signals, whereas understanding a theatrical performance seems to require we treat them as diachronic, as ever-changing, ever-shifting phenomena. Some story about belief-revision *in time*, given a shifting data-*stream*, is required. And that is why examining inferences in time is important.

The importance of updating can be underscored by noticing two striking facts, illustrated in the following anecdote. Not too long ago, I attended a performance of Caryl Churchill's *Love and Information* at the Royal Court Theatre in London. A man sitting on the row in front of me simply did not understand anything of what was on view. This may seem odd since Churchill's piece consisted of some fifty-seven straightforwardly narrative scenes. And, as Michael Billington's review puts it, 'James Macdonald's production gives them a specific social context'.[19] But, while each scene was intelligible in its own terms, the challenge posed by the piece was that there was no narrative arc and no reappearing characters to develop over the course of the short play. In the production I saw, for example, there were sixteen actors playing over 100 different characters. There did appear to be *something* holding it together; but unless you were used to that particular kind of ambiguity in a theatrical performance, you would be like that man on the row in front of me: you would seem not to understand it, even minimally. In contrast, the man's significant-other appeared to me to be totally absorbed in the play, especially as it became clear, about five to ten minutes into the performance, that there was not going to be any overall narrative expectation fulfilled over the course of the play. No longer looking for a narrative arc, she seemed to change *the kind* of expectations she had, away from the narrative structure of each individual scene and towards some other overall non-narrative structure, perhaps thematic. In sum, she appeared to 'get it', and he never did.

More explicitly, these facts show that when spectators 'get it', successfully tracking what *is* or *could be* causing the data-stream, they often do so very quickly; but when they do not, as often happens to some people when confronted with styles or traditions of theatrical performance with which they are unfamiliar, they frequently simply cannot make any sense of the performance at all. These phenomena are familiar to performance practitioners. But, until recently, neither these phenomena nor their implications have been explained by appeal to a more general model of human comprehension and response.[20] A reasonable account of the nature of updating should explain these facts.

Finally, notice that it is generally acknowledged, about the kinds of inferences people make when confronted with some stream of data, that those inferences can be modelled as supporting hypothesis formation about what to expect *and* what *has* happened. But what is less widely recognized is that the same data can support inferences about the *kinds* of things one can expect.[21] Because this is so, a spectator trained to look for different sorts of narrative arcs is able to distinguish (albeit not infallibly) among, for example, Sophoclean, Euripidean, Stanislavskian, Brechtian and Grotowskian narrative kinds, merely by gathering in the data-stream itself.[22]

WHAT DO PERFORMERS DO?

Performers create signals that guide spectators both in their discernment of the data-stream and in forming hypotheses about what is causing it.[23] The view explains how those signals are generated by taking performance to be a kind of display behaviour in the human animal.[24] The features that performers employ and display as signals, from which spectators can discern the data-stream and form hypotheses about its cause, depend on the kinds of choices performers make. Having made their choices, performers display those chosen features. This analysis allows us to explain the difference between performing, *per se*, and the narrower category of performing we call 'acting'.

The development of this view has had more to do with 'signal theory' than it does with the equally familiar semiology.[25] The reason is that I see no solid rationale for thinking that signals must always have a semantic element, a view to which semiology is committed. Nor do I think, as semiologists do, that spectators 'translate' the signals they see and hear. We can explain a wider range of phenomena by holding instead that they develop and change their expectations about what is going to happen, what is causing it and what kind of thing that is.[26]

Demonstrative theories of quotation are used to present the developed view of these signals. The demonstrative theories of quotation upon which I rely

show us why there is no substantive conceptual difference between performance and acting, contrary to what both some acting-process theories and performance theories have held.[27] There *is*, to be sure, an important historical difference, and that can be traced to a historical difference in theatrical traditions. These are importantly related historical developments, to which any acting-process theory or its critics should be attentive.

Performers' choices

Performers make choices about what spectators will hear and see. These choices form most of the data-stream that any spectator will encounter in a performance. To make their choices, performers must answer five basic questions, that I will call 'the performer's questions'.[28]

a) What do I say, if anything?
b) How do I say it?
c) What do I do when saying it?
d) What do I do when not saying anything?
e) Where do we (as a company) direct spectators' attention so they are best positioned to infer what we intend them to?

These are choices about features, often a performer's own features, and how to reveal some of them and hide others.

Performing as a kind of display behaviour

Some species of ants 'conduct ritualized tournaments, in which hundreds of ants perform highly stereotyped display fights' rather than engage in actual 'physical fighting when territorial borders are challenged'.[29] Some primates engage in 'wild and impressive display', and 'carefully plan and execute it' so as to 'better their chances of intimidating rivals without recourse to actual physical combat'.[30] And 'a ranking Kwakiutl' would avail himself of 'a channel for claims of status to be made publicly, privileges to be displayed, and ceremonial hospitality to be offered', so as to enhance his family's social status.[31] This ethnological information about members of animal species, including our own, is the grounding of the theory of performance I propose. For, similarly, performers display features of themselves for an intended sequence of effects, cognitive and affective; and by displaying a perceptible data-stream, they guide spectators in updating their expectations, conditional on changes in the data-stream.[32]

Not many performers will recognize themselves in what I have just written. This should not be surprising. Since performers are usually committed to

some performing-process theory, a theory about how to perform *well* or in a given *style*, they will usually follow the instructions they have internalized. But performing-process theories do not tell us what philosophical reflection does, namely, *what it is* that they are doing; instead, they tell people how to do it, how to do it better or how to do it a certain way.

In contrast, consider a friend, Angela, telling you about a conversation she overheard between two actors whom Angela refers to as 'He' and 'She'. Angela reports the conversation thusly:

> He said, 'I'm going to play Gertrude',
> and she went (*eyes rolling accompanied by a barely articulate gurgle*).[33]

Douglas Patterson claims that in such cases there is no difference between the references inside the quotation matrices ('he said' and 'she went'); for, he observes, both can be construed as references to behaviour that is immediately displayed. Whether or not Patterson is right about quotation in general, his claim provides us with an important suggestion for understanding what goes on in theatrical performances.[34]

Borrowing some of the apparatus that Nelson Goodman employed in discussing 'exemplification', we gain an analysis of how these displays work in performances.[35] To exemplify is to make prominent certain features of a putative sample that are the relevant features for demonstrating the target information to another person. For example, a tailor's swatch of cloth is taken to exemplify the suit, even though it is only a sample of cloth out of which a suit will be made. More precisely, to exemplify is both to present names or labels of selected properties that the target has and to make some sort of reference to them.

What governs the selection of a swatch of fabric for display is often just the fact *the other person* is interested only in certain features of the swatch and not others, the colour and texture as opposed to the size, *because* the other person is interested in how the fabric will look when it covers her sofa. As Mary Sirridge points out, in the context of a school for tailors the size may well be the very feature selected and exemplified.[36] Thus, the selection of what features to display is context dependent, then, just as are the features of demonstrated samples in indirect and direct discourse.

Performing and acting

Acting is a type of performance, no matter how influential the type has become at a given arbitrarily chosen time. As a matter of historical fact, when spectators *currently*, and appropriately, infer that what is causing the data-stream is some story, something that is *narratively structured*, the

performers are doing what we call 'acting'. Otherwise, they generally are not. A problem case, of course, is the one mentioned earlier: a performance of *Love and Information*. Part of the spectator's temptation to continue to try to give the whole production a narrative arc is that each individual scene *is* acted out. But the whole is not. And therein lies the rub for our spectators. When performers' signals guide spectators to infer agency and actions, either within a scene or through a performance, the entire performance often gets understood – or in that case misunderstood – as 'a narrative performance'.

Actors, no matter what acting-process theory they are trained in and reveal in their performances, answer those same five performer's questions. They often presuppose a particular range of answers that other kinds of performers have not. Singers, jugglers, performance artists, professional wrestlers and mimes have selected the ranges of things they are supposed to be able to say and do, and of the manner or styles in which they may say or do them. That is different from the range of things that actors have considered within their ranges for most of the past 200 years or so. But all of them choose what to display by answering those same performer's questions.

This account does not deny the fact that actors often have used narratively structured *writing* to guide *them* in making their choices. That they need not do so is shown in *Commedia dell' Arte* and contemporary improvisational performances. But in the late Western theatrical tradition, which has largely been a tradition of 'literary theatre', they have mostly done so. Stories have often been written in the form of play-scripts, and those facilitate their choices. In contrast, when performers create signals that are organized around an object that is not narratively structured, performers will attempt to guide spectators to infer the relevant structure as the cause of the data-stream. The form that guides them may be a 'script' structured according to the musical sonata form, to a numerical sequence, to the structures of a lyric poem or even to something quite random. If spectators infer that as the kind of cause producing the entire data-stream, the performance will be called 'non-narrative', 'quasi-narrative' or sometimes 'postdramatic' depending on the structure the perceived data-stream actually has.

WHAT IS THE RELATION BETWEEN OBSERVED AND PARTICIPATORY THEATRICAL PERFORMANCES?

As indicated previously, I approach this question by investigating the relation between spectating and spect-acting. In a recent article, Bertie Ferdman[37] gets two theoretical culprits in her sights and quite rightly criticizes both of them: it has been thought by many theatre theorists that (a) in order to be 'an agent of change, . . . spectating had to be active', and that (b) in order for

spectating to be active, theatre had to be 'participatory'.[38] Ferdman correctly claims that both (a) and (b) are misguided. The reasons are first that the claim that spect-actors are *active* in some *different* way from the ordinary activity of spectating does not follow from the claim that theatre is, at some historical moment, an agent of change. Nor, secondly, does the claim that theatre needs to be participatory follow from the claim that spect-acting is active.

To defend her position, Ferdman enlists Jaques Ranciere who writes, 'The spectator also acts, like the pupil or scholar. She observes, selects, compares, interprets. She links what she sees to a host of other things that she has seen on other stages, in other kinds of place'.[39] Ferdman and Ranciere correctly take their objection to be directed at the alignment of spectating with passivity and of spect-acting with activity. What is questionable about the alignment can be seen by reference to the fact that, to gain any sense of what is going on in a performance, one must engage in offering guesses as to the causes of the data-stream and revising those guesses as the data-stream changes. It is hard to see this as 'inactive' or 'passive'. Also, both spectators and spect-actors alike must come to some understanding of what prompts them to act and react; and there is no reason to think they bring a different and special mental apparatus to that task than the one they employ with everyday events. And that apparatus is always active, involving searching for relevant signals and being physically responsive to them when they are discerned.

Three issues

Ferdman claims that 'participatory practices in theatre have historically been concerned with reviving and experimenting with the actor/spectator dynamic'.[40] This tells us neither whether the distinction between observed and participatory theatre is real or unreal nor, if there is no real distinction, why so many people believe there is one. However, it does lead us to three issues we need to discuss. (a) We need an explanation of the relationship, or 'dynamic', itself. (b) Such experiments also involve human subjects. And, as with any experiments that involve human subjects, some moral issues *could* arise. That some theatre gives rise to some potentially severe moral issues also needs explanation and discussion. (c) Such experiments also raise questions about how attention can be managed in a theatrical production. This epistemic issue in theatre also needs discussion and explanation.

The moral issue about participatory theatre

Some experiments with the actor/spectator relationship can create difficult moral problems for those producing the performance. This is because some

experiments in the actor/spectator relation have employed people who cannot reasonably be thought to have given their consent to the experiments. In many other contexts, it is immoral or illegal to act in such a way that you impose some potential for harm on an agent who cannot give consent to being acted upon in that way. Consider being offered a treatment for a disease, a treatment moreover with the real potential for harmful side effects, when you are comatose. We cannot even so much as make you that offer unless you can consent. And since you are comatose, you cannot consent. Consider, for a case that may be even closer to the point, offering a treatment for a mental condition where the very presence of that condition renders an individual incapable of understanding the treatment you may wish to offer. To bring the case still closer to our target, suppose that you *who are offering the treatment* do not yourself actually know what sort of side effects the treatment you are offering might have.

These cases are very similar to some circumstances that Nicola Shaughnessy describes and worries about in a 2005 essay and a subsequent book in 2012.[41] Shaughnessy asks the right question, I believe, when she asks, 'What are the ethics of using these methodologies when we are working with real lives?'[42] At the outset of the essay, Shaughnessy describes two cases that are of particular importance to her. The first concerns a group of students who are involved in a project led by a theatre company. They were to work alongside members of the theatre company and, it appeared, to 'operate in a controlling authoring role; they decide on an issue they want to explore . . . and use the resources supplied by the company . . . to document their work and to share it with other audiences'.[43] But, while it might seem the students are engaged in a project that gives them some autonomy, that is an 'illusion', because there is in fact a hidden script that the acting company is following. And the actors are merely playing certain roles. But, as it happens, the students involved in the experiment already knew this and were not deceived.

Shaughnessy's second case is more problematic. At the time, the most recent production of a company she studied was 'developed, in part, to appeal to children with autistic spectrum disorders and offer an insight into the sensory, tactile and visually detailed world that the autistic child inhabits'. Shaughnessy comments that

> autism is generally defined in terms of three areas, referred to as the 'triad': social interaction, communication and imagination. In [the company's] theatrical environment, these elements are actively and spontaneously engaged: the regular eye contact between performer and participant as the tactile exchanges take place is one indication of the benefits of this experience. The children involved engage in turn taking and communicate through their bodies and voices in ways which are not typical for neuro-divergent individuals.[44]

The moral problem she sees in both cases is that a methodology of *pretending* to be someone else was employed by the actors, while the alleged beneficiaries of these experiments were *not* pretending.

What she finds promising for answering her basic moral question in the activities of the two companies she examines is that their theatre practices actually 'undermine the theatre of pretence'.[45] In the first case what she thinks undermines the theatre of pretence, 'of lies', is that the 'participants' were not fooled. In fact, when told it was a pretence in which they had been involved, she writes, 'The pupils were nonplussed; they revealed that they hadn't been fooled but had been aware that they were playing a game from the start'.[46] And in the second case Shaughnessy appears to claim that the theatre of pretence is undermined simply because it offered a means by which autistic children became able to do something positive that their condition had prevented them from doing before.[47]

But the real moral problem here is that to describe the students as 'participating' in the way they are characterized in Shaughnessy's essay and book is to give them a feature they do not have, the absence of which constitutes the moral problem. As Aaron Smuts writes, 'Participation is best thought of as a behavior ascribed to agents who are helping us to achieve some goal. It carries with it connotations of cooperation'.[48] But this does not seem true of many people who are alleged to participate in many 'participatory' performances. They certainly do not cooperate in either of the cases Shaughnessy describes even though, in the first case, they may know what is going on and continue anyway. They are not cooperating with the company and its aims so much as 'going along to get along'.

Perhaps all Shaughnessy means is that these students are *responsive* to the situation and the professional company, and the latter are to them as well. In which case, Smuts is right to claim 'to call an activity participatory seems to imply that we react to or are reacted to by another agent,' but that just seems a convoluted way of saying that in such activities each party is *responsive* to the other.[49] But so far we have no clear explanation of the moral dimensions of these cases *in terms of participation*.

The epistemic issue about participatory theatre

Some variations in the actor/spectator relationship create experiments that examine how attention is managed. One proposal for how these experiments work is that we should think of them as attention-*training* exercises. The rough thought is that different ways of managing the actor/spectator dynamic involve, even require, differences both in what is attended to and in how attention is gained, directed, caused and/or controlled. Experiments with the actor/spectator dynamic are, on this proposal, ways of discovering what

The relationship between 'observed' and 'participatory' performance 151

happens when both the mechanisms and the objects of theatrical attention are changed.

This proposal was recently made by Laura Cull.[50] Cull uses what Alan Kaprow called 'Activities' (instead of the better-known 'Happenings') to motivate her discussion of attention-*training*. Cull writes that

> both Kaprow and [Henri] Bergson, in particular (and, to some extent, [Giles] Deleuze) emphasize 'attention' as a condition of ontological participation in a manner that allows us to rethink participation in performance beyond any opposition to observation. Indeed, I want to suggest that Kaprow conceives the Activities as a kind of attention-training that undoes subjective discreteness in favour of inviting immanent participation in the real as a changing 'whole'.[51]

On this account, what participatory theatre can achieve is a kind of 'attention training' where the results of that training can vary depending upon (a) how much the spectator is 'in the midst of doing [something] and . . . responsible for what is done', (b) how much her attention has been 'drawn . . . to the ordinarily unattended . . ., and away from the obvious', and (c) how much she gives 'a particular kind of attention or framing which transforms that to which is attended – the routine or the everyday'.[52] As Cull acknowledges, this is also true of observed theatre. Note three elements: attention is different (in some way) when (a) one is doing something, (b) one's attention is drawn away from the ordinary objects of attention and (c) one sees the ordinary objects of attention in some new way – including, of course, just noticing how ordinary they are.

This does not tell us much about the alleged difference between 'observed' and 'participatory' theatre. It does not tell us very much about its central notions, 'attention' and 'attention training', which are to be the remedy for having a flawed understanding of these matters. What looks right about it are the facts that attention under control of a task is different from attention that is not, that attention captured by some feature becoming suddenly salient is different from attention controlled by a task and that seeing ordinary things in some new way, for example, as not ordinary at all, requires some sort of shift in attention. These three facts are important but, as yet, they are unexplained.

What is 'interactivity'?

The proposal I will make is that substituting 'interactivity' for 'participatory' helps us with all three issues. Accordingly, we should first examine the concept of 'interactivity'.

An early suggestion that has been influential comes from narratology. Marie-Laure Ryan held a work is 'interactive' if it *makes use of* 'user input'. The specific range of uses she had in mind are those wherein the user leaves

some sort of 'durable mark' on the text of a work. An influential aspect of her view is that interactivity is to be found on a continuum ranging from a relatively low level to a much higher level.[53] But her definition, even if on the right track, is too broad and allows too many things to count as interactive: any computer program whatever – for example, a word processor – makes use of user input, but many would not be called 'interactive' on just about anyone's common understanding of that term. In another direction, the definition is also too narrow, including only textual marks as durable. And instead of a genuine conception of a continuum, Ryan represents it more like a *small set of kinds*, whereas a genuine continuum is more like a sliding scale.

Another early influential entry into the discussion of interactivity found expression in an essay by Terrance Rafferty in the *New York Times*.[54] Rafferty holds that 'interactivity' refers to a kind of control that *spectators* have by virtue of being unable or unwilling to go along with the prescriptions of the artist. This is on to something important, as we will see; but it too is overly broad. On this view, someone who resists a movement in the art world, and plots out another course, could be characterized as interacting with the art world. And while some might call that an 'interaction', they would do so at the risk of making the term utterly vacuous, marking out nothing distinctive about the act of resistance. So also, someone who is prescribed to engage with a theatre piece and actively seeks any sort of control over that engagement simply by leaving the room could be said to be interactively involved with the piece.

Continuing a thought of Ryan, that interactivity is a matter of making use of user input, David Saltz has refined that notion, holding that for a work to be interactive

'the following events must occur in real time:

1. A sensing or input device that translates certain aspects of a person's behaviour into digital form that a computer can understand.
2. The computer outputs data that are systematically related to the input (i.e., the input affects the output).
3. The output data are translated back into real-world phenomena that people can perceive'.[55]

This view, despite its incorrect commitment to the view that all 'interaction' is computer based, has also been influential, most notably on the theory of Dominic McIver Lopes, whose view is now taken by philosophers of art to be the default position.[56]

Lopes retains and refines the rough ideas shared by both Saltz and Ryan in what he calls 'strongly interactive' art forms. In such forms, Lopes holds that users can change the artwork itself by their actions. He contrasts these

ideas with 'weakly interactive' media that simply allow users to control some aspects of the order of information presented to the users.

> [I]n strongly interactive media we may say that the structure itself is shaped in part by the interactor's choices. Thus strongly interactive artworks are those whose structural properties are partly determined by the interactor's actions. By a work's 'structural properties' or (more briefly) 'structure' I mean whatever intrinsic or representational properties it has the apprehension of which are necessary for aesthetic engagement with it – sound sequences in the case of music and narrative content in the case of stories.[57]

This is clearly a step forward from its predecessors and from the main alternative tradition on this topic as well.

That alternative is largely the result of the work of Janet Murray who is responsible for the two main, and unexplained, assumptions about interactive narrative made in the study of what is now called 'interactive digital narrative'.[58] Those assumptions are that interactivity is a species of participation and that the idea of 'participation' is intuitively clear.[59] But as this chapter has shown, neither of those claims is obviously true.

Even if an advance, however, Lopes's view is not free of problems. Aaron Smuts has argued against it for being overly inclusive as well and also of collapsing into the notion of 'weak interactivity', which is little more than Rafferty's early view.[60] We need not be detained by Smuts's arguments on these points; what is of interest is what he does with this material. One thing is that he holds onto the ideas that something is interactive if and only if there is some relevant and intelligible connection between the user's actions and the responses of the art work to those actions, and *vice versa*, and that an interactive medium must (a) be responsive, (b) allow for some, but not complete, control both by users and by the art work and (c) not produce completely random responses.[61] What is not present, although called for, is the idea of that 'interactivity' is a scalar concept. We want to describe some performances as having very low degrees of interactivity, some as having very high degrees of it, and to be able to explain this.

'Observed' and 'participatory' theatre

Earlier, I indicated I would propose that we get closer to resolving these issues by using the language of 'interactivity' than we do using the language of 'observation' and 'participation'. Thinking about interactivity as coming in degrees, as scalar, provides both the range and the features we want for characterizing the actual relationships within the kinds of theatre we are considering. The noun, 'scale', is often used to refer to 'a succession or progression of steps or degrees or a graduated series'. Relatedly, the term may refer

to 'series of marks laid down at determinate distances, as along a line, for purposes of measurement or computation'.[62] Just so, the term is used here primarily to note that so-called 'observed' and 'participatory' theatre are marks of that sort, and that what they mark is particular degrees of interactivity, of non-random responsiveness and of (incomplete) control by either party.[63]

So, first, and most generally, all theatre is interactive. Anyone attending a theatrical performance interacts with it to some degree. All theatregoers respond to the performance and the performers before them. Performers are able to respond to spectators and revise their performances so that they are more likely to elicit from those spectators the responses they wanted and intended. By means of their responses to each other, each party to the performance is incompletely controlling the other and, to some degree at least, the performance as well.

The distinctions between spectator and spect-actor, as well as between observed and participatory theatre are not, as I have been suggesting, distinctions between *kinds* at all, but rather between indicators of positions on a scale of interactivity. So-called observed theatre and spectating involve comparatively low degrees of interactivity. Participatory theatre and spect-acting involve comparatively higher degrees of interactivity. For example, spectators need not leave their seats nor performers leave the stage in order to interact at the lower levels. At higher levels, not only may spectators have to leave their seats and wander the performance space in order to attend to performers, but they may even change the structure of the performance. And performers could be required to leave the stage and brace the spectators in order to generate the signals that will guide those spectators.[64]

In some higher-level interactive performances spectators and performers may be required to cooperate in the collaborative generation of the performance. But others with only a slightly lower degree of interactivity will *not* involve cooperation on that kind of project.

Recasting the moral issue in terms of interactivity

Neither of the cases Shaughnessy describes are cases of genuine participation because, although they are both at a comparatively high level of interactivity, they do *not* require genuine cooperation. And, although the same general moral issue arises in each, her cases seem to differ from each other as well. In the first case, the students are made to *appear* to be genuinely cooperative, when they are not. But this is not true in the second case: these children do not even so much as appear to be cooperative.

Using a scalar notion of interactivity offers an alternative way of describing her cases that allows us to gain some clarity about their moral dimension.

That is, using that notion, both the common moral issue and the differences between the cases can be clarified. The students in both cases can be described as 'users' in an interactive environment. Thinking about the 'participants' as 'users' is the key both to what is similar and what is different about the cases. What is similar is that neither can give consent to be users of the kind required. The difference is that they do not give consent for different reasons. The students in the first instance were not privy to the details of the 'user-contract' into which they had entered and that required them to be interactive users in the generation of a performance. So they *did not* give their consent to be involved. In morality and law, if one enters into an agreement in innocent ignorance of its terms, one cannot be held to the terms. The autistic children in the second case *cannot* have given their consent requiring them to be interactive users in the generation of a performance. In morality and law, if one cannot give consent because of a mismatch between the complexity of the agreement and one's capacities for grasping those complexities, again one cannot be held to the terms of the agreement. They both can, of course, be users of the kind the contract specifies, and they both might benefit from the contract. But they either did not or could not *give consent* to being in that user-position. So, the moral dimension of both theatre practices is both very real and yet quite different, because it is arrived at by different routes.

What this comes to of course is that not all highly interactive theatrical performances are high enough in interactivity to be called 'participatory'. And the benefit of using a scalar notion of interactivity here is that it helps us see both why we might be tempted to call Shaughnessy's cases 'participatory' when they are not genuine cases of participation, but also how close they are to cases with high enough degrees of interactivity to be so called. The features of the cases – their lack of cooperation and lack of consent – both tend to reduce their level of interactivity and are responsible for the moral judgements we want to make about the cases.

Recasting the concept of attention in theatre in terms of interactivity

Cull is right to hold that attention under control of a task is different from attention that is not, that attention that is captured by some feature becoming suddenly salient is different from attention that is controlled by a task, and that seeing ordinary things in some new way, even noticing their ordinariness, requires some sort of shift in attention. And Kaprow's Activities, which Cull uses to illustrate the foregoing, involve a very high degree of interactivity; high enough, I would add, that the participants in these performances surely were cooperating in the generation of the performance.

Cull should not restrict her account of attention-training to cases like this, for it is clear that attention-training, if it is to be more generally useful, must transcend this kind of case.

That is, it would be nice if the kind of attention-training to be found in higher levels of interactive theatre had the result that it allowed for increased attention that is transferable to other circumstances, and not only in the same set of skills as occurred in the 'training set', that is, in those particular theatre practices.[65] I presume that Cull wishes to claim that result and would like to hold that the kind of attention-training she is interested in makes us more likely both to attend better and to attend to more elements of greater importance in our lived environment, outside the theatre. But it may well be that an interactive performance that yields the desired transferrable skills will not always, and perhaps not even typically, be as highly interactive as Kaprow's activities.

There are other activities wherein users interact with something and undergo a kind of attention-training as well, namely, video games. And current empirical evidence suggests that attention-training involving interactivity in video games, in contrast to other kinds of attention-training, *is transferable* to other dimensions of human life.[66] It is often the case that, while 'humans have an incredible capacity to acquire new skills and alter their behaviour as a result of experience, enhancements in performance are typically narrowly restricted to the parameters of the training environment, with little evidence of generalization to different, even seemingly highly related, tasks'.[67] But this is not so with interactive video games, *even when the degree of interactivity is fairly low*.

So, independently of Cull's correct observations about tasks, saliency and their roles in attention, it appears it is not the high level of interactivity in Kaprow's 'activities' that caused the attention-training she is seeking; it *seems* to be some feature of interactivity itself, appearing at a variety of degrees, that causes transferable attention-training.[68] This is why Cull is also correct to conclude that even so-called 'observed' theatre can involve the kind of attention-training she is interested in.[69] And this is another reason why thinking of so-called participatory and observed theatre as merely marking different degrees of interactivity is important.

NOTES

1. Matthew Reason, '*Participations* on Participation: Researching the "active" theatre audience', *Participations,* vol. 12, no. 1 (2015), 271–280.

2. For any kind of performance, what is presented to them is so for some purpose, albeit not necessarily discernible. I have argued elsewhere that because they are aware

of this teleological context some inferences about what is causing the data-stream are ruled out. James R. Hamilton, ' "Illusion" and the Distrust of Theater', *The Journal of Aesthetics and Art Criticism*, vol. 41 (1982), 39–50.

3. The term 'spect-actor', which I will henceforth use without quotation marks, is borrowed from Augusto Boal, who coined the term in conjunction with what he called 'Forum Theatre' and then used it in other contexts, with roughly the same meaning. Augusto Boal, *Theatre of the Oppressed*, trans. Charles A. McBride (Theatre Communications Group, 1993). That said, it must also be said that had I seen (or noticed) the following two articles before submitting this one, I probably would have used the word 'attendant' in order to stress both the fact that people are present at a performance and the possible fact that they might be called upon to participate in it. Stephan di Benetto, 'Guiding Somatic Responses within Performative Structures', in Sally Banes and Andre Lepecki (eds.), *The Senses in Performance* (New York/London: Routledge, 2007), 124–134; Jon Foley Sherman, 'Plural Intimacy in Micropublic Performances', *Performance Research*, vol. 16 (New York: 2011), 52–61.

4. A fuller treatment of these issues can be found in James R. Hamilton, 'Notes toward a Theory of Spectating', *The Journal of Dramatic Theory and Criticism*, vol. 27 (2015), 105–125.

5. Alison Gopnik, 'Explanation as Orgasm', *Minds and Machines*, vol. 8 (1998), 101–118.

6. Jeremy R. Reynolds, Jeffrey M. Zacks and Todd S. Braver, 'A Computational Model of Event Segmentation from Perceptual Prediction', *Cognitive Science*, vol. 31 (2007), 613–643.

7. Joseph P. Magliano and Jeffrey M. Zacks, 'The Impact of Continuity Editing in Narrative Film on Event Segmentation', *Cognitive Science* (2011), 1–29. Accessed November 2012, doi: 10.1111/j.1551–6709.2011.01202.x.

8. Jeffrey M. Zacks, Barbara Tversky and Gowri Iyer, 'Perceiving, Remembering, and Communicating Structure in Events', *Journal of Experimental Psychology,* vol. 130 (2001), 29–58; Christopher A. Kurby and Jeffrey M. Zacks, 'Segmentation in the Perception and Memory of Events', *Trends in Cognitive Sciences*, vol. 12 (2008), 72–79.

9. Much of the material in this and the next two subsections is drawn from James R. Hamilton, *The Art of Theater* (Wiley-Blackwell, 2007). See also James R. Hamilton, 'The "Uncanny Valley" and Spectating Animated Objects', *Performance Research: A Journal of the Performing Arts*, vol. 20 (New York and London: 2015), 60–69.

10. Much of the material here, as was also the case in Hamilton, *The Art of Theater*, 91–113, is based on the work of David Lewis, *Conventions* (Cambridge, MA: Harvard University Press, 1969).

11. This is a favoured example of Lewis's by which he exemplifies both the notion of salience and that of 'coordination games' and how they are unlike competitive games.

12. Hamilton, *The Art of Theater*, 96–100.

13. It is often thought that if you do not wipe a sick friend's fevered brow, you are not actually attending to him. I think this is too strong. It may be, as J. J. Thompson

puts it (in a very different context) that it is only 'minimally decent' of you to do it. But your sick friend does not have a right to it, nor does failing to do that indicate you were not watching and listening. What is required, arguably, is *preparedness* to respond, not the response itself. Judith Jarvis Thomson, 'A Defense of Abortion', *Philosophy and Public Affairs*, vol. 1 (1971), 47–66, especially 62–65.

14. It is important to note that the features regarded as salient are also typically intentionally generated by those performers and other theatre artists for that very purpose.

15. Seamus Miller, 'Coordination, Salience and Rationality', *The Southern Journal of Philosophy*, vol. 24 (1991), 359–370; Robert Sugden, 'The Role of Inductive Reasoning in the Evolution of Conventions', *Law and Philosophy*, vol. 17 (1998), 377–410; and Peter Vanderschraaf, 'Convention as Correlated Equilibrium', *Erkenntnis*, vol. 42 (1995), 65–87.

16. Anne Ubersfeld, 'The Pleasure of the Spectator', trans. Pierre Bouillaguet and Charles Jose, *Modern Drama*, vol. 25 (1982), 128.

17. Tamar Szabó Gendler, 'Imaginative Contagion', *Metaphilosophy*, vol. 37 (2006), 183–203.

18. See, for example, Erika Fischer-Lichte, *The Semiotics of Theatre*, trans. Jeremy Gaines and Doris L. Jones (Bloomington: Indiana University Press, 1992). Catherine Bouko, 'Jazz Musicality in Postdramatic Theatre and the Opacity of Auditory Signs', *Studies in Musical Theatre*, vol. 4, no. 1 (2010), 75–87.

19. Michael Billington's review in *The Guardian* gives a clever interpretation of the play, namely that what the play is about is that the information saturation we are undergoing makes it difficult to gain or remain in human and humane relationships. That is, this is what Billington takes as a *theme* that holds it together. Perhaps he is right. But I am not discussing interpretations here. Michael Billington, 'Caryl Churchill, Love and Information – Review', *The Guardian*, 15 September 2012, accessed 24 November 2012, http://www.theguardian.com/stage/2012/sep/15/love-and-information-royal-court-review.

20. Noël Carroll has described these phenomena, albeit not in these terms, in Noël Carroll, 'Toward a Theory of Film Suspense', *Persistence of Vision*, vol. 1 (1984), 65–89 and Noël Carroll, 'The Power of Movies', *Daedalus*, vol. 114 (1985), 79–103.

21. Noah D. Goodman, Tomer D. Ullman and Joshua B. Tenenbaum, 'Learning a Theory of Causality', *Psychological Review*, vol. 118 (2011), 110–119.

22. For these reasons one might be inclined, as I am, towards a Bayesian account of updating.

23. A fuller treatment of some of this material can be found in James R. Hamilton, 'Acting', *The Journal of Dramatic Theory and Criticism*, vol. 28 (2013), 35–59.

24. Those familiar with performance theory will notice Richard Schechner's early attempts to use ethnological information as influencing this theory. Indeed, I think his ethnological view was substantially correct. But I also think it has remained largely underdeveloped.

25. Brian Skyrms, *Signals: Evolution, Learning, and Information* (Oxford: Oxford University Press, 2010).

26. Other terms for 'expectations' might be 'credences' or 'predictions'.

27. The term 'acting process theory' was introduced by Phillip Zarilli, 'Introduction', in Phillip B. Zarrilli (ed.), *Acting (Re)Considered: A Theoretical and Practical Guide* (London: Routledge, 2002).

28. Herbert Blau suggested the first four were as the core performer questions in an NEH Summer Seminar on theatre and performance at NYU in the summer of 1981. The fifth is taken from Joseph Chaikin, *The Presence of the Actor* (New York: Atheneum, 1980), 59: 'Acting always has to do with attention, and with where the attention is'.

29. Bert Hölldobler, 'Tournaments and Slavery in a Desert Ant', *Science*, vol. 192, no. 4242 (1976), 912–914.

30. Jane Goodall, *Through a Window: My Thirty Years with the Chimpanzees of Gombe* (New York: Mariner Books).

31. An ethnographically informed self-description of a potlatch by the members of the Kwakiutl Indian Band located in the T'sakis Village at Fort Rupert, BC. The webpage where this description appeared was http://www.kwakiutl.bc.ca/culture/potlatch.htm. Unfortunately, it is no longer accessible. But see Aldona Jonaitis, *Chiefly Feasts: The Enduring Kwakiutl Potlatch* (Seattle, WA: University of Washington Press, 1991).

32. In the present context, I am discussing successful signalling. Failures are perhaps even more revealing; but space does not permit a discussion of them.

33. I adopt Jane Heal's convention of putting descriptions of the relevant non-linguistic behaviour in brackets, {}, and italicizing the descriptive language. Jane Heal, 'On Speaking Thus: The Semantics of Indirect Discourse', *The Philosophical Quarterly*, vol. 51 (2001), 433–454.

34. Douglas Patterson, 'Comment on Paul Saka, "Quotation Matters"' (paper presented at the Central Division of the American Philosophical Association, Chicago, Illinois, April, 2005).

35. Nelson Goodman, 'The Sound of Pictures', in *Languages of Art* (Indianapolis, IN: Bobbs-Merrill Company, Inc., 1968), 45–95, especially 52–57.

36. Mary Sirridge, 'The Moral of the Story: Exemplification and the Literary Work', *Philosophical Studies*, vol. 38 (1980), 392.

37. Bertie Ferdman, 'Participation and Its Discontents', *PAJ: Performing Arts Journal,* vol. 107 (2014), 100–107.

38. Ferdman, 'Participation and Its Discontents', 101.

39. Jaques Ranciere, *The Emancipated Spectator*, trans. Gregory Elliott (Brooklyn, NY and London: Verso, 2009), 13.

40. Ferdman, 'Participation and Its Discontents', 100.

41. Nicola Shaughnessy, 'Truths and Lies: Exploring the Ethics of Performance Applications', *Research in Drama Education: The Journal of Applied Theatre and Performance*, vol. 10 (2005), 201–212; Nicola Shaughnessy, *Applying Performance: Live Art, Socially Engaged Theatre and Affective Practice* (London: Palgrave Macmillan, 2012).

42. Shaughnessy, 'Truths and lies', 202.

43. Shaughnessy, 'Truths and lies', 205.

44. Shaughnessy, 'Truths and lies', 210–211.

45. Paradoxically, Shaughnessy, appears to accept the view that acting *is* pretending; for she writes that 'the actor is a master of pretence, mimicry and artifice'. Shaughnessy, 'Truths and lies', 202.

46. Shaughnessy, 'Truths and lies', 207.

47. Shaughnessy, 'Truths and lies', 210–211.
48. Aaron Smuts, 'What Is Interactivity?' *Journal of Aesthetic Education*, vol. 43 (2009), 62.
49. He actually writes that to call this participatory is 'confused'. Smuts, 'What Is Interactivity?, 63.
50. Laura Cull, 'Attention Training Immanence and Ontological Participation in Kaprow, Deleuze and Bergson', *Performance Research: A Journal of the Performing Arts*, vol. 16 (2011), 80–91.
51. Cull, 'Attention Training', 80.
52. Cull, 'Attention Training', 86, 86 and 90.
53. Marie-Laure Ryan, *Narrative as Virtual Reality: Immersion and Interactivity in Literature and Electronic Media* (Baltimore, MD: Johns Hopkins University Press, 2001), 17.
54. Terrence Rafferty, 4 May 2003. 'Everybody Gets a Cut', *New York Times*, reprinted in Noel Carroll and Jinhee Choi (eds.) *Philosophy of Film and Motion Pictures* (London and New York Blackwell, 2006), 44–48.
55. David Z. Saltz, 'The Art of Interaction: Interactivity, Performativity, and Computers', *Journal of Aesthetics and Art Criticism*, vol. 55 (1997), 117–127. The quotation is from page 118.
56. See, for example, a recent essay in which Lopes's notion of 'strong interactivity' is simply adopted wholesale and without remark. Jon Robson and Aaron Meskin, 'Video Games as Self-Involving Interactive Fictions', *The Journal of Aesthetics and Art Criticism,* vol. 74 (2016), 165–177.
57. Dominic McIver Lopes, 'The Ontology of Interactive Art', *Journal of Aesthetic Education*, vol. 35 (2001), 65–81, especially 68.
58. Hartmut Koenitz, 'A Concise History of Interactive Digital Narrative', in Hartmut Koenitz, Gabriele Ferri, Mads Haahr, Diğdem Sezen and Tonguç İbrahim Sezen (eds.), *Interactive Digital Narrative: History, Theory and Practice* (Florence, KY: Routledge, 2015), 9–21.
59. Janet H. Murray, *Hamlet on the Holodeck: The Future of Narrative in Cyberspace* (Cambridge, MA: The MIT Press, 1998).
60. Smuts, 'What Is Interactivity?' 64–66.
61. Smuts, 'What Is Interactivity?' 65.
62. 'Scale', Dictionary.com, accessed on 8 June 2016, http://www.dictionary.com/browse/scale.
63. Leading ideas here are that both belief and moral status come in degrees, not kinds. Nicholas J.J. Smith, 'Vagueness, Uncertainty and Degrees of Belief: Two Kinds of Indeterminacy – One Kind of Credence', *Erkenntnis*, vol. 79 (2014), 1027–1044 and Agnieszka Jaworska and Julie Tannenbaum, 'The Grounds of Moral Status', in Edward N. Zalta (ed.), *The Stanford Encyclopedia of Philosophy*, last revised on 22 March 2013, and accessible at http://plato.stanford.edu/archives/sum2013/entries/grounds-moral-status/.
64. Using this strategy one might readily develop an error theory that could explain why people want to use the terms 'participatory' and its cognates that do not actually apply to all the kinds of phenomena they wish to describe.

65. Dennis M. Levi and Roger W. Li, 'Perceptual Learning as a Potential Treatment for Amblyopia: A Mini-Review', *Vision Research*, vol. 49 (2009), 2535–2549.

66. Moreover, even at fairly low degrees, interactivity seems also to have important consequences for determinations of credibility and on reductions in gender differences in spatial location and imaging abilities (although in the former case, cooperative interactivity at a very high degree is more likely to result in stronger determinations of credibility). Thomas J. Johnson and Barbara K. Kaye, 'Some Like It Lots: The Influence of Interactivity and Reliance on Credibility', *Computers in Human Behavior*, vol. 61 (2016), 136–145; Jing Feng, Ian Spence and Jay Pratt, 'Playing an Action Video Game Reduces Gender Differences in Spatial Cognition', *Association for Psychological Science*, vol. 18 (2007), 850–855.

67. C. S. Green and D. Bavelier, 'Learning, Attentional Control, and Action', *Current Biology*, vol. 22 (2012), 197–206.

68. Boot et al. have argued that the evidence is inconclusive as between that explanation and an alternative holding that 'pre-existing group differences in abilities that result in a self-selection effect'. Walter R. Boot et al., 'The Effects of Video Game Playing on Attention, Memory, and Executive Control', *Acta Psychologica*, vol. 129 (2008), 387–398. Nevertheless, the outlook is promising. And as recent work has shown, de-biasing across bias types and domain-generally by playing video games is strikingly more effective at bias removal than other and more direct interventions: Carey K. Morewedge et al., 'Debiasing Decisions: Improved Decision Making with a Single Training Intervention', *Policy Insights from the Behavioral and Brain Sciences*, vol. 2 (2015), 129–140.

69. Cull, 'Attention Training', 81.

BIBLIOGRAPHY

Billington, Michael. 'Caryl Churchill, Love and Information – Review'. *The Guardian*, 15 September 2012, accessed 24 November 2012. http://www.theguardian.com/stage/2012/sep/15/love-and-information-royal-court-review.

Boal, Augusto. *Theatre of the Oppressed*. Trans. Charles A. McBride. New York: Theatre Communications Group, 1993.

Boot, Walter R., Arthur F. Kramer, Daniel J. Simons, Monica Fabiani and Gabriele Gratton. 'The Effects of Video Game Playing on Attention, Memory, and Executive Control'. *Acta Psychologica* 129 (2008): 387–398.

Bouko, Catherine. 'Jazz Musicality in Postdramatic Theatre and the Opacity of Auditory Signs'. *Studies in Musical Theatre* 4, no. 1 (2010): 75–87.

Carroll, Noël. 'The Power of Movies'. *Daedalus* 114 (1985): 79–103.

Carroll, Noël. 'Toward a Theory of Film Suspense'. *Persistence of Vision* 1 (1984): 65–89.

Chaikin, Joseph. *The Presence of the Actor*. New York: Atheneum, 1980.

Cull, Laura. 'Attention Training Immanence and Ontological Participation in Kaprow, Deleuze and Bergson'. *Performance Research: A Journal of the Performing Arts* 16 (2011): 80–91.

di Benetto, Stephan. 'Guiding Somatic Responses within Performative Structures'. In *The Senses in Performance*, edited by Sally Banes and André Lepecki. New York/London: Routledge, 2007, 124–134.

Feng, Jing, Ian Spence and Jay Pratt. 'Playing an Action Video Game Reduces Gender Differences in Spatial Cognition'. *Association for Psychological Science* 18 (2007): 850–855.

Ferdman, Bertie. 'Participation and Its Discontents'. *PAJ: Performing Arts Journal* 107 (2014): 100–107.

Fischer-Lichte, Erika. *The Semiotics of Theatre*. Trans. Jeremy Gaines and Doris L. Jones. Bloomington: Indiana University Press, 1992.

Gendler, Tamar Szabó. 'Imaginative Contagion'. *Metaphilosophy* 37 (2006): 183–203.

Goodall, Jane. *Through a Window: My Thirty Years with the Chimpanzees of Gombe*. New York: Mariner Books. Houghton Mifflin Harcourt, 2000.

Goodman, Nelson. 'The Sound of Pictures', In Nelson Goodman, *Languages of Art*. Indianapolis, IN: Bobbs-Merrill Company, Inc., 1968, 45–95.

Goodman, Noah D., Tomer D. Ullman and Joshua B. Tenenbaum. 'Learning a Theory of Causality'. *Psychological Review* 118 (2011): 110–119.

Gopnik, Alison. 'Explanation as Orgasm'. *Minds and Machines* 8 (1998): 101–118.

Green, C. S. and D. Bavelier. 'Learning, Attentional Control, and Action'. *Current Biology* 22 (2012): 197–206.

Hamilton, James R. 'Acting'. *The Journal of Dramatic Theory and Criticism* 28 (2013): 35–59.

Hamilton, James R. *The Art of Theater*. London and New York Wiley-Blackwell, 2007.

Hamilton, James R. '"Illusion" and the Distrust of Theater'. *The Journal of Aesthetics and Art Criticism* 41 (1982): 39–50.

Hamilton, James R. 'Notes toward a Theory of Spectating'. *The Journal of Dramatic Theory and Criticism* 27 (2015): 105–125.

Hamilton, James R. 'The "Uncanny Valley" and Spectating Animated Objects'. *Performance Research: A Journal of the Performing Arts* 20 (2015): 60–69.

Heal, Jane. 'On Speaking Thus: The Semantics of Indirect Discourse'. *The Philosophical Quarterly* 51 (2001): 433–454.

Hölldobler, Bert. 'Tournaments and Slavery in a Desert Ant'. *Science* 192, no. 4242 (1976): 912–914.

Jaworska, Agnieszka and Julie Tannenbaum. 'The Grounds of Moral Status'. In *The Stanford Encyclopedia of Philosophy*, edited by Edward N. Zalta: last revised on 22 March 2013, and accessible at http://plato.stanford.edu/archives/sum2013/entries/grounds-moral-status/.

Johnson, Thomas J. and Barbara K. Kaye. 'Some Like It Lots: The Influence of Interactivity and Reliance on Credibility'. *Computers in Human Behavior* 61 (2016): 136–145.

Jonaitis, Aldona. *Chiefly Feasts: The Enduring Kwakiutl Potlatch*. Seattle, WA: University of Washington Press, 1991.

Koenitz, Hartmut. 'A Concise History of Interactive Digital Narrative'. In *Interactive Digital Narrative: History, Theory and Practice*, edited by Hartmut Koenitz,

Gabriele Ferri, Mads Haahr, Diğdem Sezen and Tonguç İbrahim Sezen, 9–21. London: Routlege, 2015.
Kurby, Christopher A. and Jeffrey M. Zacks. 'Segmentation in the Perception and Memory of Events'. *Trends in Cognitive Sciences* 12 (2008): 72–79.
Levi, Dennis M. and Roger W. Li. 'Perceptual Learning as a Potential Treatment for Amblyopia: A Mini-Review'. *Vision Research* 49 (2009): 2535–2549.
Lewis, David. *Conventions*. Cambridge, MA: Harvard University Press, 1969.
Lopes, Dominic McIver. 'The Ontology of Interactive Art'. *Journal of Aesthetic Education* 35 (2001): 65–81.
Magliano, Joseph P. and Jeffrey M. Zacks. 'The Impact of Continuity Editing in Narrative Film on Event Segmentation'. *Cognitive Science* (2011): 1–29. Accessed November 2012. doi: 10.1111/j.1551-6709.2011.01202.x.
Miller, Seamus. 'Coordination, Salience and Rationality'. *The Southern Journal of Philosophy* 24 (1991): 359–370.
Morewedge, Carey K., Haewon Yoon, Irene Scopelliti, Carl W. Symborski, James H. Korris and Karim S. Kassam. 'Debiasing Decisions: Improved Decision Making with a Single Training Intervention'. *Policy Insights from the Behavioral and Brain Sciences* 2 (2015): 129–140.
Murray, Janet H. *Hamlet on the Holodeck: The Future of Narrative in Cyberspace*. Cambridge, MA: The MIT Press, 1998.
Patterson, Douglas. 'Comment on Paul Saka, "Quotation Matters"'. Paper presented at the Central Division of the American Philosophical Association, Chicago, Illinois, April 2005.
Rafferty, Terrence. 'Everybody Gets a Cut'. In *Philosophy of Film and Motion Pictures*, edited by Noël Carroll and Jinhee Choi, 44–48. London and New York: Blackwell, 2006.
Ranciere, Jaques. *The Emancipated Spectator*. Trans. Gregory Elliott. Brooklyn, NY and London: Verso, 2009.
Reason, Matthew. '*Participations* on Participation: Researching the "Active" Theatre Audience'. *Participations* 12, no. 1 (2015): 271–280.
Reynolds, Jeremy R., Jeffrey M. Zacks and Todd S. Braver. 'A Computational Model of Event Segmentation from Perceptual Prediction'. *Cognitive Science* 31 (2007): 613–643.
Robson, Jon and Aaron Meskin. 'Video Games as Self-Involving Interactive Fictions'. *The Journal of Aesthetics and Art Criticism* 74 (2016): 165–177.
Ryan, Marie-Laure. *Narrative as Virtual Reality: Immersion and Interactivity in Literature and Electronic Media*. Baltimore, MD: Johns Hopkins University Press, 2001.
Saltz, David Z. 'The Art of Interaction: Interactivity, Performativity, and Computers'. *The Journal of Aesthetics and Art Criticism* 55 (1997): 117–127.
Shaughnessy, Nicola. *Applying Performance: Live Art, Socially Engaged Theatre and Affective Practice*. London: Palgrave Macmillan, 2012.
Shaughnessy, Nicola. 'Truths and Lies: Exploring the Ethics of Performance Applications'. *Research in Drama Education: The Journal of Applied Theatre and Performance* 10 (2005): 201–212.
Sherman, Jon Foley. 'Plural Intimacy in Micropublic Performances'. *Performance Research: A Journal of the Performing Arts* 16 (2011): 52–61.

Sirridge, Mary. 'The Moral of the Story: Exemplification and the Literary Work'. *Philosophical Studies* 38 (1980): 391–402.

Skyrms, Brian. *Signals: Evolution, Learning, and Information*. Oxford: Oxford University Press, 2010.

Smith, Nicholas J.J. 'Vagueness, Uncertainty and Degrees of Belief: Two Kinds of Indeterminacy – One Kind of Credence'. *Erkenntnis* 79 (2014): 1027–1044.

Smuts, Aaron. 'What Is Interactivity?' *Journal of Aesthetic Education* 43 (2009): 62.

Sugden, Robert. 'The Role of Inductive Reasoning in the Evolution of Conventions'. *Law and Philosophy* 17 (1998): 377–410.

Thomson, Judith Jarvis. 'A Defense of Abortion'. *Philosophy and Public Affairs* 1 (1971): 47–66.

Übersfeld, Anne. 'The Pleasure of the Spectator'. Trans. Pierre Bouillaguet and Charles Jose. *Modern Drama* 25 (1982): 128.

Vanderschraaf, Peter. 'Convention as Correlated Equilibrium'. *Erkenntnis* 42 (1995): 65–87.

Zacks, Jeffrey M., Barbara Tversky and Gowri Iyer. 'Perceiving, Remembering, and Communicating Structure in Events'. *Journal of Experimental Psychology* 130 (2001): 29–58.

Zarilli, Phillip. Introduction to *Acting (Re)Considered: A Theoretical and Practical Guide*. Ed. Phillip B. Zarrilli. London: Routledge, 2002.

Chapter 9

Plays are games, movies are pictures: Ludic vs. pictorial representation

David Z. Saltz

Over the past twenty-five years, I have been drawing on current work in the philosophy of mind and aesthetics to develop a model of theatre predicated on the idea that theatre is best understood not as a kind of text or picture but as a real-world event that draws on the imagination of both actors and spectators, more specifically, as a kind of game.[1] My position is part of a philosophical tradition, including Ernst Gombrich's 1951 essay 'Meditations on a Hobby Horse or the Roots of Artistic Form'[2] and Kendall Walton's 1990 book *Mimesis as Make Believe,* that understands fictional representation generally as an imaginative activity engaged in by spectators. Walton, in particular, argues that works of representational art, including novels, paintings, film and theatre, serve as 'props' for the audience's games of make-believe; the differences between artistic media, in his view, can mostly be explained in terms of the differences in the rules of the games audiences play. My own position more fully develops the implications of the fact that in theatre, the so-called props with which spectators engage are themselves real human beings who are engaging in games of make-believe. And the actions they perform in this context are *real* actions, in the sense that any action performed in any sort of game situation – from chess to baseball – is real. The most basic role that fiction plays in theatre, then, is to define the context within which the performer acts, that is, to define the rules of the game the actors play.

My goal here is to clarify and flesh out the notion of theatricality implicit in the game model by contrasting theatre with film.[3] Specifically, I will argue that theatrical performances and films characteristically employ distinct modes of representation, with theatre being primarily ludic, and film, pictorial. In other words, film is not merely photographed theatre with close-ups and editing. In the final section of the chapter, I will consider whether these

FILM AS A DRAMATIC MEDIUM

Both narrative theatre and film are dramatic art forms. That is to say, they are predicated on a mode of representation in which actors embody fictional characters and act out stories. The two art forms differ, of course, in numerous other significant respects. The most obvious difference is ontological, with theatre characterized by the presence of live actors and real objects in a space shared by the audience, and film consisting of photographic (or simulated) images of absent (or non-existent) actors, objects and places. This ontological difference no doubt leads to phenomenological differences in audiences' experiences. Moreover, the technology of cinema radically alters the way audiences can view dramatic performances; in film, the camera allows viewers to observe a performer from any angle and at any distance, and can cut from one location to another instantaneously.

These ontological, phenomenological and technical differences notwithstanding, one might argue that the relationship between actors and objects on the one hand, and the fictional characters and worlds they represent on the other, remains fundamentally the same in the two art forms. Bruce McConachie describes film and theatre as 'continuous' phenomena: 'Most of the mental operations that *Homo sapiens* deploy to make sense of live performance are also used to understand filmic ones. . . . While there are important historical differences among live and mediated modes of communication, they share a common evolutionary and cognitive foundation'.[4] Film, as a host of theorists including André Bazin, Stanley Cavell, Roland Barthes and Kendall Walton have emphasized, is a photographic, reproductive medium. Walton argues that the presence of actors in theatre 'is important only because they are objects of imagining'.[5] As a result, he suggests, spectators have a more 'vivid' experience in theatre than in the cinema, where they 'are in the presence of nothing but images on a screen'.[6] Conversely, many cinephiles feel that film's ability to provide viewers with close-ups produces a vivid intimacy that theatre cannot match. In either case, a difference in the degree of vividness, in whichever direction it may go, would not fundamentally alter the nature of the relationship between the performance and the fictional event it portrays. According to this line of reasoning, theatre is a live event in which live actors enact a fictional narrative, while film is a visual recording of such an event. If we have the ability to comprehend the dramatic enactment of a fictional narrative when we see actors performing it live, we should be able to apply that same ability to a filmic documentation of those performances.

There is an obvious problem with this account. Film does not, in fact, always, or even usually, record a continuous profilmic event in which the actors enact the narrative. Instead, films typically employ continuity editing to construct a narrative by stringing together a sequence of shots recorded at various times, sometimes months or years apart, and often in various locations. So, for example, when we see a film sequence that begins with a man seen from behind, walking towards the door to a house, then we see a close-up of a hand turning the doorknob, and then watch the man enter the house from the inside, it is quite possible that the three shots were taken on different days and in different cities, and even that each one uses a different actor. There is no single performance that this video sequence captures.

Continuity editing in film is analogous to multitrack studio recording in music. While multitrack and/or heavily edited and manipulated audio recordings are not *recordings* of any actual musical performance, and often the audience is, on an intellectual level, perfectly cognizant of and comfortable with that fact, nonetheless, as philosophers and performance theorists such as Jacques Attali, Theodore Gracyk and Philip Auslander have argued, such recordings may nonetheless *represent* musical performances.[7] One might say that the audience listens to such recordings *as if* they were recordings of live musical performances. Similarly, in the case of continuity editing, one might say that the spectator views the video sequence *as if* it were a recording of a continuous live event. The continuous sequence of shots, then, constitutes a *simulated* event that generates an ordered series of fictional propositions: (a) a man walks towards a door, (b) turns the knob and (c) enters the house. As we watch this edited sequence, we imagine that we are watching a recording of those events occurring in sequence, regardless of whether we are aware of how the editing process actually works.[8] Hence, we can modify our initial account of the relationship between theatre and film relatively easily to accommodate continuity editing – as well as other post-production processes such as modifications to the audio track and the addition of visual effects – by describing film as a real *or simulated* visual recording of a narrative theatrical performance.

Unfortunately, however, this modified account, though superficially plausible, is still wrong – or at least radically impoverished.

FILM REPRESENTATION VS. RECORDED THEATRE

In his 1931 *Happy Journey from Trenton to Camden*, Thornton Wilder calls for no scenery beyond 'perhaps a few dusty flats [that] may be seen leaning against the brick wall at the back of the stage'.[9] *Happy Journey* tells the story of a family of four driving on a road trip. To represent this journey, Wilder

stipulates that the four actors sit on four chairs arranged at the centre of the stage, with two chairs set on a slightly raised platform behind the others. When spectators watch performers following these instructions, they will not, of course, see four people in a car. They will, however, experience the event as *a theatrical performance of people driving*. In other words, the performance the play describes exemplifies one of many perfectly viable ways that theatre can represent a fictional world in which four people are driving in a car.

Now imagine that you are watching the same performance captured on film. Once again, you will not see four people in a car. But in this case, you will not even have the experience of watching *a film of four people in a car*. What you will see, assuming you have caught onto the convention that the actors are following, is a film of *four people sitting on chairs on a stage pretending that they are driving a car*. In other words, you will see a second-order representation: a film about a theatrical performance that represents a fiction. There is a clear difference between a filmic documentation of a theatrical production, such as the 1982 filmed performance of Harold Prince's original Broadway production of *Sweeney Todd,* and a cinematic adaptation of the same play, such as Tim Burton's 2007 film version. Significantly, the difference cannot simply be the byproduct of technological aspects of film, such as continuity editing, camerawork and audio and video post-production. Filmed documentations of theatrical performances, such as the recording of the Broadway *Sweeney Todd*, can employ all these techniques and still fully retain its status as a documentary of a theatrical event, rather than a first-order filmic representation of the fiction. While our initial line of reasoning suggested that film is simply an enhanced mechanism through which to see theatre, this example reveals that the two mediums are, in fact, radically distinct on a representational level. Wherein, precisely, does this difference lie?

FILM AS PICTORIALLY REPLETE

Gregory Currie has described film as a *pictorial* medium.[10] By that he means simply that the film consists of moving visual depictions of the fictional world. To put it even more simply, when we see something in a film, we accept it as part of the fictional world. For example, Currie suggests that seeing a film image that represents a fictional character, Harry Lime, conveys a wealth of detailed information about what is fictional in the story: 'For example, that the man called "Harry Lime" has a certain visual appearance. If the image I see onscreen were different in various ways, it would tell me different things about what is fictional in the story: that Harry is slimmer or shorter, or has a different facial expression'.[11] He describes the process of

engaging with such images as involving *perceptual imagining* – a process that he rightly distinguishes from that of *imagining that I am seeing something*, which would place the viewer within the imaginary world. 'Perceptual imagining', he argues,

> exhibits the characteristics of counterfactual dependence and structure characteristic of perceptual belief; when we see the screen we imagine that the character's eyes are exactly *that* shape, *that* colour and *that* size in relation to the rest of the character's features. If what we saw on the screen were shaped or coloured in a slightly different way, what we would then have imagined about the character's features would have been correspondingly different.[12]

Moreover, to adopt Nelson Goodman's term, the film image is a visually *replete* representation of the fictional world.[13] Narrative cinema has developed clear conventions that distinguish what film scholars commonly describe as nondiegetic elements, such as titles and musical underscoring, from diegetic elements.[14] Diegetic elements exist within the same world as the characters, while nondiegetic elements exist only for us as spectators. To say that the film image is 'replete' means that it constitutes a single, unarticulated, continuous representation of the fictional world at a given point in time. When we describe any element within the diegetic frame we are also describing a corresponding element in the fictional world. If an actor is wearing glasses, the character is wearing glasses, and if he or she is holding a book, the character is holding a book and, moreover, is holding exactly the same book. If a clock is hanging on the wall in the background, an identical clock exists on the corresponding wall in the fictional world and tells the same time. (Hence great care is taken in continuity editing to ensure that all such details remain consistent from shot to shot within a scene.) If a cockroach is crawling on the wall behind the actors, then even if the characters never acknowledge the creature, the camera never makes it the focus of the image, and most viewers never even notice it, we can nonetheless take for granted that there is a cockroach in the fictional world. And should an object slip into the frame that is not supposed to be in the fictional world, such as a boom microphone, we regard the appearance of that object as a mistake or 'blooper'.

The concept of pictorial *repleteness* should not be confused with that of *realism*. The principle of pictorial repleteness applies whether a film purports to represent a world like the one we live in, or a fantastic, science-fiction, surrealistic, subjective or hallucinatory world. Pictorial repleteness pertains to the relationship between the film image and the fictional world it represents; realism pertains to the relationship between the fictional world and (what we regard as) the real world. When a film shows a six-headed ferret wandering across a sandy desert under two suns, or, as in Luis Buñel and Salvador

Dali's *Un Chien Andalou* (1929), ants swarming inexplicably out of a hole in a man's palm, that is precisely what we will imagine is occurring in the fictional world. Note that this principle still applies when a shot represents the subjective perspective of a particular character or something that is occurring in a character's imagination or dream. In that case, the film pictorially represents what the character is supposed to be seeing or imagining. If during a dream sequence we see a purple rhinoceros on a rowboat on screen, we can assume that the character is seeing the same image in his or her dream. Moreover, a film may create a world with an overarching tonal or stylistic quality that sets it apart from quotidian reality, such as a pervasive feeling of off-kilter foreboding or high-energy comedic wackiness. Daniel Yacavone usefully emphasizes that films can create worlds that 'transcend and diverge from what is known and most familiar in our firsthand, extracinematic, and nonartistically mediated experience'.[15]

THEATRE AS VISUALLY MINIMALISTIC

Like film, theatre can and often does contain visual elements that picture elements of the fictional world. Theatrical productions combine pictorial and non-pictorial elements in varying proportions. The stage image as a whole, however, only rarely constitutes a replete picture of the fictional world in the way a filmic image does. The conventions of scenic realism (which I consider in more depth later) come closest to achieving the pictorial repleteness of cinema; such productions occupy one end of a continuum, with productions entirely devoid of representational scenery and costumes at the other.

Considered within the full range of both present-day and historical theatrical genres, Wilder's *Happy Journey* falls somewhere in the middle of this continuum. Most of what an audience sees on stage does not directly picture the fictional world. Neither the free-standing wooden chairs, the exposed brick walls behind the actors, nor the wooden stage floor are aspects of that world. Note that unlike a filmic image, this stage picture does not exhibit counterfactual dependence. Were I to notice a cockroach crawling up the wall behind the actors, unacknowledged by them, I could not legitimately infer that a cockroach existed in the fictional world of the play. Conversely, countless things that one might presume would be in fictional world – the car, road, houses and trees along the road, passing cars, the sky and so on – are not pictured for the audience.

One common, but not entirely satisfactory way, of expressing this point is to say that the conventions of this play are *minimalistic*. In the 1930s and early 1940s Wilder stood out in the context of American domestic realism, which was just establishing itself as the dominant aesthetic. However, from

Plays are games, movies are pictures 171

a global and historical perspective, such theatrical minimalism is the norm rather than the exception. As Wilder himself observes in his Author's Note to the play, 'The healthiest ages of the theatre have been marked by the fact that there was the least literally representative scenery. The sympathetic participation of the audience was most engaged when their collaborative imagination was called upon to supply a large part of the background'.[16] Wilder most likely had in mind such theatrical genres as the medieval mystery and morality play, the Elizabethan/Jacobean stage, commedia dell'arte and Noh (a Japanese tradition that in the 1930s was captivating the imagination of modernist writers throughout the Western world). In the decades that would follow, such visual minimalism would once again become the rule rather than the exception in Western theatre, not just in the work of avant-garde practitioners such as Jerzy Grotowski and the Open Theatre, but in myriad mainstream West End and Broadway productions from *Equus* to *The Curious Incident of the Dog in the Night-Time*.

Compare a photograph of the National Theatre's 1973 production of Peter Shaffer's play *Equus* (figure 9.1) to a frame from the corresponding moment in the 1977 film version of the play (figure 9.2). The film featured the same actors in the lead roles and made very few changes to the script. However, the difference in representational conventions could hardly be more obvious. The image in the film still pictures a naked boy, Alan Strang, riding a white

Figure 9.1. *Equus* (1973), by Peter Shaffer. Opening production, National Theatre. Peter Firth as Alan Strang. © John Haynes/Lebrecht Music & Arts.

Figure 9.2. *Equus* (1977), directed by Sidney Lumet. Peter Firth as Alan Stang. © 1977 Metro-Goldwyn-Mayer Studios Inc.

horse in the woods. We can infer from this image details about that world that are not specified in the script, and would not be true in other enactments of the script. In this *Equus,* for example, Alan stops his horse, which is white, between two leafless trees. By contrast, as in our imagined production of *Happy Journey,* the production photograph from the stage version of *Equus* pictures a great deal that is not in the fictional world, such as men wearing wire-mesh masks of horses' heads, and the simple wooden and metal fence that lines the edge of the stage. Also as in *Happy Journey*, numerous elements in the fictional world are not pictured at all, such as the horses' back legs, tails and fur, and while Alan is riding outside at this point in the narrative, it is impossible to ascertain any details about the scenery he is riding through.

It might be tempting to try to account for the difference between the filmic and theatrical images in purely quantitative terms, as indeed the term 'minimalism' suggests. One might propose that theatre employs what is sometimes called 'selective realism', with some visual elements being diegetic, or in-frame, and others being nondiegetic, or out-of-frame. But while that explanation might be appropriate to certain specific cases, it does not work as a general account. There are elements within the theatrical images we have been considering that cannot simply be ignored or erased without fundamentally altering our understanding of the fictional world, such as the chairs in

Happy Journey and the wire-frame horse heads in *Equus*. These elements do not provide a replete picture of the objects they represent but are nonetheless integral to the performances' representation of those objects.

THEATRE AS GAME: THE INFICTION

The problem with describing non-pictorial theatrical conventions as 'minimalistic' is that such a description merely marks what certain theatrical performances *lack,* that is, replete pictures of a fictional world. It does not offer a positive account of how these performances do relate to the fiction. In theatre, the performance is not merely a means to an end, a conduit through which the audience accesses a fictional narrative. The key is to shift our perspective away from the question of what the performance *represents,* that is to say, what information it conveys to us about the fictional world, and to focus instead on the reality of the performance event itself and the way the fiction informs the spectator's understanding and appreciation of it. In narrative theatre, spectators must have some understanding of the fictional framework if they are to understand *what the performers are doing* in the here-and-now of the performance. The fiction is not simply something the performance signifies, but functions as a cognitive template that informs an audience's perception of the reality occurring onstage. Insofar as fiction serves this function for spectators and performers, I have called it the *infiction*.[17] Subsequent to a performance, spectators may (and critics inevitably do) extract a fictional narrative from that performance. Most representational theories of theatre, including semiotics, focus exclusively on this operation, which generates what I call the *outfiction*.[18] Both the infiction and outfiction are a set of propositions about the fictional world. The difference is that in the case of the outfiction, viewers use the real-world theatrical performance to gain an understanding of the fictional world, while in the case of the infiction, viewers use their knowledge of the fiction to interpret what is happening in the real-world performance itself.

Here we get to the key difference between theatre and film as modes of fictional representation. In pictorially replete arts such as film, the concept of the infiction serves little purpose because there is a one-to-one relationship between the infiction and outfiction. The pictorial repleteness of the visual elements allows viewers to extract information about the fictional world, in other words the outfiction, from everything they see within the image. In the case of ludic forms such as theatre, however, the spectator can, and I argue often will, attend entirely to the nuances of the material world of the performance as structured and governed by the infiction. At any point a spectator might reflect back on the theatrical event that has transpired to recap and

generate an outfiction, but on a moment-to-moment level the spectator's focus is on the here-and-how of the performance itself.[19] At this level the question of which elements on stage exist in the fictional world, or how the fictional objects those elements represent appear within that world, simply need not arise.

The infiction is the use of the fiction to define a rule, specifically a *constitutive rule* in the sense described by John Searle. According to Searle, 'Constitutive rules do not merely regulate, they create or define new forms of behavior. The rules of football or chess, for example, do not merely regulate playing football or chess, but as it were they create the very possibility of playing such games'.[20] Constitutive rules take the form 'X counts as Y in context C'.[21] In theatre, virtually any object or action on stage can count as any other image or action once the proper conventions have been established. Visual elements in theatre do not need to be pictorial, or even iconic; they are endowed with symbolic meaning on a case-by-case basis by production or genre-specific conventions. The rule itself is invisible, like the rules of a language or a game; what the spectator sees is the performer's behaviour as governed by the rule. The audience must understand what the rules are in order to make sense of those behaviours (though there may be, and are, cases where it is aesthetically desirable for the audience *not* to fully understand the rules, endowing the performance with a degree of mystery or interpretive openness), just as a viewer must understand the rules to follow the players' action in any game or sporting event. In some cases, spectators will come to the theatre with an understanding of the rules as defined within the genre (e.g., in Noh a specific gesture of raising both hands towards the face counts as weeping) or a particular play. In most cases, however, spectators will learn most the constitutive rules of the game by inferring them from the performance itself.

For example, in a performance of *Happy Journey*, the four wooden chairs count as a car. If the spectators do not understand this basic constitutive rule, the actions of the four performers on stage will be unintelligible. Once these rules are established, a spectator could ask a host of what Walton calls 'silly questions':[22] what colour is the car? If the character opens a window, why doesn't her hair blow? But these questions typically do not arise in an audience's mind. We simply play along. Our focus is on the here-and-now game, not the fiction used to set that game in motion.

Constitutive rules apply not just to visual and spatial objects – scenic elements, areas of the stage that represent different locations, props, costume pieces – but, perhaps more significantly, to actions. For example, the actor who plays the father in *Happy Journey* performs an action that counts as *driving the car* when he mimes a steering wheel with his hands and an accelerator pedal with his right foot. In the stage version of *Equus*, the actor playing Alan Strang gestures towards the mask of a horse's head with his fist to perform an

action that counts as *blinding the horse*. The human actors playing the horses, then, are compelled by the rules of the theatrical game to react to that gesture as if they are being wounded physically.[23] By contrast, the film version of *Equus* represents the same action pictorially, showing a steel spike piercing the eyes of each horse in close-up.

EXCEPTIONS THAT PROVE THE RULE: PICTORIAL THEATRE AND LUDIC CINEMA

In 1912, David Belasco meticulously re-created the interior of a popular New York restaurant chain, Childs' Restaurant, for the last act of his production of *The Governor's Lady*.[24] According to a contemporary newspaper review, 'It is as if he had taken the audience between the intermission, walked them around the corner of Seventh Avenue, and seated them to one side of the Childs' restaurant at that location and let the last act be played there'.[25] The reproduction was exact to the smallest detail, constructed with the same materials and populated with the same supplies as an actual branch of the restaurant. The set filled the entire proscenium frame, side-to-side and top-to-bottom. Indeed, the set could easily have functioned as a sound stage for a film, and photographs of the production are at least as pictorially replete as any film still of the period (figure 9.3). Theatre historians commonly point to Belasco's production as the apogee of scenic realism in Western theatre that culminates a trend that spanned from the mid-seventeenth century through the start of the twentieth century.

The conventions of scenic realism are guided by precisely the same commitment to pictorial repleteness that I have argued characterizes film. Hence, theatre and film historians are justified in commonly describing this period

Figure 9.3. *The Governor's Lady* (1913), produced by David Belasco. Emma Dunn and Emmett Corrigan.

of theatre history as proto-cinematic.[26] Though the conventions of scenic realism dominated European and American stages to varying degrees for approximately 100 years, within the broader context of theatre history these conventions are an aberration. Nonetheless, such productions demonstrate that pictorial repleteness is possible in theatre. One may argue, as many twentieth-century avant-garde theatre artists did, that theatre that embraces such conventions of scenic realism is less 'pure' than theatre that adopts the sort of ludic conventions that I have described as being more characteristic of theatre, but that aesthetic judgement is itself a matter of historically contingent taste – as indeed is the distinctly modernist insistence that artists should strive to identify and remain true to the essence of their medium.

Conversely, some films adopt ludic rather than pictorial conventions in whole or in part, for example, when a character within a scene turns directly to the camera to make an aside to the audience in films such as *Annie Hall* (1976) and *The Big Short* (2015). In these cases, performers break the filmic convention of pictorial repleteness by performing an action that is not part of the film's outfiction; at such moments, it is unproductive to ask why the other characters do not acknowledge the performer's aside, or who, exactly, the character thinks he or she is addressing. Significantly, this kind of theatrical moment in a film usually creates a slight shock, producing a Brechtian distancing or *Verfremdungseffekt* – and often has a humorous effect.

One of the most striking counter-examples to the general trend of filmic pictorialism is Lars von Trier's 2004 film *Dogville*. This work was created from the ground-up for the screen, but its mode of representation is thoroughly ludic and theatrical. Von Trier filmed *Dogville* on a bare sound stage with scenic locations neatly delineated by chalk outlines, and stencilled labels specifying what each area represents, on the floor. The set has no walls and employs only minimal furniture and props (figure 9.4). Much like the minimalist sets for Thornton Wilder's *Happy Journey* and his later more famous play, *Our Town,* the scenery functions as a game board for the actors, with specified areas of the stage 'counting as' (rather than picturing) specific houses, stores, streets or other landmarks in the town. For example, at one point in the film, Nicole Kidman (playing a character named Grace) walks down the central strip of the soundstage labelled 'Elm Street', and then turns into a narrow lane with the word 'bushes' written on the floor to her right and 'gooseberry' to her left. This action counts as walking through a garden. She wends her way to a chalk-line demarcating a house, makes a knocking gesture with her fist in the air and waits for the house's occupant to mime opening the door before she crosses the boundary. The film's claim to fame, which no critic who writes about the film fails to discuss, is precisely its unconventional (for film) theatricality. Ann Hornaday, in her review for the *Washington Post,* describes *Dogville* as being '*not so much a film* [my italics]

Figure 9.4. *Dogville* (2003), directed by Lars von Trier. Nicole Kidman. © 2003 Lions Gate Entertainment.

as one of [von Trier's] signature provocations. . . . an often fascinating, just as often confounding, cinematic experiment'.[27] The film was embraced by some critics precisely because of its novelty – but, as evidenced by its very low box office appeal, it left most consumers befuddled.

MUSICALS

No genre better exemplifies the game model of theatre than the musical. The defining convention of the musical is that performers break into song, and often dance, to express their characters' thoughts and feelings, typically accompanied by instrumental music of undeterminable source. It is usually fruitless and counterproductive to inquire into what, precisely, is supposed to be happening in the fictional world as these musical numbers are occurring. Are the characters singing in the fictional world? Is the instrumental music audible in that world? Typically, the answer to both of those questions is surely no. But neither are the singing, dancing and music simply nondiegetic in the usual sense; the musical performances cannot be simply erased from our account of the fictional world the way that titles or fully nondiegetic musical film scores can. *Something* is happening during these musical numbers, and that something bears a close relationship to what the actors are singing and doing; indeed often pivotal changes in the story occur during these musical sequences.

Consider the two cabinet battles in Act 2 of the musical *Hamilton* (2015). In the Broadway production, the scenes are staged as rap battles between Alexander Hamilton and Thomas Jefferson. Hamilton and Jefferson stand on a bare wooden stage, with the rest of the cabinet members sitting on chairs

arranged in a semicircle behind them and Washington serving as a kind of referee. Hamilton, Jefferson and Washington all hold hand mics. If we try to interpret this scene in a pictorially replete way, even accepting that many elements function metaphorically rather than literally, we will be confronted with a series of classically silly questions. Are the characters holding mics in the fictional world? If not, what are they supposed to be doing with their hands? Are Hamilton and Jefferson really speaking in rhyme, using a combination of modern-day and period-appropriate language? If not, what are they really supposed to be saying? A spectator who focused on such questions while watching the scene would gain nothing, since the questions have no meaningful answers. When we construe both the fictional (or in the case quasi-historical) narrative and the conventions of musical theatre as defining the parameters of the performative game that the performers are playing, rather than as semiotic codes, these questions dissolve. The scenes do convey general information about the fictional world, that is, an outfiction: that the two characters debated issues and strove to impress their onstage audience with their superior eloquence, wit and confidence. The actors' granulated performance choices and the specific words they speak, however, can only be understood in terms of a game in which they take on fictional roles to engage in a present-tense contest of virtuosity and wit using all the theatrical and musical resources at their disposal. The production's non-traditional casting similarly follows ludic rather than pictorial conventions. The play does not posit an alternate history in which America's Founding Fathers were ethnically diverse. The casting of ethnically diverse actors is a feature of the game being played, not the fiction that game generates. To see the play performed with skill, passion and conviction by these actors produces a powerful impact, reclaiming (without rewriting) the nation's history for all its current citizens.

Because the conventions of the musical are inherently ludic, the genre of the film musical complicates the account that I have offered so far of film as a pictorial medium. Some musical films avoid having to adopt theatrical conventions for the musical sequences by framing the sequences as a diegetic representation of a stage performance, as in Bob Fosse's film adaptation of *Cabaret* (1972), or as a dream or fantasy sequence, as in Rob Marshall's film adaptation of *Chicago* (2002). In classic film musicals, however, the sequences involving singing and dancing function just as they do in theatre, following ludic conventions that do not generate a granulated outfiction. When the Jets and Sharks dance through the streets in the prologue of *West Side Story* (1961), this sequence cannot be explained away as a character's dream or fantasy. Neither, however, are we expected to perceive the story as transpiring in a magical world where music fills the air and members of street gangs are highly trained dancers with remarkable improvisational abilities.

Moreover, even in films such as *West Side Story* that employ theatrical conventions for the musical numbers – unexplained singing, dancing and musical accompaniment – the actors typically perform these numbers within a pictorially replete setting. *West Side Story* was filmed on real New York streets, *Fiddler on the Roof* (1971) in an Eastern European town in Croatia and *Into the Woods* (2014) in a real forest with a real milk cow. The awkwardness of this hybrid strategy – pictorial with respect to the environment and ludic with respect to the performances – helps to explain why the convention of singing and dancing in musicals can be hard for some film spectators, especially those unaccustomed to theatre, to accept or take seriously. The audience needs to compartmentalize the actors' musical performances and treat that one aspect of the film differently from everything else it sees.

CONCLUSION

I have argued that theatre and film, as the art forms have developed over the past century, relate to fictional worlds in fundamentally different ways: theatre is a ludic medium, while film is a pictorial medium. This difference has been overlooked in theoretical accounts proffered by theorists of film, theatre and philosophical aesthetics. Significantly, however, we can find real exceptions to this principle. Scenic realism in theatrical set design, for example, operates according to quasi-filmic pictorial conventions, and many song and dance sequences in film musicals adopt quasi-theatrical game conventions. The difference between the two mediums that I have been highlighting is ontologically grounded in the sense that theatre and film are highly compatible with their characteristic modes of representation. Nonetheless, it remains historically and culturally contingent and mutable, not baked into the ontology of the two mediums.

NOTES

1. See David Z. Saltz, 'How To Do Things on Stage', *The Journal of Aesthetics and Art Criticism*, vol. 49, no. 1 (1991), 31–45, and David Z. Saltz, 'Infiction and Outfiction: The Role of Fiction in Theatrical Performance', in David Krasner and David Z. Saltz (eds.), *Staging Philosophy: Intersections of Theater, Performance, and Philosophy* (Ann Arbor: University of Michigan Press, 2006), 203–220.

2. E. H. Gombrich, *Meditations on a Hobby Horse and Other Essays on the Theory of Art,* fourth edition (London: Phaidon Press, 1985).

3. It is important to specify that my use of the term 'film' throughout this chapter refers specifically to live-action film, that is film that is composed of, or that appears

to be composed of, moving photographs. Animation is a different case that requires a separate analysis. Indeed, different kinds of animation employ different modes of representation, some closer to what I attribute here to film, and others to theatre.

4. Bruce McConachie, 'Theatre and Film in Evolutionary Perspective', *Theatre Symposium*, vol. 19 (2011), 130.

5. Kendall Walton, *Mimesis as Make Believe* (Cambridge, MA: Harvard University Press, 1990), 27.

6. Ibid., 26.

7. Philip Auslander, *Liveness: Performance in a Mediatized Culture,* second edition (Abingdon: Routledge, 2008), 74–77; Theodore Gracyk, 'Listening to Music: Performance and Recordings', *The Journal of Aesthetics and Art Criticism,* vol. 55, no. 2 (1997), 139–150; Jacques Attali, *Noise: The Political Economy of Music*, trans. Brian Massumi (Minneapolis: University of Minnesota Press, 1985), 106.

8. One might make an even stronger argument, and assert that continuity editing creates, not just a representation, but an *illusion* of a real event. Note that if, indeed, we are saying film is illusory in this way, that is a very different claim than the one Currie rightly rejects, that film creates *an illusion of reality*. The position I am entertaining here is that it creates the illusion of *a photographic representation of a continuous event*, not of the event itself. Consider, for example, the energy directors, designers and editors put into matching continuity: maintaining continuity in body position, make-up, lighting and so on. Often someone is charged specifically with the role of maintaining continuity. The effort here is to deceive the audience in the same way a magician does. But there is no need to commit to the stronger notion of an illusory event; the weaker concept of a simulated event works just as well for present purposes.

9. Thornton Wilder, 'The Happy Journey to Trenton and Camden', in Donald Gallup and A. Tappan Wilder (eds.), *The Collected Short Plays of Thornton Wilder: Volume 1* (New York: Theatre Communications Group Press, 1997), 85.

10. Noël Carroll objects to Currie's claim that being pictorial is an essential property of film as a medium. He correctly notes that Currie's 'account excludes significant portions of avant-garde filmmaking', and 'just as one would not discount Brancusi's *Bird in Flight* as sculpture on the grounds that it is nonpictorial (non-versimilitudinous) and abstract, it seems equally questionable to me to frame an account of the essence of cinema that fails to include something like Brakhage's *Text of Light'*. Carroll does not, however, challenge the proposition that most narrative cinema is pictorial in Currie's sense: 'Had Currie simply said that he meant to be talking about how films typically are, there will be little merit in disputing him. . . . Instead, I would argue that he has only talked about certain types of cinema, albeit the most popular kinds'. As will become apparent by the end of this chapter, I regard neither pictorial representation as essential to film nor ludic representation as essential to theatre; my argument is simply that these two modes of representation are distinct, and that at the present time (and throughout much of the past century) they have been characteristic of film and theatre respectively throughout much of the world. See Noël Carroll, 'The Essence of Cinema?' *Philosophical Studies*, vol. 89 (1998), 326, 329–330.

11. Gregory Currie, *Image and Mind: Film, Philosophy, and Cognitive Science* (Cambridge UK: Cambridge University Press, 1995), 9.

12. Ibid., 184, original italics.

13. Goodman, *Languages of Art*, second edition (Indianapolis: Hackett Publishing Company, 1976), 227–228. Again, my analysis of film in this chapter applies only to live-action film, not animation. (See note 2 above.) Some styles of animation are replete, others are not.

14. Some recent film theorists have questioned the distinction between diegetic and nondiegetic film elements. For example, Ben Winters argues that the distinction should be abandoned because many purportedly nondiegetic elements, in particular musical underscoring, are integral to, and inextricable from, spectators' phenomenological experiences of the film world. While granting the phenomenological significance of such elements, Yacavone nonetheless argues that 'those audio and visual features frequently termed nondiegetic are quite properly regarded as being outside and certainly *distinct from* a film's story-world (i.e., including all that the characters as characters are known to be aware of)'. He accommodates Winters's point by usefully distinguishing between 'the (fictional) world in a film and the strongly suggested existence of another, "larger" world of a cinematic work', or what he calls the 'world-in' and the 'world-of' the film (with the latter encompassing the former). See Ben Winters, 'The Non-Diegetic Fallacy: Film, Music, and Narrative Space', *Music and Letters*, vol. 91, no. 2 (2010), 224–244; Yacavone, *Film Worlds: A Philosophical Aesthetics of Cinema* (New York: Columbia University Press, 2015), 23.

15. Daniel Yacavone, *Film Worlds*, 229.

16. Wilder, *The Happy Journey*, 84.

17. See Saltz, 'Infiction and Outfiction'.

18. Eli Rozik provides the most recent and fully developed analysis of how theatre functions as a communicative medium, or, in my terms, generates an outfiction. As with most semiotic approaches, Rozik defines theatrical performance as a kind of text, and spectating as a kind of reading: '*A theatre performance is a text generated by the theatre medium, which describes a specific world for a specific audience at a specific time and place. It is the actual text that a spectator is expected to read, interpret, and experience*'. Eli Rozik, *Generating Theatre Meaning: A Theory and Methodology of Performance Analysis* (Brighton: Sussex Academic Press, 2008), 27, original italics.

19. Cf. James Hamilton, who argues that 'there is a basic level of comprehension of theatrical performances that does not require more than what is provided in the moment-to-moment tracking of the performance as it is happening on the stage'. James R. Hamilton, *The Art of Theater* (Oxford: Blackwell Publishing, 2007), xii. Hamilton's project, however, is fundamentally different from mine. His goal is to provide an account of theatrical comprehension and engagement that does not rely on the notion of a play or text outside of or distinct from the performance itself. Hence, Hamilton is uninterested in the ways that a play or fictional structure constrains or constitutes a performance.

20. John Searle, *Speech Acts: An Essay in the Philosophy of Language,* reprint ed. (Cambridge UK: Cambridge University Press, 1970), 33. Searle's distinction between

constitutive and regulatory rules has been widely adopted by philosophers, but has recently been the focus of critique. Searle takes on some of these critiques in *The Construction of Social Reality* (New York: The Free Press, 1995), 43–51.

21. John Searle, *Speech Acts,* 35.

22. Walton, *Mimesis,* 174–183.

23. I have argued that these sort of performative gestures are illocutionary acts whose force is defined by the rules of the theatrical game. See Saltz, *How to Do Things,* 42.

24. Lise-Lone Marker, *David Belasco: Naturalism in the American Theatre* (Princeton: Princeton University Press, 1975), 61.

25. Ibid., 6–63.

26. Nicolas Vardac famously promoted the idea that design in theatre grew increasing realistic from the late eighteenth through the early twentieth century, effectively paving the way for film before handing scenic realism over to the cinema and returning to non-realistic styles. While Vardac's argument held sway among theatre and film scholars for several decades, it has recently been the object of considerable criticism. Ben Brewster and Lea Jacobs, for example, agree with Vardac that theatre developed a new scenic approach during this period, which they (in resonance with my own analysis) describe as 'pictorialism'. However, they reject many details of Vardac's argument, such as, among other things, the suggestion that early cinema evolved directly from theatre (film, in fact, had multiple influences), and that the rise of pictorialism was synonymous with the rise of naturalism. I agree emphatically with them on both fronts. See Nicolas Vardac, *Stage to Screen: Theatrical Origins of Early Film* (Cambridge, MA: Harvard University Press, 1949), and Ben Brewster and Lea Jacobs, *Theatre to Cinema: Stage Pictorialism and the Early Feature Film* (Oxford: Oxford University Press, 1997), 6–10.

27. Ann Hornaday, 'Danish Cinema Cuts to the Chaste', *The Washington Post,* 11 January 2004, http://www.washingtonpost.com/wp-dyn/content/article/2004/01/11/AR2005033113042.html.

Chapter 10

Ideals of theatrical art
Paul Thom

Critics across the ages have lamented the unartistic state of theatre. The vanity of actors, the venality of managers, the vulgarity of audiences, the dependency of the whole enterprise on a swag of non-theatrical art forms including painting, music and literature – all these things have been cited as crippling any chance of theatre attaining the status of art. Some critics take theatre to be afflicted by a deep and incurable malaise which will forever block any ambitions it might have to be art.[1] Others, while admitting the sorry state of theatre as it actually exists, dream of a possible state which, if only it were actualized, would generate a new and artistic theatre. These latter are the theatrical idealists. In this chapter I discuss three idealist philosophies of the theatre. One of these philosophies concerns theatrical practice itself, envisaging a radical reform of that practice. A second concerns the choices audiences make in going to the theatre, prescribing what it sees as sound reasons for making those choices. A third concerns our experience of the theatre, proposing a two-stage analysis of that experience, in which our immediate perceptual grasp of a performance is subsequently deepened through an understanding of the performance's context and genesis. In all three cases an ideal is envisaged in which the practice itself, or our reasons for partaking of it, or our experience of it, is purified through the removal of elements that detract from what is seen as properly theatrical.

EDWARD GORDON CRAIG

Designer and director Edward Gordon Craig (1872–1966), in his 1911 book *On the Art of the Theatre*, imagined an art theatre, which, borrowing from

Wagner,[2] he called the 'theatre of the future'. The theatre of the future would reform traditional theatrical practice in three radical ways.

First, in place of the traditional mélange of directors – one for costumes, one for design, one for stage movement and so on – a single mind would have sole power over the design and production of each theatrical work. In this way theatrical productions would come to share the character that distinguishes great visual and literary artworks, where the work's unity and design is the product of a single creative mind. In the theatre of the future this unique artist will be the stage director:

> *Playgoer:* I understand, then, that you would allow no one to rule on the stage except the stage manager?
>
> *Stage Director:* The nature of the work permits nothing else.
>
> *Playgoer:* Not even the playwright?
>
> *Stage Director:* Goethe, whose love for the theatre remained ever fresh and beautiful, was in many ways one of the greatest of stage directors. But, when he linked himself to the Weimar theatre, he forgot to do what the great musician who followed him remembered. Goethe permitted an authority in the theatre higher than himself, that is to say, the owner of the theatre. Wagner was careful to possess himself of his theatre, and become a sort of feudal baron in his castle.[3]

This is an extreme version of what, in the art of cinema, would become known as the *auteur* theory. It is also one of the important sources leading to the contemporary idea of the Regietheater. The authority of the stage director, as imagined by Craig, will be guaranteed by the fact that would-be directors must first master 'the crafts of acting, scene-painting, costume, lighting, and dance'.[4]

Second, Craig's imagined art theatre abandons the traditional idea of the stage play as the material that is to be performed. The theatre of the future will rediscover what is unique to theatre as distinct from the other fine arts. Thus, the idealized theatre will be independent of all those other arts, including the literary arts:

> It is not only the writer whose work is useless in the theatre. It is the musician's work which is useless there, and it is the painter's work which is useless there. All three are utterly useless. Let them keep to their own preserves, let them keep to their kingdoms, and let those of the theatre return to theirs. Only when the last are reunited there shall spring so great an art . . . [that] will not show us the definite images which the sculptor and painter show. It will unveil thought to our eyes, silently – by movements – in visions.[5]

The idea here is that of a *pure* art of theatre, comparable to the idea of 'absolute music'. Craig thought that theatre's primary appeal is to the eyes.[6] In

Ideals of theatrical art

relegating the play-script to the lowest place among theatrical priorities and raising the visual element to the top, he precisely reversed the Aristotelian priorities where the written drama is the most important thing and the 'look' (*opsis*) the least important.[7] Still, even without the benefit of play-scripts authored by masters of dramatic literature, the theatre of the future will have a content (he calls it 'an idea').[8] This content reduces to 'Sound, Light and Motion – or, as I have spoken of them elsewhere, voice, scene and action'.[9]

The third reform that Craig proposes is to abandon the traditional idea of actors as performing artists:

> Acting is not an art. It is therefore incorrect to speak of the actor as an artist. For accident is an enemy of the artist. . . . Therefore the mind of the actor, we see, is less powerful than his emotion, for emotion is able to win over the mind to assist in the destruction of that which the mind would produce; and as the mind becomes the slave of the emotion it follows that accident upon accident must be continually occurring. . . . Art, as we have said, can admit of no accidents. That, then, which the actor gives us, is not a work of art; it is a series of accidental confessions.[10]

Craig assumes that the supposed 'art' of the actors consists in emotional expression. He also assumes that there is no hope of turning this practice into a genuine art. For him, there is no alternative but to create a theatre that dispenses with actors altogether. What will replace them will be an inanimate figure, one that is not subject to the unartistic display of emotion – the Über-marionette.[11] Theatre will then take its place alongside the other fine arts, not subservient to them; and its practitioners will be directors, not actors – directors who devise displays of Sound, Light and Motion.

Craig's vision of an ideal art theatre contrasts sharply with his practice as a designer/director. As a man who loved the theatre he admired actors' talents and continued to work with actors. As a theorist his perception of the British theatre of his day led him to wish for a theatre without actors. That wish was to some extent coloured by prejudice – particularly in relation to women. Stanislavsky reports him as decrying the behaviour of women in the theatre. 'They take a bad advantage of the power and influence they exercise over men', he is supposed to have said, accusing actresses of making evil use of favouritism and flirtation to create ruinous intrigue.[12] An interesting reaction from the son of a famous actress.

Stanislavsky noted an ambivalence in Craig's attitude towards actors. On the one hand:

> Craig says that every work of art must be made of dead material . . . fixed forever in artistic form. According to these fundamentals, the living material of the actor's body, which endlessly changes and is never the same, was not useful for the purposes of creation. . . . Craig dreamed of a theatre without men and women, without actors. He wanted to supplant them with marionettes who

had no bad habits or bad gestures, no painted faces, no exaggerated voices, no smallness of soul, no worthless ambitions.[13]

On the other hand:

> But . . . the denial of actors did not interfere with Craig's enthusiasm for the slightest hint of true theatrical talent in men and women. Feeling it, Craig would turn into a child, leap in joy from his chair, propel himself headlong at the footlights, the long mane of his graying hair thrown in disorder about his face. When he saw the absence of talent he would become angry and dream of his marionettes again.[14]

Craig was genuinely enthusiastic about Stanislavsky's own acting:

> Less of a spontaneous whirlwind than Grasso,[15] their first actor Stanislawsky is more intellectual. This is not to be misunderstood. You are not to imagine that this actor is cold or stilted. A simpler technique, a more human result, would be difficult to find. A master of psychology, his acting is most realistic, yet he avoids nearly all the brutalities; his performances are remarkable for their grace. I can find no better word. I have been most pleased by the performance of *Onkel Wanja*, although this company is able to handle any play admirably. In *The Enemy of the People* Stanislawsky shows us how to act Dr. Stockmann without being 'theatrical' and without being comic or dull. The audience smile all the time that they are not being moved to tears, but never does a coarse roar go up such as we are used to in the English theatre.[16]

Craig was himself aware of his conflicted attitude to actors. He explained it by saying that his theories were about an imaginary theatre which dispensed with play texts and actors, while his theatrical praxis dealt with current theatrical realities:

> I believe in the time when we shall be able to create works of art in the Theatre without the use of the written play, without the use of actors; *but* I believe also in the necessity of daily work under the conditions which are to-day offered us.[17]

A similar ambivalence affected his conception of the Über-marionette. At times it seemed to be a serious proposal. If Patrick de Boeuf is right, the Über-marionette was 'an actor encased in a sort of armour, so that he could make none but graceful, slow, sweeping gestures'.[18] At other times, Craig made out that his talk of the Über-marionette was never meant to be taken literally. Here he is in 1924:

> Is it not true that when we cry 'Oh, go to the devil!' we never really want that to happen? What we mean is, 'get a little of his fire and come back cured'.
> And that is what I wanted the actors to do – some actors – the bad ones, when I said that they must go and the Über-marionette replace them.

The Über-marionette is the actor plus fire, minus egoism: the fire of the gods and demons, without the smoke and steam of mortality.[19]

Working in the real world, but dreaming of an ideal world, how could he escape the odd contradiction?

PAUL WOODRUFF

Far removed from all this is Paul Woodruff's idea of theatre. In his recent book *The Necessity of Theater*,[20] Woodruff (a philosopher and classicist) defines theatre as the art of watching and being watched in a measured time and place. Tom Stern draws attention to 'the absence of text, playwright, actors, stage and theatre (the place)' in this definition;[21] and that list of absences may create the impression that Woodruff endorses something like Craig's ideal of the art theatre. But this is not so. Craig's conception is an aesthetic one. But Woodruff is not principally concerned with theatre as fine art. His broad conception of theatre covers sports events and weddings in addition to the art theatre. And he is interested in theatre's moral, rather than its aesthetic, value. Moreover, what he wants to reform is not the practice of theatre, but what determines spectator's choices of which theatrical performances to attend:

> If theater is not beneficial to you, you should change your life – or else change the theater to which you are exposed.[22]

Tom Stern argues that Woodruff 'stands in a long line of treating theatre as a "school of morals"'.[23]

Theatre in Woodruff's broad sense comprises two arts – one that is concerned with the observation and appreciation of what is worth watching, the other with performing what is worthy of being watched. The first art is exercised by the spectator, the second by performers; the special kind of reception that the first art envisages involves a kind of learning which guides human action. The two arts together form a pair: the second provides the object of attention for the first, and the first is the purpose for which the second exists.

But watching and being watched are not arts in the same sense. Theatrical performers can be understood as exercising an art in a sense derived from the ancient Greek idea of a body of skilled productive knowledge. Theatrical spectators, on the other hand, do not as such produce anything at all. What makes for a good audience, in Woodruff's view, is simply that their watching exhibits the moral virtues of reverence, humanity, courage and justice:

> The important idea here is that good watchers respond virtuously to whatever it is they watch.[24]

This is the reason why Woodruff takes watching to be an art. He defines an art as a kind of learning that guides human actions.[25] The good watchers are the virtuous; and the virtues are, as the Greek philosophers said, arts (*technai*), kinds of learning that guide human action.

For Woodruff, theatre in the broad sense may or may not involve make-believe, may or may not involve everyday actions and events, may or may not involve spectator participation, may or may not aim at transformation of the participants. The art theatre may also take any of these forms; but it is 'not so much a kind of theater as a context for theater of any of the other kinds'.[26]

Woodruff dismisses as 'a technical dodge' the appreciation of 'how the art is practised by those who perform' without caring for the characters.[27] And he sees the fine arts in general as a historically specific European device for excluding a broad audience:

> The modern notion of the fine arts as systematically related to and distinct from other human endeavors is fairly new, a new sandbar built up by shifting currents of thought in Europe during the early modern period. . . . I regard the concept of fine art as a navigational hazard.[28]

According to Woodruff, the art of watching and being watched is necessary for our lives. We are all under 'a kind of psychological necessity' to aim at being worth watching. Communities depend on the existence of occasions for witnessing public events, and participation in such acts of witnessing strengthens social bonds.[29] By contrast, the art theatre is a luxury, 'not necessary for our lives':

> [Art theatre] is a formal, cultivated expression of the art . . . that makes human action in general worth watching. . . . Art theater is part of our cultural clothing . . . highly desirable, because necessary for our comfort.[30]

Similar views are not unknown in the discipline of performance studies. For instance, Richard Schechner declares:

> It is my belief that performance and theatre are universal, but that drama is not.[31]

The art of watching and being watched is also unlike the art theatre in that it functions in an inclusive, not an exclusionary, way. On this point Woodruff hearkens back to the ancient Athenian theatre:

> Lucky Athenians to have had a theatrical tradition that bound them together as performers, not merely as members of an audience. A dramatic chorus would live and practice together for a long time before their performance, and they would have to learn to move and sing as one.[32]

Gregory Clark picks up this reference in his review of three of Woodruff's books:

> If a genuinely democratic politics is founded on particular values, attitudes, and modes of interaction, then those values, attitudes, and modes of interaction must be experienced as the identity that is shared by the individuals who enact it. That is why, according to Paul Woodruff's account of democracy in fifth-century Athens, the Greeks saturated their public culture with experiences that would prompt individual citizens to attitudes and actions that we can describe as democratic. . . . *The Necessity of Theater* might be read as a meditation on what it would take for Americans to prepare themselves to . . . realize their readily stated but rarely realized democratic aspirations.[33]

The inclusiveness of the art of watching and being watched turns out to be the inclusiveness of an ancient democratic ideal.

It is odd that the case which best fits Woodruff's ideal of a moral theatre is the art theatre. Woodruff himself implicitly acknowledges this fact by spending so much time discussing classic texts of the art theatre, especially Shakespeare. And yet his ideal is theatre in the broad sense, where serious treatment of moral issues is not usually found. Noël Carroll makes the point:

> Recall that Woodruff counts football games as theater. I think I've understood every football I have ever seen, but none of them have any relevance to my life or my understanding of my life. Perhaps theatrical understanding of the very best theater will involve self-transfiguration. Yet there is a great deal of theater the understanding of which has nothing to do with its bearing on my own life.[34]

Woodruff loves the traditional art theatre's exploration of morality, and at the same time wishes its exclusivity could be replaced by the inclusiveness of the ancient Greek theatre. Like Craig, he is an idealist immersed in a reality he loves but wants to transcend. But his work is not a manifesto for a 'theatre of the future' like the work of Craig and other twentieth-century reformers. It is rather the past that Woodruff sees as the locus of an ideal of art, in particular the ancient Greek past. His ideal theatre is an art, or a pair of arts, not in the sense of the fine arts, but in the sense of the kind of combination of knowledge and skill that the Greeks called *technē*, especially the knowledgeable skills that make for good citizens.

JAMES HAMILTON

The title of James Hamilton's philosophical study *The Art of Theater* echoes that of Craig's book almost exactly. And on one important point Hamilton

is in agreement with Craig: the art of theatre, properly conceived, does not depend on any other art form, and in particular does not depend on the art of literature. But Hamilton's way of arriving at a proper conception of the art of theatre is different from Craig's. Rather than positing independence from literary texts as an ideal that will correct current theatrical practice, Hamilton appeals to current theatrical realities as demonstrating the independence of theatre from the other arts. Among those realities, one is found in avant-garde theatrical practice, another in spectators' actual experience in the theatre. Seen in this way, Hamilton appears as a realist, not an idealist. But, as we shall see, his realism is a tenuous one.

Hamilton appeals to the fact that avant-garde practices influenced by the work of such figures as Brecht, Artaud and Grotowski – and (we may add) Craig – show that in fact the art of theatre is often practised in the absence of any pre-existing dramatic text. Hamilton makes the same point through a number of imaginary examples. In these examples a theatre company arrives at the theatre to start rehearsals for a performance called *Hedda Gabler*. Before rehearsal starts, each line in Ibsen's *Hedda Gabler* (or some reinterpretation of some subset of those lines) is assigned to one or more of the actors, not necessarily to Ibsen's characters, and not necessarily in the order of Ibsen's script.[35] Hamilton explains that the possible aims of this assignment are multifarious. It might aim at having the actors make true statements, or it might be guided by some theme (perhaps something having contemporary social relevance), or it might aim simply at creating sonic effects, perhaps organized according to a known musical form. In any case, the rehearsals will add visual effects and movement to the selected ways of speaking the assigned lines; and there is no guarantee that Ibsen's text will survive the rehearsal process intact – or that it will survive at all.

This line of argument is not strong enough to establish the claim that a theatrical performance is *never* in fact a performance of any other work; and yet Hamilton sometimes states his thesis in this strong form.[36] Accordingly, one critic asks:

> Why, then, does Hamilton think that experimental theatre has shown us what is necessarily absent in the case of theatrical performance rather than what is not necessarily present?[37]

To this objection, one might reply on Hamilton's behalf, that even if some contemporary practice remains fixed in past theatrical modes that made theatre subservient to literature, avant-garde practice should be our guide to a theatrical ideal. But, of course, in taking such a line, one would have abandoned a purely realist approach.

Hamilton's second line of argument points to the way in which audiences *experience* performances. He sees this as a two-stage process. In the first stage 'performance identity is established by reference to aspects of, or facts about, the performance itself and sometimes to aspects of and facts about other performances too'.[38] At the most basic level, spectators' experience of the performance they are witnessing does not go beyond what they are directly seeing and hearing:

> People . . . who are unable to distinguish the performance from what is performed . . . can comprehend at least at a very basic level . . . something to which they are referring. . . . That something must be fully contained in the performance itself, for they have no other reference point. Moreover, since there is something contained in and deliverable in the present performance that spectators who comprehend the performance more deeply refer to when they say 'it' is the same as some other routine they saw, that must also be the same thing that the merely basically comprehending spectators see.[39]

His point is that in reality spectators' basic experience in the theatre does not make reference to any literary work that may be being enacted before them. Again, the objection can be made that this claim cannot be defended as factually true in all cases: spectators with a good knowledge of the play that is being performed will experience the performance as a performance *of* the play. And again, a reply can be made on Hamilton's behalf. Ideally, he might say, we can leave aside sophisticated spectators whose experience combines the immediate theatrical impact with a literary knowledge of the work performed; the immediate theatrical impact – the pure theatrical experience – carries no literary baggage. And again, one has to comment that this reply forsakes the pure realism from which Hamilton started. He finds his theatrical ideal in avant-garde theatrical practice and in this first stage of spectator response.

But there is a second stage. In this stage, spectators develop an appreciation and understanding of a performance's achievement.[40] Hamilton sees the 'full appreciation' of a performance as requiring the ability to grasp a background in relation to which the performance's achievement becomes clear, and the ability to discourse about the ways in which the performance practices adopted (as contrasted with other possible practices) enhance or detract from the piece performed.[41] He defines a full appreciation of a theatrical performance as

> a reconstruction of the creative process which explains how a particular theatrical performance came about, in its entirety and in detail, whether successfully or unsuccessfully.[42]

Hamilton acknowledges that his expression 'reconstruction of the creative process' is a borrowing from Richard Wollheim.[43] It is the key term in Wollheim's account of the criticism of a particular work of art, that is, the process of coming to understand it as art:

> Criticism is retrieval. The task of criticism is the reconstruction of the creative process, where the creative process must in turn be thought of as something not stopping short of, but terminating on, the work of art itself.[44]

Wollheim contrasts retrieval in this sense with scrutiny:

> Understanding is reached through description, but through profound description, or description profounder than scrutiny can provide, and such description may be expected to include such issues as how much of the character of the work is by design, how much has come about through changes of intention, and what were the ambitions that went to its making but were not realized in the final product.[45]

In Wollheim's terms it might be said that Hamilton's 'basic theatrical understanding' is what is achieved by someone who merely scrutinizes the performance. Full appreciation requires reconstruction of the creative process – not of every detail but of what is salient to the generation of an artistic product. In the case of theatrical art such a reconstruction involves some appreciation of the rehearsal process.

Noël Carroll comments on Hamilton's notion of full appreciation:

> Even if there are not many examples of appreciations of theatrical performances that meet these high standards, Hamilton has nevertheless surely captured an important regulative ideal with this account.[46]

Such understanding is indeed rare. It is a kind of understanding that is found in the visual, literary and musical arts when the art lover possesses knowledge of the history of the relevant art form, knowledge of how works of the given genre are produced and some detailed knowledge of how the individual artist produced the work in question. Possession of such knowledge does not entail that the work in question has any artistic value; on the contrary, to know certain things about the work's genre and genesis is to know that it possesses no artistic value.

It seems that spectators having only a basic understanding of the performance rely exclusively on what they see and hear during the performance, but those who have a full appreciation of the performance draw on what they know about the performance's genre and its genesis, including the performance plan which is supposed to guide it. If this is so, then Hamilton is

claiming that a basic understanding of theatrical performances never involves reference to anything at all beyond the performance itself. But he cannot be making this claim about deeper ways of appreciating performances. On the contrary, he has to admit that deeper appreciation does involve awareness of facts about broader contexts from which the performance derives its meaning and value.

In sum, Hamilton's philosophy of theatre offers a two-stage analysis of the spectator's experience, in which an immediate perceptual grasp of a performance is subsequently deepened through an understanding of the performance's context and genesis. What is strange in this account is that the first, naïve, stage of theatrical experience embodies Hamilton's ideal of pure theatre, freed from the other arts; however, the full appreciation of theatre as art cannot be achieved in the first stage but must wait for the second.

REFLECTIONS ON THEATRE AND ART

Where is the art in theatre? The question presupposes some specific conception of art. Our three authors had different conceptions in mind when they wrote about theatre and art. For Craig, two considerations were paramount: the fact of being devised by a single artist, and the aesthetic qualities of sight and sound displayed in the finished product. For Woodruff, theatre deserves the name of art by virtue of its moral dimension, whether it be in the content it presents to its public or in the inclusiveness with which it addresses that public. For Hamilton, the artistry of a particular performance is something spectators discover as they acquire deeper understanding of the genre to which the performance belongs and the manner of its creation.

All these things – being devised by a single artist, beauties of sight and sound, having a moral content, addressing the public in an inclusive way, genre and the manner in which theatre is created – are qualities rather than objects. So, in place of the question 'When is something an art-object?' I suggest we ask 'What qualities are indicative of art?' The indicators of art include all the qualities singled out by our authors, and many more. These are criteria, not necessary or sufficient conditions: they are defeasible indicators of artistic quality. Some of these criteria have a higher weighting than others. In particular, artefactuality (the aspect of the artistic as made or done) has the greatest weighting and is arguably a necessary condition: whatever has artistic quality must at least be something made or done. The traditional conception of art requires that it be something that is made or done by an artist with a view to its design being appreciated by an audience.[47] 'Artistic quality' is a cluster concept: its applicability depends on a plurality of weighted criteria. In his

defence of 'art' as a cluster concept, Berys Gaut lists ten criteria that are commonly taken to count in favour of something's being art: (1) having aesthetic qualities, (2) being expressive of emotion, (3) questioning received views and modes of thought, (4) being formally complex and coherent, (5) conveying complex meanings, (6) presenting an individual point of view, (7) creative originality, (8) being an artefact or performance whose production requires considerable skill, (9) belonging to an art form and (10) being the product of an intention to make art. Since artistic quality admits of degrees, an object or event may have artistic quality to a high degree of artistry in respect of some of its qualities but not in respect of others. Using this framework, we can evaluate our three authors' ideas on art and theatre.

Craig's ideal theatre certainly has some of the qualities that are criterial for art. His vision of a theatre of light, sound and movement is clearly an aesthetic one; and his insistence on the unique controlling director shows an artistic concern with the way theatre is created. The problem with his manifesto lies not in the vision he expounds but in the implausible premises from which he starts and in the weakness of his reasoning. His pessimism about the possibilities of artistic collaboration is exaggerated, and his view of a pure theatre independent of the other arts is misguided since the theatre is essentially a mixed artform. Even if one wants to highlight theatre's purely theatrical elements, it wouldn't follow that one has to forego the performance of written plays. His attitude towards actors is negative to the point of prejudice, and even if actors were as bad as he states, it would not follow that they cannot contribute to art in the theatre.

Craig thinks collaboration between a director, a designer and specialists in the other theatrical arts necessarily destroys overall artistic quality. He claims that 'it is impossible for a work of art ever to be produced where more than one brain is permitted to direct'.[48] This conclusion is based on his belief that collaboration is incompatible with one of the widely accepted criteria of art, namely coherence. (Craig's focus on a single 'brain' seems misplaced; surely what matters is a coherent conception unifying stage design, costuming, action, lighting, etc.) The question is whether such coherence can result from the efforts of a cooperative team of specialists in different arts. And it clearly can. Craig has overstated his case. He confuses the difficult with the impossible. Consequently, he has no compelling argument that the traditional collaborative theatre must be abandoned in favour of a theatre centred on a single all-powerful director.

It is true that collaboration carries with it the risk of compromising artistic quality (a risk, not a certainty). It is also true that collaboration brings considerable benefits: the various arts of the theatre are likely to be exercised at a higher level by a team of specialists than by a single individual. An artist-director can also be the leader of a team.

Craig's argument that an art theatre must do away with actors is similarly flawed. His argument is that because actors introduce accidental elements into the theatre by giving way to the expression of their emotions, they destroy one of the commonly accepted criteria of art across artforms, namely intentional design. What this fails to take into account is that intentional design is a defeasible criterion of art, not a necessary condition. An improvisation may be artistic and yet contain accidental elements – for example, what is initially a slip may be taken up and creatively developed. So Craig's argument is not watertight. But the argument is also based on a false premise: it is totally inadequate to characterize acting as simple self-expression. Craig fails to acknowledge that there is an art of acting.

The question of actors in the theatre can also be viewed from the perspective of risks and benefits. Let us suppose, with Craig, that there is a risk of actors spoiling an artistic effect by indulging in personal displays of emotion. This risk can be managed through proper training and directorial control. On the other side of the ledger, actors bring unique artistic potential to the theatre. Through their *presence* before the spectators they embody, in the most powerful possible way, the human condition that is the subject of much dramatic art.

Craig's ideal of pure theatre seems to be based on the thought that art ideally is pure, so that if there is to be an art theatre it must be pure theatre and not be mixed with other artforms. Now, there is nothing in the cluster theory of the concept of art that requires artforms to be pure. On the contrary, the way the theory is set up, with criteria being neutral across artforms, is hospitable to the possibility of mixed cases in which some criteria are drawn from one artform and some from another. The analysis of art as a cluster concept thus provides no support for an ideal theatre purged of all literary elements. Moreover, if we look at the result of such a purging process, it seems very frugal. The future art theatre which excludes actors and dramatic texts would be, by Craig's own admission, an art stripped of its very materials. It would be like poetry without words, or invisible painting. Compare this with the artistic power that actors and the great dramatic texts bring to the theatre!

Woodruff's ideal of a moral theatre also satisfies some of the criteria spelt out in Gaut's list. A theatre of morality will inevitably challenge some received opinions and take an individual point of view. But, to make morality the sole measure of theatre's value would be to remove it from the domain of the fine arts by denying it the polymorphous character of the latter. There are many things besides moral edification that contribute to theatre's being appreciated as art: the purely aesthetic qualities of *coups de théâtre*, the technical virtuosity of the performers or staging, the originality of the director.

But what of the second stage? Hamilton's account of theatre is far richer than those of Craig and Woodruff. His concern is not to remake the theatre,

nor to prescribe the right reasons for attending it. His concern is a descriptive one: to give a correct description of what an ordinary spectator experiences in the theatre. It is a two-stage description whose first stage sounds rather like Craig's description of what the artist-director of the future would offer to the audience. However, this is not because Hamilton thinks that we already have the theatre of the future, but because he thinks that the immediate experience of all theatre, past present and future, is as he describes it.

Hamilton expresses great respect for Stanislavsky as a theatrical artist:

> [Stanislavsky's] work changed the way anyone in Europe thought about theater if they thought about theater at all.[49]

He notes that Stanislavsky insisted

> on a new approach to rehearsals – an approach that emphasized the attitude to the inner lives of characters . . . and insisted on the director's absolute control of the vision of each play. Stanislavski sought this control not because of the pragmatic need to organize a company in new economic conditions, as the Duke of Saxe-Meiningen may be thought to have done. Stanislavski's aim was, in some sense, artistic.[50]

The sense in which this aim was artistic can be spelt out as follows. A concern with the rehearsal process is a concern about how theatre is *made*, and thus is a concern with theatre as artefact. Since artefactuality is one of the criteria of art, an appreciation of the rehearsal process is part of what constitutes an appreciation of theatre as art.

If rehearsals are a method of memorizing routines, so that the same routines will be used in performance (as is suggested by Hamilton's distinction between those routines that are 'discarded' in rehearsal and those that are 'chosen' because 'the company thinks [they] will have the desired effects'), then, contrary to Hamilton's thesis, performances are in fact performances *of* something, namely the routines that have been established in rehearsal. So, to the extent that performances are not improvisatory, it seems they are *of* something, namely a performance plan.

There may be artistry in elements of the performance plan, and the performers individually or collectively may be responsible for those elements. But that doesn't make them artists *as performers*. The art they exercised in devising or contributing to the performance plan is a vital part of the art of theatre, but it is not the same as the art which is the particular preserve of theatrical performers. There is more than one art of the theatre.

Who are the artists who practise these arts? There are two groups. The performers, and all those who are contribute in real time to Craig's theatrical values of light, sound and movement, are potentially artists insofar as they

have an opportunity to carry out their respective tasks in ways that exhibit theatrical artistry. A second group comprises the director and the production team, including all those who contribute to the performance plan. Among this group must be included playwrights and other authors of works for theatrical performance (in those cases where a work is to be performed); and these creative individuals have the opportunity to carry out their functions with theatrical art. The great playwrights may be literary artists; however, what makes them masters of theatrical art is not their literary artistry but their creation of performance directives whose realization demands or invites artistry on the part of those who contribute in real time to the theatrical event.

Because Hamilton's conception of theatre is centred on avant-garde practices in which much of the important work is done in complex rehearsal processes, the actors are for him not the mere materials of theatrical art, as Craig held. Nor are they interpreters of the basic artwork, the play, as in the traditional conception. Rather, they collectively constitute a theatrical artist who creatively transforms pre-existing material.

Hamilton's concern with the rehearsal process takes a particular form – a form that aligns with a late twentieth-century conception of art. This is the conception of art as the transfiguration of the commonplace.[51] According to this conception of art, the making that characterizes art is a kind of higher-order making in which what is already made is *transformed* by the artist so that it becomes something else, a work of art. Hamilton displays a particular interest in the kind of rehearsal processes that are analogous to this kind of higher-order art-making. The rehearsal processes he describes take works from the standard theatrical repertoire – works such as *Hedda Gabler* – as commonplace, and work an artistic transformation on them.

One problem remains. Earlier I suggested that, contrary to Hamilton's thesis that a performance is never *of* anything other than itself, the second stage of the spectators' experience involves experiencing the performance as a performance of something else, namely of the performance plan. Can Hamilton's thesis be defended against this objection? I think it can.

Tom Stern puts his finger on the key consideration:

What really bugs Hamilton is the criticism of performances – standard or experimental – on the grounds that they are inadequate performances of the text.[52]

Stern says that Hamilton's target is 'the thought that theatrical performances are *of* something else (principally of play texts) and that the artistry of theatre requires some connection between text and performance'.[53] I agree: Hamilton's real target is the idea that theatre can be *artistic* only through a validating relationship between the performance and what is performed. And, I think, Hamilton is insisting on the important truth that there are autonomous

arts of theatre, distinct from all forms of art that may be present in any content that is performed. This applies even to those forms of theatrical practice which aim at the presentation of a dramatic literary work. For even in that case the value (if any) of the performance, as art, is not reducible to the artistic value of the work performed. To present, or to quote, something artistic doesn't make one an artist. So why should performing an artwork make one an artist? The only way to be sure the performer is an artist is to look at the performance itself, and to find art there.

NOTES

1. For the history of this attitude see Jonas Barish, *The Antitheatrical Prejudice* (Berkeley: University of California Press, 1981).

2. Richard Wagner, trans. and ed. W. Ashton Ellis, *The Art-Work of the Future, and Other Works* (Lincoln and London: University of Nebraska Press, 1993).

3. E. Gordon Craig, 'The Art of the Theatre, 1st Dialogue' (1905), in E. Gordon Craig (ed.), *The Art of the Theatre* (Heinemann, 1911, reprinted 1955), 174–175.

4. Craig, 'The Art of the Theatre, 1st Dialogue' (1905), 174.

5. Craig, 'Plays and Playwrights, Picture and Painters in the Theatre' (1908), in Craig, The Art of Theatre (London: Heinemann, 1911, Reprinted 1955), 123.

6. Craig, 'The Art of the Theatre, 1st Dialogue' (1905), 141.

7. Aristotle, *Poetics* 6, 1450b15.

8. Craig, 179.

9. Craig, 'The Art of the Theatre, 2nd Dialogue' (1910), 240.

10. Craig, 'The Actor and the Über-Marionette' (1907), 55f. Craig has a second reason for dispensing with actors, namely that human beings are not a suitable *material* from which to make art. His argument seems to be that actors, insofar as they have human freedom, are insufficiently pliable to be the materials from which an author or a director might fashion a theatrical work of art.

11. Craig, 'The Actor and the Über-Marionette' (1907), 81.

12. Constantin Stanislavsky, *My Life in Art,* trans. J.J. Robbins (Boston, MA: Theatre Art Books, 1948), 442.

13. Stanislavsky, *My Life in Art*, 442.

14. Stanislavsky, *My Life in Art*, 443.

15. 'Giovanni Grasso (1873–1930). Italian actor, son and grandson of Sicilian puppet-masters. . . . He was considered a fine actor of the *verismo* school, being at his best in the plays of Pirandello. He was several times seen in London, where in 1910 he played Othello'. Phyllis Hartnoll and Peter Found, *The Concise Oxford Companion to the Theatre,* second edition (Oxford: Oxford University Press, 1992), 194. See Craig's 'Recollections of a Remarkable Actor', *The Listener,* vol. 57, no. 1451 (January 17, 1957) (London: BBC, 1957).

16. Craig, 'The Theatre in Russia, Germany, and England' (1908), 135–136.

17. Craig, 53.

18. Patrick de Boeuf, 'On the Nature of Edward Gordon Craig's Über-Marionette', *New Theatre Quarterly,* vol. 26 (2010), 102–114, 104.

19. Craig, ix.

20. Paul Woodruff, *The Necessity of Theater: The Art of Watching and Being Watched* (Oxford: Oxford University Press, 2008).

21. Tom Stern, 'Theatre and Philosophy', *European Journal of Philosophy,* vol. 21 (2013), 158–167, 159.

22. Woodruff, *The Necessity of Theater,* 68.

23. Stern, 'Theatre and Philosophy', 161.

24. Woodruff, *The Necessity of Theater,* 205.

25. Woodruff, *The Necessity of Theater,* 42.

26. Woodruff, *The Necessity of Theater,* 33–34.

27. Woodruff, *The Necessity of Theater,* 150.

28. Woodruff, *The Necessity of Theater,* 46.

29. Woodruff, *The Necessity of Theater,* 22ff.

30. Woodruff, *The Necessity of Theater,* 25.

31. Richard Schechner, 'Drama, Script, Theatre and Performance', in *Essays on Performance Theory 1970–1976* (New York: Drama Book Specialists, 1977), 60.

32. Woodruff, *The Necessity of Theater,* 12.

33. Gregory Clark, 'Experiencing Democratic Identity', review of Paul Woodruff, *Reverence: Renewing a Forgotten Virtue* (Oxford: Oxford University Press, 2001); *First Democracy: The Challenge of an Ancient Idea* (Oxford: Oxford University Press, 2005), *The Necessity of Theater: The Art of Watching and Being Watched* (Oxford: Oxford University Press, 2008), *Rhetoric Society Quarterly*, vol. 41 (2011), 75–85, 77.

34. Noël Carroll, 'Review of Woodruff', *Philosophy and Literature*, vol. 33 (2009), 435–441, 440.

35. Hamilton, *The Art*, 43–49.

36. Hamilton, *The Art*, 200.

37. Aaron Meskin, 'Scrutinizing the Art of Theater', *Journal of Aesthetic Education*, vol. 43 (2009), 51–66, 64.

38. Hamilton, *The Art*, 32.

39. Hamilton, 'Replies', 90.

40. Hamilton, *The Art*, 34ff.

41. Hamilton, *The Art*, 137.

42. Hamilton, *The Art*, 217.

43. Hamilton, *The Art,* 195 n.1.

44. Richard Wollheim, *Art and Its Objects*, second edition with six supplementary essays (Cambridge, UK: Cambridge University Press 1980), 124.

45. Wollheim, *Art and Its Objects,* 129.

46. Noël Carroll, 'Basic Theatrical Understanding: Considerations for James Hamilton', *The Journal of Aesthetic Education*, vol. 43 (2009), 15–22, 17.

47. Francis Sparshott, *The Theory of the Arts* (Princeton: Princeton University Press, 1982), 149–168.

48. E. Gordon Craig, *The Art of the Theatre* (Heinemann, 1911, reprinted 1955), 'Some evil tendencies of the modern theatre' (1908), 99.

49. Hamilton, *The Art*, 3.
50. Hamilton, *The Art*, 5.
51. Arthur C. Danto, *The Transfiguration of the Commonplace: A Philosophy of Art* (Cambridge, MA: Harvard University Press, 1981).
52. Stern, 'Theatre and Philosophy', 163.
53. Stern, 'Theatre and Philosophy', 162.

BIBLIOGRAPHY

Barish, Jonas. *The Antitheatrical Prejudice*. Berkeley: University of California Press, 1981.
Clark, Gregory, 'Experiencing Democratic Identity'. *Rhetoric Society Quarterly* 41 (2011): 75–85.
Craig, Edward Gordon. *The Art of the Theatre*. London: Heinemann, 1911, reprinted 1955.
Craig, Edward Gordon. 'Recollections of a Remarkable Actor'. *The Listener* 57, no. 1451 (17 January 1957) (London: BBC, 1957).
Danto, Arthur. *The Transfiguration of the Commonplace: A Philosophy of Art*. Harvard University Press, 1981.
De Boeuf, Patrick. 'On the Nature of Edward Gordon Craig's Über-Marionette'. *New Theatre Quarterly* 26 (2010): 102–114.
Hamilton, James R. *The Art of Theater*. Oxford: Blackwell Publishing, 2007.
Hartnoll, Phyllis and Peter Found. *The Concise Oxford Companion to the Theatre*, second edition. New York: Oxford University Press, 1992.
Schechner, Richard. 'Drama, Script, Theatre and Performance'. In *Essays on Performance Theory 1970–1976*. New York: Drama Book Specialists, 1977.
Sparshott, Francis. *The Theory of the Arts*. Princeton University Press, 1982.
Stanislavsky, Constantin. *My Life in Art*. Trans. J.J. Robbins. Boston, MA: Theatre Art Books, 1948.
Stern, Tom. 'Theatre and Philosophy'. *European Journal of Philosophy* 21, no. 1 (March 2013): 158–167.
Wagner, Richard. *The Art-Work of the Future, and Other Works*. Trans. and ed. W. Ashton Ellis. Lincoln and London: University of Nebraska Press, 1993.
Wollheim, Richard. *Art and Its Objects: Second Edition with Six Supplementary Essays*. Cambridge, UK Cambridge University Press, 1980.
Woodruff, Paul. *The Necessity of Theater: The Art of Watching and Being Watched*. Oxford: Oxford University Press, 2008.

Index

Note: Page numbers in italics indicate figures.

Achaeans in Battle (Twombly), 90
acting, 11, 89; awareness of audience while, 96; Brecht on, 105nn20–21; Craig on Stanislavsky's, 186; 'exemplification' in, 146; facticity in, 101; focalized, 130–31; four dimensions of, 71; generosity in, 129–30; 'giving focus' technique in, 5–6, 123; 'giving in' ideal of, 126–28; 'ideal ape' model of, 73; identifying with the audience in, 131–32; indicating as sin in, 110; mimesis in, 111; narrative structure and, 146–47; Nietzsche on social, 74–75; Nietzsche's three models of, 71; 'performer's questions' to guide, 145, 147, 159n28; performing-process theory in, 146; Plato on audience enjoyment of, 94; self-deception in, 72, 73–74; as 'showing', 128–30; Talma's description of, 73; tension in the experience of, 125–26; uncontrollable elements in, 96; underemphasized, 127; unselfing in, 126, 132. *See also* gymnastic acting; immersive acting; marionette acting

acting-process theory, 145, 158n27
action representing action, 90
actors, 4, 76, 80; in art, 195; Craig's attitude towards, 8, 185–86, 195, 198n10; generous, 11; 'giving in' ideal of, 126–28; inner experience of, 71; Nietzsche's criticism of, 68; outer appearance of, 71–72, 74; Sartre on, 93–97, 101–2; as 'showing', 128–30; social, 74–75
aesthetic achievement, 45, 130, 132, 133n1
analogues, 91, 93, 95–97, 101
Annie Hall, 176
anti-theatricalism, 4, 67
Antonio (fictional character), 21–22, 24–26
Aristotle, 1, 90, 104n3, 114
Ars Poetica (Horace), 71–72
art: actors in, 195; artefactuality in, 193; artistic groups contributing to, 196–97; as cluster concept, 195; collaboration in, 194; Gaut's ten criteria for, 194; indicators of, 193; intentional design in, 195; performance plans and, 196; rehearsal process as, 196; text and

performance in, 197–98; theatre as, 110–11, 193–98; traditional conception of, 193
Artaud, Antonin, 190
The Art of Theater (Hamilton, J.), 189
art of theatre, 110–14, 119, 184, 190, 196
Attali, Jacques, 167
attention-training, 151, 155–56
audience: awareness in acting of, 96; complicity, 116, 119; film and theatre differences in experiences of, 166; identification with characters, 131–32; Nietzsche's concern about communication with, 76; participation of, 137; Plato on enjoyment of, 94. See also spectators
Aufhebung (sublation), 2, 15–16, 27–28, 30–31, 34
Auslander, Philip, 167
auteur theory, 184
avant-garde, 10, 171, 176, 180, 190–91, 197

Badiou, Alan, 104n6
Barthes, Roland, 166
Bassanio (fictional character), 21–22, 24–26, 29, 31–33
Bazin, André, 166
Beethoven's Opus, 101; number 28 in A major, 109
Being and Nothingness (Sartre), 89, 98–99
being someone (in Sartre), 101–3
Belasco, David, 175
Benjamin, Walter, 50
Bertram, Ernst, 84n6, 84n10
The Big Short, 176
Billington, Michael, 143, 158n19
The Birth of Tragedy (Nietzsche), 72
Blau, Herbert, 159n28
Boal, Augusto, 157n3
Boswell, James, 130
Branagh, Kenneth, 94
Brecht, Bertolt, 93, 95, 105nn20–21, 115–16, 133n9, 190

Brewster, Ben, 182n26
Broadway, New York, 168, 177
Buñel, Luis, 167–68
Burton, Tim, 168

Cabaret, 178
Carroll, Noël, 180n10, 189, 192
Cavell, Stanley, 166
chains of signification, 15, 30–31
Chaplin, Charlie, 123–24, 127–28, 131
Chicago, 178
children's theatre, 96
Childs' Restaurant, New York, 175
Churchill, Caryl, 139, 143
Clark, Gregory, 189
Commedia dell' Arte, 147, 171
constitutive rules, 174–75
contemporary drama, 55–56, 62n35
continuity editing, 167, 180n8
Craig, Edward Gordon, 10, 183–87, 189, 196; art considerations of, 193; on art of actors, 185; attitude to actors of, 8, 186, 195, 198n10; on pure art, 184; pure theatre idea of, 195; on Stanislavsky's acting, 186; theatre of future idea of, 184–85; Über-marionette conception of, 186–87; on women in theatre, 185
Crime and Punishment (Dostoyevsky), 90, 92
critics: as professional watchers, 114; Schlegel on, 51; on unartistic state of theatre, 183
Cull, Laura, 151, 155–56
The Curious Incident of the Dog in the Night-Time, 171
Currie, Gregory, 168, 180n8, 180n10

Dali, Salvador, 167–68
The Dance of Death (Strindberg), 110–11
data-stream, 137–48, 156–57n2
Davies, David, 133n1
Daybreak (Nietzsche), 73
De Boeuf, Patrick, 186

demonstrative theories of quotation, 144–45
Derrida, Jacques, 31
Diderot, Denis, 72
Dilthey, Wilhelm, 60n24
'Discobolus', 90
Dogville, 176, *177*
Dostoyevsky, Fyodor, 90, 92
drama: as art form, 1; genre theory in, 48; Hegel on, 9, 33–34; philosophy's relationship with, 44, 57; romantic, 48; Schlegel on, 9, 43–44, 46, 48, 55–56, 57–58, 62n35
dramatic poetry, 43–44, 52, 56–58
dramatic theatre, 89–91

Eagleton, Terry, 16, 26–27, 38n58
ego, 103, 107n50, 124, 126
emotional connection, 114
Encyclopedia Philosophy of Nature (Hegel), 19–20
Equus, filmic and theatrical images of, *171–72*, 171–75
event segmentation theory, 140

facticity, 99, 101
The Family Idiot (Sartre), 104n17
Ferdman, Bertie, 147–48
Fichte, Johann Gottlieb, 17, 50
fictional framework understanding, 173
Fiddler on the Roof, 179
film, 179–80n3; auteur theory in, 184; continuity editing in, 167, 180n8; as 'continuous' with theatre, 166; diegetic and nondiegetic elements in, 169, 181n14; *Dogville* ludic example of, 176, *177*; *Equus* as play comparison with as, *171–72*, 171–75; fictional character representation in, 168; *Happy Journey from Trenton to Camden* representation on, 168; ludic conventions in, 176, 178–79; perceptual imagining in, 169; phenomenological differences in audience experiences of, 166; as photographic reproductive medium, 166; pictorial repleteness in, 169–70; pictorial representation in, 165–66, 179, 180n10, 182n26; representational art in, 165; theatre ontological difference from, 166; vividness degrees in, 166
Fischer-Lichte, Erika, 106n29
Fisher, Tony, 95–96, 104n2
Fosse, Bob, 178

Gaut, Berys, 194, 195
Genealogy of Morality (Nietzsche), 76
genre theory, 48
German stage, 45, 58n7
'getting it', 144
Gilels, Emil, 109–10
giving focus, 123–34; aesthetic achievement in, 130, 132; art of, 124; art-subjectivity connection in, 124–25; audience identification in, 131–32; authenticity as creative process in, 125, 127; empathy in, 131; *The Gold Rush* example of, 123; scene support of, 132; self-authorship in, 127; serving scene in, 125; unselfing in, 126, 132. *See also* acting
Goethe, Johann Wolfgang von, 48, 50, 52, 55, 58n5, 125, 127
The Gold Rush, 123
Gombrich, Ernst, 165
Goodman, Nelson, 146, 169
Gopnik, Alison, 139
The Governor's Lady, 175, *175*
Gracyk, Theodore, 167
Grasso, Giovanni, 186, 198n15
Greek chorus, 51, 61n29
Greek comedy and tragedy, 47–48
Greek culture, 45, 48, 59n13, 60n16
Grotowski, Jerzy, 171, 190
gymnastic acting, 72, 74–76

Hamburg Dramaturgy (Lessing), 62n36
Hamilton, 177–78
Hamilton, Alexander (fictional character), 177–78

Hamilton, James R., 10, 133n1, 181n19, 189–93, 195–97
Hamlet (fictional character), 53–54, 93–95, 97, 100–102, 110, 113, 121
Hamlet (Shakespeare), 53–54, 120
Happy Journey from Trenton to Camden (Wilder), 167–68, 170, 172–74, 176
Hardenberg, Georg Friedrich Philipp von, 43
Haverkamp, Anselm, 30–31, 39n86
Hedda Gabler (Ibsen), 190
Hegel, Georg Wilhelm Friedrich, 2, 15–21, 30–34, 35n15, 36–37n28, 39n86; drama and absolute spirit of, 33–34; speculative science of, 16, 21, 43. See also *Phenomenology of Spirit*
Herder, Johann Gottfried, 45, 47–49, 57, 60n16, 61n26, 62n35; on nature's purpose, 60n20; on romantic criticism, 50; Schlegel's relation to, 59nn10–11
Hippolyta (fictional character), 117–19
Hopkins, Anthony, 120n3
Horace, 71–72
Hornaday, Ann, 176–77
Human, All too Human (Nietzsche), 72
human action worth watching, 110–12
Hume, David, 46, 50

Ibsen, Henrik, 137, 190
'ideal ape' model of acting (in Nietzsche), 73
The Imaginary (Sartre), 89, 91, 93
imagination, 104–5nn17–18, 119, 121n9
imagining consciousness, 92
immersive acting, 3; actor's inner experience in, 71; actor's outer appearance in, 71–72; philosopher as engaged in, 75–76
inner experience, 71–78, 80, 85n28
inner of inner, 18–19, 25, 31–32
instinctive reason (in Hegel), 15, 17, 22–23, 36n22; conceptual levels of, 18; observation in, 18; phrenology in, 18–19; as rationalizing impulse, 19
interactivity, 138; attention-training concept of, 155–56; credibility in, 161n66; Lopes's view of, 152–53; moral issue in, 154–55, 160n63; Murray's assumptions about, 153; in participatory and observed theatre, 153–54, 160n64; Saltz on, 152; as scalar concept, 153–55; spectator control in, 152; user input in, 151–52; in video games, 156, 161n68
Into the Woods, 179
Ion (Plato), 93

Jacobs, Lea, 182n26
Jaspers, Karl, 84n8
Jefferson, Thomas (fictional character), 177–78

Kant, Immanuel, 17, 43, 44, 55, 57, 62n35
Kaprow, Alan, 151, 155–56
Kean, Edmund, 93–95, 101
Kidman, Nicole, 176, *177*
Kleist, Heinrich von, 73, 75

Lancelot (fictional character), 22, 39n77
Lectures on Aesthetics (Hegel), 33
Lectures on Dramatic Art and Literature (Schlegel, A.), 3, 43ff
Lessing, Gotthold Ephraim, 45, 55, 58n7, 59n11, 62nn34–36
Lester, Adrian, 130
Lion King, 115
Lopes, Dominic McIver, 152–53
Love and Information (Churchill), 139, 143
ludic representation, 165–66, 176–79, 180n10

Ma, Yo-Yo, 109–10
Macbeth (Shakespeare), 116
Macdonald, James, 143

marionette acting, 3; Kleist on, 73; mask metaphor in, 74; philosopher as engaging in, 76; self-eradication in, 74; social actor in, 75
Marshall, Rob, 178
masking, 74, 115; honesty and, 69; as indirect communication, 69, 84n8; insincerity in, 69–71, 78–79, 84n10; Nietzsche's attack on, 68. *See also* Nietzsche, Friedrich Wilhelm
McConachie, Bruce, 166
'Meditations on a Hobby Horse or the Roots of Artistic Form' (Gombrich), 165
The Merchant of Venice (Shakespeare), 2, 21–34, 56; Bassanio's casket choice in, 22–26; blindness in, 22; bond of flesh in, 26–27; chains of signification in, 15; eyes and seeing in, 23–24; inner and outer disjunction in, 22–23; latencies and mis-representations regarding, 30–31; music in, 27–28; summary of, 21–22; transparency of sight in, 25–26; wit and context in, 28–30
A Midsummer Night's Dream (Shakespeare), 117–19
mimesis: audience complicity in, 116, 119; of dangerous objects, 114; hunter and lion example of, 114; illusions as inhibitive of, 115–16; in medicine, 115; music and character in, 115; selective effect of, 115, 121n7; technique issue of, 111–12; theatre masking of, 115; war example of, 114–15
Mimesis as Make Believe (Walton), 165
Mirren, Helen, 94
modern drama, 3, 9, 43–45, 49, 56–58
Mother Courage (Brecht), 115
movement, 20, 96, 104n6, 113, 124, 194, 196
Murray, Janet, 153
musicals, 8, 177–79

Nathan the Wise (Lessing), 55
National Theatre, 171
The Necessity of Theater (Woodruff), 187
Nerissa (fictional character), 21–22, 28–29
Nietzsche, Friedrich Wilhelm, 6, 10, 30, 61n29, 67–87, 128; anti-theatricalism of, 4, 67; on art-subjectivity connection, 124; attacks on acting, 68; 'ideal ape' model of acting, 73; insincerity and masking in, 69–71, 78–79, 84n10; on the mask, 9, 67–68, 70, 77, 78, 85n39; models of acting, 71–74; naturalism and naturalistic readings of, 81–83; objections to his support for philosophical masking, 79–81; philosophical intention of, 81; problems with the communication of philosophical ideas in, 77; self-authorship vision of, 124–25; on social acting, 74–75; on the unmasked philosopher, 77–78
No Exit (Sartre), 90
Noh theatrical genre, 171
'non-narrative' performance, 147

observed theatre, 6–7, 154, 160n64
Observing Reason, 17–19, 35nn9–10
Olivier, Laurence, 110–12, 124
On the Art of the Theatre (Craig), 183
Our Town (Wilder), 176

Paris Students Drama Association, 90
participatory and observed theatre, 6–7, 154, 160n64
Patterson, Douglas, 146
performer's questions, 145, 147, 159n28
performing-process theory, 146
Phenomenology of Spirit (Hegel), 30, 33–34, 35n15; *Aufhebung* in, 2, 15; chapters of, 16; inner of inner in, 18–19, 31–32; instinctive reason in, 17–19; 'Reason' chapter overview, 16–18; skulls and phrenology in, 19,

35–36n20; speculative reason in, 19–21
philosophical expression, 81–82
pictorial representation, 165–66, 169–70, 176, 179, 180n10, 182n26
Plato, 1, 79, 93–94, 105n21, 115
Poetics (Aristotle), 90
Portia (fictional character), 21–26, 28–30, 39n78
Prince, Harold, 168
pure theatre, 193–94, 195

Rafferty, Terrance, 152, 153
Ranciere, Jacques, 138, 148
Realphilosophie (Hegel), 36–37n28
Reason, Matthew, 137
Regietheater, 184
rehearsal process, 196–97
romantic criticism, 50–55, 62n34
Romeo and Juliet (Shakespeare), 53
Royal Court Theatre, London, 143
Rozik, Eli, 181n18
Ryan, Marie-Laure, 151–52

Sache selbst, 34, 35n9
Sainte-Albine, Pierre Rémond de, 130
Saltz, David Z., 152
Sartre, Jean-Paul, 11, 89–108; on actor/character distinction, 93–95; on actors as makers and products, 96; on acts and actions, 97–99, 106n32; on analogue and image, 91–93, 95–97; on being someone, 101–3; on enjoyment of theatre, 94; 'Epic Theater and Dramatic Theater' lecture, 90; facticity, 99; image theory, 90–91; on imagination, 91–92, 104–5nn17–18; on original choice or project, 99–103; on resemblance, 92; on 'singularizing', 100–101; on spectators as active participants, 97, 106nn29–30; on theatrical action, 97–98, 100–103, 106n31; on three levels of action in theatre, 90; on uncontrollable elements of performance, 96

scenic realism, 175–76, 179, 182n26
Schechner, Richard, 158n24, 188
Schlegel, August Wilhelm, 2, 6, 10, 43–63; art and work-oriented approach of, 57; art's relationship to philosophy in, 55; bottom-up approach of, 44; central aesthetic categories of, 45; on contemporary drama, 55–56, 62n35; on critics, 51; definition of drama, 44; dramatic art lectures of, 43; dramatic form in, 48; dramatic poetry in, 43–44, 52, 56–58; on English dramatists and foreign influence, 46; on English stage, 46; on genre, 47–50; on German stage, 45, 58n7; on Greek chorus, 51, 61n29; on Greek comedy and tragedy, 47–48; on Greek culture, 45, 48, 59n13, 60n16; on mechanical and organic form, 48–49, 61n27; on mediating criticism, 60n23; modern drama's relationship to modern criticism, 44; on poetry, 49; relation to Herder, 59nn10–11; romantic criticism, 50, 53, 54, 56; romantic philosophy of drama by, 57–58; on Shakespeare, 45–46, 59n12; on Shakespeare's *Hamlet*, 53–54; on Shakespeare's mastery of human heart, 53; on universality in criticism, 54–55, 62n34; Vienna lectures of, 44, 47, 50
Schlegel, Friedrich, 43, 49, 57, 58n4
Searle, John, 174, 181–82n20
selective realism, 172
self-authorship, 124–25, 127
Shaffer, Peter, 171
Shakespeare, William, 2, 15–41, 46, 54–56, 62n36, 118–20; *Macbeth* of, 116; *A Midsummer Night's Dream* of, 117–19; Schlegel on, 45–46, 52, 59n12; Schlegel on *Hamlet*, 53–54; Schlegel on mastery of human heart by, 53. See also *The Merchant of Venice*

Shaughnessy, Nicola, 149–50, 154–55, 159n45
Shylock (fictional character), 15, 21–22, 24–28, 30–33, 37n45, 39n85
signal theory, 144, 159n32
Sirridge, Mary, 146
Smuts, Aaron, 150, 153
Socrates, 73, 80, 93, 105n21
Sophocles, 100
spect-actors, 138, 147–48, 154, 157n3
spectators: apparatus employed by, 139; attending to performers as, 140–42; attention-capacities of, 138–39; attention management of, 150–51; complicity of, 116, 119; data-stream of, 137–39, 142, 156–57n2; empathy of, 131–32; event segmentation theory of, 140; expectation updating of, 143; features of performance which are salient to, 141; fictional framework in understanding of, 173; as finding human action worth watching, 110–12; Hamilton on two-stage process response of, 191, 193, 195–96; identification with fictional characters by, 131–32; inferences of, 140, 143–44; interactivity of, 138; interpretation of, 139–40; moral status of, 138; narrative structure and, 146–47; non-theatrical actions discovered by, 90; objective reports of fact by, 139; performance understanding of, 192–93; performer signal choices for, 144, 158n24; 'performer's questions' to guide, 145, 147, 159n28; performer's signals to, 138, 143; performing as a 'display behaviour' for, 145–46; physical reactions of, 142; Rozik on, 181n18; Sartre on, 9, 97, 101, 106nn29–30; 'signal theory' about, 144, 159n32; spect-actors' relation to, 138, 147–48, 154, 157n3; in theatre compared with film, 166; theatrical minimalism engaging sympathetic participation of, 171, 172; understanding of performance by, 142–44, 192–93; watcher and watched agreement in, 112; Woodruff on, 187
speculative reason (in Hegel), 19–20, 36n23
Spiderman, 115
Stanislavsky, Konstantin, 185–86, 196
Stern, Tom, 121n10, 187, 197
Strang, Alan (fictional character), 171–72
Strindberg, August, 110–11
sublation. *See* Aufhebung
Swain, Mack, 123–25, 127–28, 130–31
Sweeney Todd, 168

Talma, François-Joseph, 73
technique, 109–21; bad, 116, 118–19; critics as professional watchers of, 114; dual arts in, 110; educated watching of, 120; imagination in, 119, 121n9; indicating as sin in, 110; *A Midsummer Night's Dream* scene on, 117–19; mimesis in, 111–12; in games and contests, 113; in music and dance, 110; as object of attention, 112, 113, 121n10; pedagogy and, 113; as secondary object, 114; watcher and watched agreement in, 112
theatre: active, 137; as art form, 1, 6, 193–98; audience participation in, 137; constitutive rules in, 174–75; as 'continuous' with film, 166; Craig on, 184–85, 195; critics on unartistic state of, 183; drama's relation to (in Schlegel), 44; dual arts in, 110; emotional connections and caring in, 114; *Equus* film comparison with, *171–72*, 171–75; fictional framework understanding in, 173; fiction role in, 165; film's ontological difference from, 166; Hamilton, J., on, 6–7, 190; *Hamilton* ludic example of, 177–78; *Happy*

Journey from Trenton to Camden representation in, 167–68, 170; human action in, 111; image and analogue in, 93–97; infiction and outfiction distinction in, 173–74; informing practice in, 10; as interactive, 154; ludic representation in, 165–66, 179, 180n10; mimesis in, 6, 111, 114–16; minimalistic conventions in, 170–71; musical as game model of, 177; Nietzsche on, 67–68, 71–74; Nietzsche's antipathy to, 67; observed and participatory, 137–64; participatory practice issues in, 148; phenomenological differences in audience experiences of, 166; pictorial and non-pictorial elements in, 170; pictorial repleteness in, 176; as real-world event, 165–66; representational art in, 165; Rozik on, 181n18; Sartre on, 89–90, 94, 100; scenic realism in, 175–76, 179, 182n26; Shakespeare making fun of, 118; types of action in, 90; vividness in, 166; watcher and watched agreement in, 112; Woodruff on, 5, 187–89, 195

theatre, participatory, 160n64; attention management in, 150–51; consent as moral issue in, 148–50; interactivity concept and scale in, 151–54; passivity and activity in, 148; practice issues in, 148; scalar notion of interactivity in, 153–55

theatre of the future (in Craig), 184–85

theatrical action as pretence, 97–98, 106n31

theatrical idealists, 8–10, 18, 57, 183, 189–90

theory of action, 98, 106n32

Theseus (fictional character), 117–18, 121n9

Thom, Paul, 133n1

Thompson, Judith Jarvis, 157–58n13

The Transcendence of the Ego (Sartre), 102–3

transcendental idealism, 17, 50

Twombly, Cy, 90

two-stage process of spectator response, 191, 193, 195–96

Über-marionette, 186–87

Un Chien Andalou, 170

unconscious actors, 72

universality, 20, 54–56, 62n34

unselfing, 126, 132

Vardac, Nicolas, 182n26

video games, 138, 156, 161n68

vividness, degrees of, 166

Voltaire, 46, 55

Von Trier, Lars, 176

Walton, Kendall, 165–66

watcher and watched in agreement, 112

Wellek, René, 50, 58n3, 61n26

West Side Story, 178–79

Wilder, Thornton, 167–68, 170–74, 176

Wilhelm Meister (Goethe), 55

Winters, Ben, 181n14

Wollheim, Richard, 130, 192

Women of Trachis (Sophocles), 100

Woodruff, Paul, 187–89, 193, 195

Yacavone, Daniel, 170, 181n14

Young, Edward, 59n9

Zamir, Tzachi, 95

Zarilli, Phillip, 158n27

About the Editor and Contributors

EDITOR

Tom Stern is Senior Lecturer in Philosophy at University College London. He is the author of *Philosophy and Theatre: An Introduction* (2013).

CONTRIBUTORS

Jennifer Ann Bates, Professor of Philosophy, Duquesne University.

Kristin Gjesdal, Associate Professor of Philosophy, Temple University.

James R. Hamilton, Professor of Philosophy, Kansas State University.

Lior Levy, Lecturer, Department of Philosophy, University of Haifa.

David Z. Saltz, Professor of Theatre and Film Studies, University of Georgia.

Paul Thom, Honorary Visiting Professor in the School of Philosophical and Historical Inquiry, University of Sydney, Australia.

Paul Woodruff, Professor of Philosophy and Classics, University of Texas at Austin.

Tzachi Zamir, Associate Professor of English and General & Comparative Literature, The Hebrew University of Jerusalem.

Printed in Great Britain
by Amazon